Difference and Excess in Contemporary Art

Difference and Excess in Contemporary Art

The Visibility of Women's Practice

Edited by
Gill Perry

Blackwell
Publishing

© 2004 Association of Art Historians

First published as Volume 26, number 3 of *Art History*

BLACKWELL PUBLISHING
350 Main Street, Malden, MA 02148-5020, USA
108 Cowley Road, Oxford OX41JF, UK
550 Swanston Street, Carlton, Victoria 3053, Australia

First published 2004 by Blackwell Publishing Ltd

Library of Congress Cataloging-in-Publication Data has been applied for

ISBN 1-4051-1202-6

A catalogue record for this title is available from the British Library.

Set by Macmillan, India
Printed and bound in the United Kingdom
by MPG Books Ltd. Bodmin, Cornwall

The publisher's policy is to use permanent paper from mills that operate a sustainable forestry policy, and which has been manufactured from pulp processed using acid-free and elementary chlorine-free practices. Furthermore, the publisher ensures that the text paper and cover board used have met acceptable environmental accreditation standards.

For further information on
Blackwell Publishing, visit our website:
http://www.blackwellpublishing.com

CONTENTS

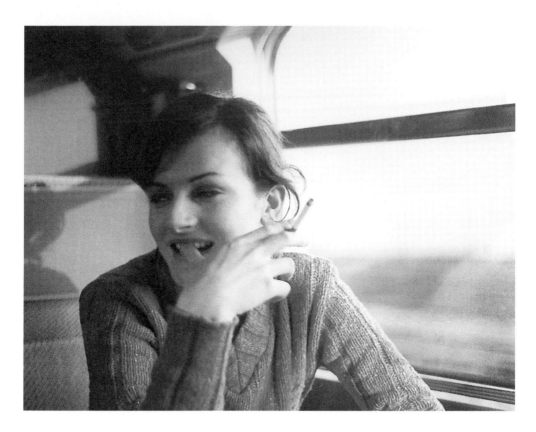

This book is dedicated to the memory of Lorna Healy, who died of cancer on 8 September 2002. At the time of her death, Healy was writing an essay for this collection on the work of Hannah Starkey, and continually expressed support and enthusiasm for the project. Sadly, she was unable to complete the piece and her contribution will be sorely missed. Born in Ireland in 1970, she will be remembered for her imaginative and energetic teaching at the National College of Art and Design, Dublin, Crawford College, Cork, and the Open University. In 1998 she joined the education department at Tate Britain, where she developed lively new programmes in unexplored areas of British visual culture. Many of her articles and reviews for art magazines and other publications (including *CIRCA*) addressed issues around art, feminism and popular culture. For example, in the year before her death she completed an essay on pop cultural strategies in Tracey Emin's work, 'We Love You, Tracey', now published in *The Art of Tracey Emin* (edited by Mandy Merck and Chris Townsend, London, 2002), which makes an important contribution to the study of contemporary video work. As editor, I would also like to express a strong personal sense of loss for a clever, combative, witty and engaging friend and colleague, who had so much to contribute.

Notes on Contributors

Fionna Barber is Senior Lecturer in Art History at Manchester Metropolitan University. She is currently working on a study of nation, gender and modernity in Irish art and culture (to be published by Reaktion Books).

Jane Beckett is Professor of Contemporary British Art at New York University/ London. She has published extensively on Dutch and English modernism, and contemporary British art; she is co-editor of *Henry Moore: Critical Essays* (Ashgate, 2003). She is currently writing a book on Amsterdam.

Michael Corris is Senior Research Fellow in the History of Art and Design, Kingston University, Kingston-upon-Thames. He has published widely on contemporary art and is the editor of a collection of essays *Conceptual Art* (Cambridge University Press, forthcoming).

Robert Hobbs holds the Rhoda Thalhimer Endowed Chair at Virginia Commonwealth University. In 2002 Professor Hobbs served as the United States Commissioner for the 25th International Biennial of São Paolo, Brazil, in which capacity he curated the exhibition *Kara Walker: Slavery! Slavery!* Professor Hobbs is currently completing a monograph on Walker's art.

David Hopkins is Reader in Art History at the University of Glasgow. His books include *Marcel Duchamp and Max Ernst: The Bride Shared* (Oxford, 1998) and *After Modern Art 1945–2000* (Oxford, 2000). A study of Dada and Surrealism is forthcoming.

Sue Malvern lectures in History of Art at the University of Reading. She has published extensively on art and war is completing a book entitled *Witnessing, Testimony and Remberance. Modern Art, Britain and the Great War.*

Marsha Meskimmon is Reader in Art History and Theory at Loughborough University. She is the author of *The Art of Reflection: Women Artists' Self-Portaiture in the Twentieth Century* (1996), *We Weren't Modern Enough: Women Artists and the Limits of German Modernism* (1999) and *Women Making Art: History, Subjectivity, Aesthetics* (2003).

Gill Perry is Senior Lecturer in Art History at the Open University. She has published books, articles and edited collections on eighteenth century British art and twentieth-century European art, including *Women Artists and the Parisian Avant-Garde* (1995), and *Gender and Art* (1999). She is currently writing books on eighteenth-century representations of the actress (*Spectacular Flirtations*) and on contemporary women's practice in Britain.

Dorothy Rowe is Senior Lecturer in Art History Theory at Roehampton, University of Surrey. She is author of *Representing Berlin: Sexuality and the City in Imperial and Weimar Germany* (Ashgate, 2003) as well as a number of articles concerned with issues of race, gender and the European city. She currently serves on the editorial board of *Art History*.

Lisa Tickner is Professor of Art History at Middlesex University. She is author of *The Spectacle of Woman: Imagery of the Suffrage Campaign, 1907–1914* (1988), *Modern Life and Modern Subjects: British Art in the Early Twentieth Century* (2000), and a number of articles on history and theory. She has recently written a short book on Rossetti.

Acknowledgements

The authors would like to acknowledge the generosity of many artists, dealers and collectors who have kindly lent reproductions and/or given permission for works to be reproduced. They include: Rachel Whiteread, Artangel, Martha Rosler, Gillian Wearing, Maud Sulter, Minerva Cuevas, Sutapa Biswas, Maureen Paley at Interim Art, Cornelia Parker, the Frith Street Gallery, Alice Maher, Christine Borland, the Lisson Gallery, the Art Gallery of New South Wales, Kara Walker, Cady Noland, Mona Hatoum, Jay Jopling/the White Cube Gallery, Sarah Lucas, Lubaina Himid, Sadie Coles Gallery, Public Art Fund NY, Brent Sikkema Gallery NY, Margaret Morgan and Peter Fleissig.

We are immensely grateful to the Paul Mellon Centre for Studies in British Art, London, for providing financial assistance to cover the cost of reproductions. Special thanks must also go to the Open University secretaries Shirley Parsons and Debbie Williams, who helped to format and correct drafts of the manuscript, to Sarah Sears for her skilful copy-editing, and to all those at Blackwells who enabled and supported the production. And we are especially indebted to Deborah Cherry for her enthusiasm for this project and her invaluable support.

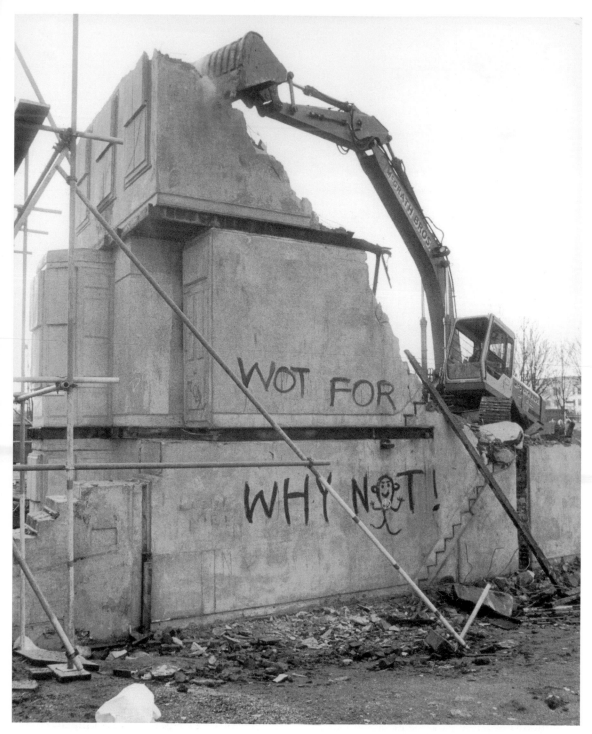

1.1 Rachel Whiteread, *House*, Demolition, 11 January 1994. Reproduced courtesy of Artangel, London. Photo: Stephen White.

1

Introduction: Visibility, Difference and Excess

Gill Perry

'Difference is far more entangled and complex than we like to admit.'
M. Catherine de Zegher (1995)[1]

Visibility

On 23 November 1993 two seemingly incompatible decisions were made in different parts of London. Bow Neighbourhood Councillors voted to demolish *House*, Rachel Whiteread's cast of the interior of a condemned house on Grove Road in the East End of London (plate 1.1). Meanwhile, at the Tate Gallery, Millbank, the jurors of the annual art competition, the Turner Prize, voted to give Whiteread the award, partly as an acknowledgement of the artistic value of *House*. Whiteread was the first woman to win the Turner Prize (established in 1984) and during the mid-1990s she rapidly became one of the most 'visible' of the so-called yBas (young British artists). The social, political and aesthetic ramifications of the production of *House* attracted widespread debate in national broadsheets and the local press, and concentrated public attention on the controversies at the heart of a 'new' British art.[2] Apart from the repeated refrain of 'but is it art?' in the columns of the broadsheets, the local press focused on issues of housing policies and local housing shortages, questioning the appropriateness of the cost (£50,000) of the work, which was commissioned and supported by the pioneering arts charity Artangel. Many art world figures and institutions rallied in defence of *House*, citing its innovative status as a site-specific installation which evoked memories – and revealed visible traces – of domestic lives and deaths (plate 1.2). Even within the various constituencies supposedly pitted against each other, there were differences of opinion. Local councillors and inhabitants of neighbouring houses were divided on the issue, and the decision to demolish the work (rather than extend its life for a limited period) was taken by a casting vote of one (plate 1.3).[3] As James Lingwood has suggested, '*House* laid bare the limits of language and expectations which afflict the contentious arena of public art.'[4] Unlike more conventional forms of memorial, it was unclear what values or associations the work was seeking to promote. Such confusions about meaning and value are now seen as critical signifiers of the controversial status of recent British art.

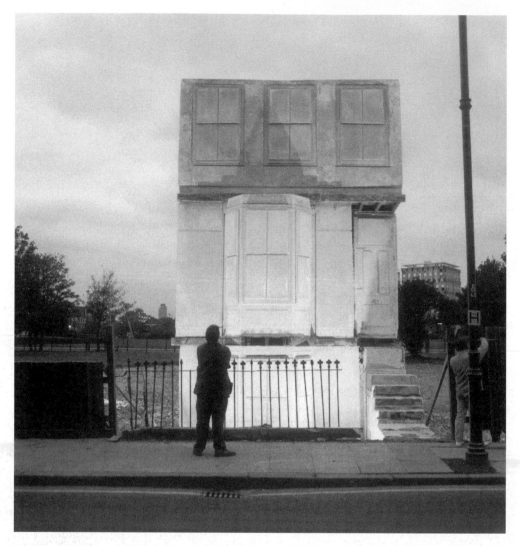

1.2 Rachel Whiteread, *House*, view from Grove Road, 1993. Reproduced courtesy of Artangel, London. Photo: John Davies.

However, within these debates, the gender of the artist and her visibility as a woman working in a sculptural medium previously dominated by men[5] have figured as less prominent concerns. The gendered resonances of domestic iconography have already engaged the interest of some scholars of Whiteread's work[6] (and will be explored further in Sue Malvern's essay 'Antibodies' on Whiteread's *Water Tower*). But there is also much contextual and analytical work still to be done around issues of visibility, strategies of self-narration, identity and the possible relationships between (feminist) theory and practice in the work of Whiteread and her contemporaries. This collection of essays and interviews seeks to advance such concerns through diverse encounters with the role of 'difference' within the practice of selected women artists.

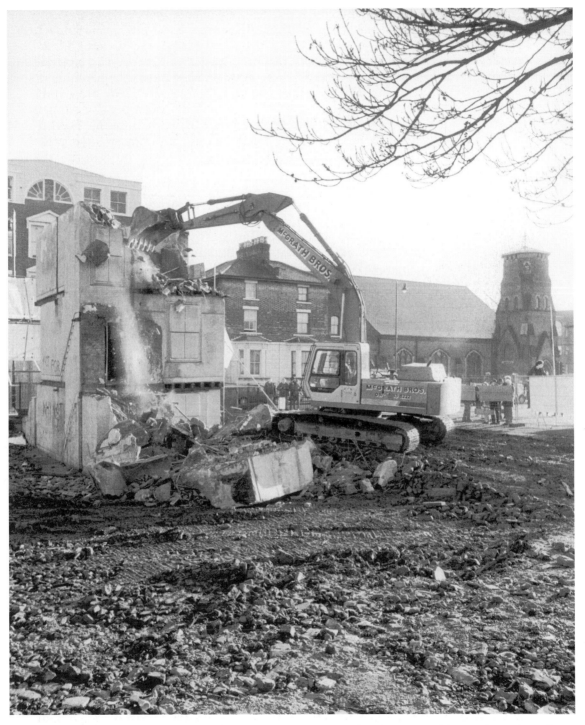

1.3 Rachel Whiteread, *House*, Demolition, 11 January 1994. Reproduced courtesy of Artangel, London. Photo: Stephen White.

Recognition of the complexities and 'entanglements' which underpin any notion of 'difference' in visual representation has directly informed this project. Over recent years, concepts of difference (as the gendered, the sexual and the racial 'Other') have been energetically explored in feminist theory and practice in the pursuit of new and reworked aesthetic languages. Binary oppositions of female/male, feminine/masculine, culture/nature, white/black have been both exploded and reconstituted within some forms of contemporary art (by women and men), influenced by ideas scavenged from deconstructionism, psychoanalysis, post-structuralism, Marxism, anthropology, philosophy and post-colonial theory. Twenty years ago Craig Owens famously proclaimed the importance of issues of sexual difference within a postmodern critique of representation, citing the work of several women as key figures in this expanding discourse.[7] Drawing on various strands of postmodern theory, Owens explored the work of artists who were forging various alliances with feminist theory. With reference to the work of, for example, Martha Rosler, Mary Kelly, Sherry Levine, Dara Birnbaum, Cindy Sherman and Barbara Kruger in America, he asserted the contemporary cultural and aesthetic relevance of different forms of postmodern feminist practice. He argued that such women 'had begun the long overdue process of deconstructing femininity', by exploring not so much what representation says about women, as what 'representation *does* to women'.[8]

Twenty years on, the agenda has become more complex and fragmented. The evolving relationships between feminist theory and artistic practice now appear more troubled and 'entangled' than Owens's influential essay led us to believe, especially when we shift our focus to include the wide range of work produced by British and European women artists over the past two decades. However, this collection has been conceived and produced in the belief that these sometimes difficult relationships, and the debates which they have nurtured, have enriched and enabled a wide diversity of practices by women artists, some of whom (unlike many of Owens's protagonists) do not directly identify themselves either as feminists or as theoretically engaged.

Owens was concerned with issues of visibility. He noted the extent to which theories of postmodernism had tended to neglect or ignore the 'presence of an insistent feminist voice'[9] and the resulting absence of discussions of sexual difference. An important aspect of contemporary practice was thus (according to his argument) rendered invisible, or marginalized. Another concern with issues of visibility and invisibility has also been located within feminist strategies of deconstruction in which artists such as Rosler (whose work *The Bowery* is juxtaposed with Gillian Wearing's *Drunk* in David Hopkins's essay 'Drunkenness') or Kruger have sought to reveal the hidden social, cultural and sexual agendas within the visual and textual imagery of the modern mass media. Writing of these interests in the early 1980s, Owens was prompted to ask 'what does it mean to claim that these artists render the invisible visible, especially in a culture in which visibility is always on the side of the male, invisibility on the side of the female?'[10] Since the early 1980s such questions have resonated within the discourse on gender and 'women's art', and recent developments within feminist art practice and theory have encouraged explorations of the cultural, psychic, aesthetic and curatorial mechanisms of in/visibility.[11]

4

Catherine de Zegher's groundbreaking exhibition and catalogue of 1995–6, *Inside the Visible: an elliptical traverse of 20th century art in, of, and from the feminine*, engaged directly with these concerns. Through the exhibition of work by thirty-seven women artists from around the world, from the 1930s to the (then) present day, the curators sought not to produce a survey of women's art, but rather to address 'hidden themes' in contemporary art. The show combined the work of well-known artists with that of relatively 'invisible' figures, encouraging its audience to reflect on overlapping themes of gender and sexuality, the intersection of ethnic, class and sexual identities, the relationship between viewer and art work and the complex structures of visual languages.

It could be argued that many of these themes are no longer 'hidden' or marginal, that they are increasingly visible within the cultural and intellectual discourse which surrounds the production of contemporary art during the early years of the twenty-first century. That said, this book has been produced in the belief that some of the concerns and explorations which underpinned the intellectual and curatorial project of *Inside the Visible* are still relevant to a study of contemporary practice by women. In her introduction to the exhibition catalogue de Zegher wrote: 'It may seem paradoxical to argue against the separation of the world into exact oppositions and then confirm the binary system by selecting work on the basis of gender.' In defence of her selection she cited the need to show the partiality of historical structures, and 'to display the art of women because their roles as active agents of culture have too often been minimized'.[12] In this context, the project of making 'visible' involves the unveiling or rewriting of history in which language and visual images can be used to naturalize traditional patriarchal power relations.

This collection might deploy a similar defence for its gender bias, although (as I shall argue) the conditions of current practice reveal shifts in some of those power relations. Within our defence we should also stress our desire to avoid reductive or essentializing notions of 'women artists', while also acknowledging that the author is firmly back in the text. The complex relationship of the (woman) artist to her work – as narrator, observer, mediator, complicit autobiographical subject – is a theme which runs through many of the essays and interviews which follow. This project also emerges from the recognition of a further, perhaps paradoxical, development: the increasing visibility of the work of some women artists, especially (but not exclusively) in Britain at the beginning of the twenty-first century. Through the deployment of different analytical strategies and forms of interrogation and research, this collection tentatively sets out to explore how and why such visibility has emerged.

Work by women has featured prominently within recent debates about the status and 'meanings' of contemporary art practice in Britain, Europe and America. In Britain the rise to prominence of the so-called yBas, the much-trumpeted launch of Tate Modern at Bankside, London, the frenzy of publicity generated by the Turner Prize and the seemingly insatiable appetite of the press for art world stories which feature media-friendly artists (both women and men), have helped to focus critical attention on the work of several women. Artists such as Tracey Emin, Sarah Lucas and Fiona Banner, whose work draws on popular culture and deploys readable strategies of irony and sexual

provocation, have been seen by some to be carrying the torch for a transgressive 'bad girl' art, indulging in an aesthetics of excess.[13] Gillian Wearing, Sam Taylor-Wood and the Lebanese-born artist Mona Hatoum, have also each been included at various times within – or on the margins of – the category of British 'bad girls', partly for their (albeit different but) irreverent engagements with themes of female sexuality through strategic and performative uses of video and photography (plate 1.4).[14]

In his influential account of the British art scene, Julian Stallabrass formulated the category of 'high art lite'[15] with which to articulate an art-historical and political critique of works by an increasingly successful group of male and female artists. The crude courting of media notoriety and celebrity status, the strategic deployment of popular culture, resistance to theory, political emptiness and juvenile superficiality have been identified in the work of yBas such as Emin and Lucas, Taylor-Wood and Wearing and critiqued by Stallabrass, among others. Strategies deployed by such artists have generated a fertile debate on the critical potential of representing excessive behaviour within art practices.[16] In what follows, the authors explore some of these readings of works by Emin, Wearing, Lucas and others, revealing some of the social and psychic meanings which can underpin an aesthetics of 'excess'. For example, in his essay 'Drunkenness', David Hopkins explores the performative aspects of Wearing's video *Drunk*, arguing that this is a self-reflexive work which provokes reflection on our obsessively confessional media culture.

Most of the other art practices featured in this book fit uncomfortably within the currently available geographical, national and art-historical categories. For example, the evocative sculptural installations by Rachel Whiteread (discussed in Malvern's essay on *The Water Tower*); the combination of sexual, art-historical and deconstructive references in works by Cornelia Parker (explored in Lisa Tickner's interview with the artist); and the potential for theoretical engagement in the obsessive installations of Christine Borland (featured in Marsha Meskimmon's essay 'Corporeal Theory') do not sit easily within the 'high art lite' frame.

Dorothy Rowe's essay on the performative strategies of the diasporic artist-led group moti-roti explores other issues of gendered and racial identity. The activities of this London-based group of male and fermale performers include techniques of parody, mimicry and excess, and further confuse the boundaries of both a 'British' art practice and a gendered category of 'women's art'. Similarly, Jane Beckett's essay on Lubaina Himid's *Plan B*, commissioned by Tate St Ives in 1998, focuses on the artist's use of narrative as a means of exploring diasporic and geographical identities in a series of paintings that plays with illusion and allusion. The inclusion of Fionna Barber's interview with the Irish artist Alice Maher is part of a deliberate and continuous editorial strategy to problematize cultural and geographical boundaries around ideas of 'Britishness' and its colonial histories. Furthermore, Michael Corris's interview with Robert Hobbs on the work of the American artist Kara Walker is included in an attempt to explore the representation of (gendered) difference within another national and ethnic context, outside the parochial preoccupations and debates which have circulated around concepts of 'Britishness'.

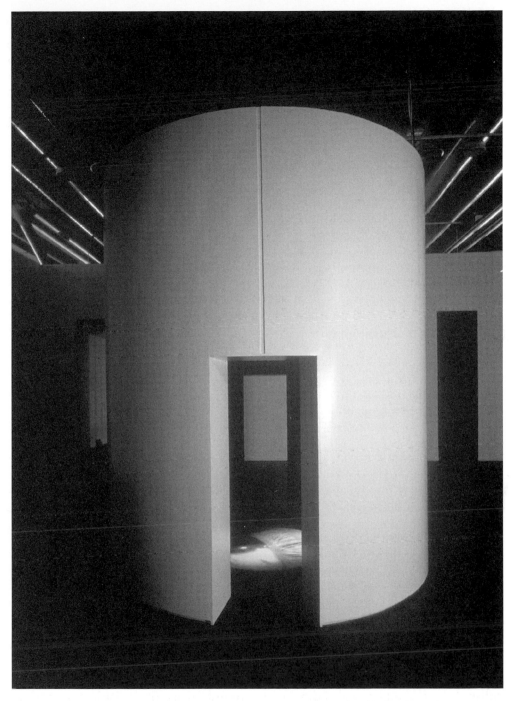

1.4 Mona Hatoum, *Corps étranger*, 1994. Video installation with cylindrical wooden structure, video projector, amplifier, four speakers, 350 × 300 × 300 cm. Courtesy Jay Jopling/White Cube, London.

The texts in this collection have been combined to provoke a rethinking of some of those broad categories, critical and otherwise, which have been used to represent diverse forms of production in contemporary art, with a deliberate emphasis on Britain. Stallabrass himself emphasizes the inadequacies of labels such as Brit art or yBas as descriptive categories for a group of artists who live in Britain, but who are not all British.[17] He also registers an important characteristic of British art in the 1990s – the increasing prominence of women:

> The turn to the domestic is one factor that has favoured women artists who are strikingly more prominent in British art than they were ten years ago – and this development must count as one of the signal achievements of high art lite. A simple way of registering change is to look at the proportion of women in exhibitions that are meant to give an impression of the British art scene to those in other countries. While the previous wave of British art to come to prominence (the 'new sculpture') was dominated by males and by work that often made mystifying claims to its own spiritual significance, current exhibitions, such as *Real/Life* shown in various venues in Japan, contain art that is more domestically inclined, and a little more modest in its claims to cosmic import...[18]

Eight of the twelve artists in the *Real/Life* show in 1998 were women. This marks a significant shift, but such a high proportion of female exhibitors in a field previously dominated by established male 'heavyweights', such as Tony Cragg, Richard Deacon, Bill Woodrow, Richard Long and, more recently, Anish Kapoor and Anthony Gormley, is unusual. For example, the 'new' British sculpture show at the Whitechapel Gallery, London in 2002, *Early One Morning*, featured the work of three men and two women, a more typical gender balance for recent shows.[19] 'The turn to the domestic' and the iconography of the 'home' has undoubtedly featured prominently in the work of many contemporary women artists, apart from Whiteread. Although Stallabrass sees these interests as possible sites of media exploitation and trivialization (we might identify Emin's *My Bed* of 1999 as vulnerable to such appropriation), many of the texts which follow suggest that engagements with such themes can also reveal the artists' explorations of (female) subjectivities, identities and histories.

An underlying concern of this collection, then, is the need to acknowledge the complex play of issues of difference (in both the production and the viewing of art) in the formulation of our historical and theoretical categories. The critical undercurrents of high art lite have provided us with theoretical ammunition for the deconstruction of the media-friendly rhetoric of sensationalism. But the category may now be in danger both of feeding a seductive philistinism, and of homogenizing diverse and sometimes innovatory engagements with issues of identity, sexuality and aesthetic exploration.[20] It is hoped that the essays and interviews which follow will reveal possibilities and frameworks for re-categorizing and contextualizing such forms of practice by women.

In curatorial and critical terms both the 'yBa' and 'high art lite' categories have already been questioned. In 2000 a major exhibition, *British Art Show 5*, curated by Matthew Higgs, challenged pre-existing perceptions and identified a state of

'crisis' in British art. In a leaflet accompanying the Edinburgh phase of the show, Susanna Beaumont cited the last British Art Show that had toured to the Scottish capital in 1996, and Charles Saatchi's *Sensation*, which 'proclaimed the attitude-soaked brilliance of a select band of contemporary artists'. Such art 'was made by bad boys and even badder girls'.[21] Beaumont echoed a common perception of the art of the 1990s, that the girls were somehow naughtier than the boys. Such 'bad' behaviour could be identified in strategies of (sexual) provocation in both the art itself and the media performances which accompanied its display. This emphasis on 'bad' behaviour of 'girls' also signalled a more general audience response to a practice which was seen to be gendered, and which was marketed and promoted on that basis.[22] But the 2000 show, which included artists of all ages – ranging from the 'bad girl' Emin to David Hockney – refused any easy categorization. Of the fifty-five artists included, seventeen were women, a lower percentage than we might expect in the wake of Stallabrass's earlier claims about 'prominence'.[23] Higgs sought to show that 'British art' embraced a wide range of practices, many of which had not enjoyed the London-focused media interest: 'There was an initial curiosity and generosity about British art in the 1990s, it is now being replaced by a general scepticism and weariness of its homogenous packaging.'[24] The essays in this collection seek both to strip away this 'packaging', and to explore some of the social, psychic and aesthetic interests which have constructed several of our protagonists as 'bad'.

The economic reasons for the dramatic rise in the popularity, marketability and institutionalization of contemporary British art in the 1990s have been well aired in recent publications. An art market emerging from the recession of the late 1980s was attracted to less expensive 'home-grown' talent in the early 1990s, and encouraged a growth of artist-run gallery spaces and exhibitions, especially in the (then) cheaper East End of London. One of the most powerful private dealers, Charles Saatchi, sold much of his priceless collection of internationally renowned, largely male, artists (among them Andy Warhol, Julian Schnabel, Francesco Clemente and Anselm Kiefer), and began collecting and exhibiting the work of young British artists, provoking debate about the influence of wealthy private individuals on the formation of public 'taste'. At the same time an influential group of small private galleries, which included Maureen Paley's Interim Art, Karsten Schubert, Laure Gennillard, Jay Jopling's White Cube, Victoria Miro, Anthony Reynolds and Jane Hamlyn's Frith Street Gallery, began buying and showing work by British artists, many of them graduates from the fine art course at Goldsmiths College, London.[25]

Women featured prominently among the young artists taken on by these dealers, marking a significant shift from the gender bias of the (largely male) British 'blue-chip' artists patronized by the most prominent contemporary art dealers of the 1970s and 1980s, among them the Lisson Gallery, Anthony D'Offay and Waddingtons.[26] For example, Karsten Schubert, who established his Charlotte Street Gallery in 1987 in partnership with Richard Salmon, gave Anya Gallaccio (1991), Rachel Whiteread (1991) and Abigail Lane (1992) their first solo shows.[27] Jay Jopling at the White Cube gave Sam Taylor-Wood and Tracey Emin their first solo shows in 1994 and 1995 respectively, and took on Mona Hatoum in 1995. Maureen Paley at Interim Art took on Gillian Wearing in 1993,

giving the artist her first show in 1994.[28] In addition, the increasing number of women occupying influential curatorial positions in major public galleries over recent years has contributed to the general visibility of the work of some more established women artists within well-publicized venues.[29] For example, the work of (New York-based) Louise Bourgeois, the doyenne of an older generation, was featured in a major solo show at the Serpentine Gallery, London, in 1998–99, and was specially commissioned for the opening display in the turbine hall of Tate Modern in 2000. Such factors have contributed to a general public awareness of women as increasingly significant players within contemporary art in general, and as artists who work in ambitious, large-scale media, such as sculpture and installation, which have been traditionally dominated by men.

However, reasons for the increased patronage of these women are, of course, complex, and, in the absence of detailed histories (yet to be written), vulnerable to anecdotal speculation. As Maureen Paley has astutely pointed out: 'A great deal of the history of women's practice from that era is oral history.'[30] It is tempting to see the significant numbers of women gallery owners occupying the influential private dealer 'A list' (in my list above from the early 1990s four of the seven are women) as a critical force in shifting the balance, although my own research suggests that most of these dealers did not make any clear decisions to patronize women at the expense of male artists. It is rather the case that a younger generation of dealers, mostly art school and university educated and many of them women, shared the 'progressive' or loose feminist concerns of their peer group, seeking to correct exclusions rather than positively discriminating in favour of women. In a recent interview Richard Salmon has discussed curatorial decisions made in the planning of influential shows of British artists at Karsten Schubert's gallery in around 1990, recalling that 'if you had a shortlist for a show of six, then we would often include two women among the six as a kind of unconscious principle.'[31] Moreover, through increased opportunities for women in British art schools since the 1960s, many talented female artists were graduating with ambitions, actively seeking out career opportunities and forms of financial support. Encouraged by more opportunities for exhibiting and marketing their work, they were better placed to adopt more aggressive (masculine) methods of self-promotion and self-narration. Among those methods we might include those strategies of sexual provocation and irreverence which have both attracted relentless media attention and (it is argued) helped marketability.

Interestingly, Rachel Whiteread, the British woman artist who currently enjoys perhaps the most prominent international status and whose work commands some of the highest prices of her generation,[32] produces installations and sculptures which are free of such strategies. We have seen that a different sort of notoriety was generated by public responses to *House*, completed in October 1993. Lisa Tickner has argued that we might better understand the social and aesthetic relations which have enabled Whiteread's progress through a notion of the 'de-masculinization of creative potential'. In her 2002 essay 'The Mother–Daughter Plot', Tickner explores the intricate relationship between individual agency and changing socio-aesthetic-economic relations in Whiteread's career.[33] She points out that Whiteread belongs to the first generation in which

women artists have grown up with mothers and female role models who themselves have been influenced by feminism, or at least informed by its ideals. Her mother is an artist, and early in her career Whiteread worked as an assistant to the sculptor Alison Wilding, herself a Turner nominee in 1988 and 1992.[34] Tickner argues:

> What women have needed is the revision of actual or perceived forms of experiential, discursive and psychological difference. That is, freedom from the constraints on their social opportunity ('our institutions and our education'); and from the delimiting effects of mythic narratives of creativity allied to narcissistic cultural investments in the Artist as an infantile idealization of the oedipal father (who has then to be struggled with and overcome). De-idealization here is connected to the de-masculinization of creative potential.[35]

Tickner goes on to make the important point that there is a body of psychoanalytic literature on gender and creativity which needs rethinking, 'now that the critical mass of women's work is sufficient to undermine its founding premises…'.[36] It is hoped that the essays in this collection will make some contribution to the process of 'rethinking' and developing the existing literature on gender and creativity. In her interview with Cornelia Parker, Tickner explores such issues, suggesting that as a student in the 1970s, Parker was working 'against a backdrop of emerging debates around art and gender'. Parker, however, represents herself as a 'person making art' rather than as a woman artist, which Tickner situates within a cultural field which has enabled certain freedoms for a generation of women artists who have grown up with positive role models of both sexes. In the context of these arguments, then, Parker's sense of her artistic identity might be contrasted with the more overtly feminist strategies of self-narration adopted by an earlier generation of (American) women such as Rosler or Kruger, whose work informed Owens's article of 1983.

Developments within the British art school system during the 1970s and 1980s are often cited in attempts to map a changing institutional culture of art.[37] During the 1970s political debate flourished within these art schools around concepts of art education and creativity, encouraging (as some have argued) creative experimentation. Much has now been written about the importance of the pedagogic and artistic environment of Goldsmiths College, London, in the 1980s in helping to cultivate and encourage a generation of 'socially and culturally inquisitive' graduates and post-graduates.[38] Many well-known artists taught at the college during the 1970s, 1980s and 1990s (including Mary Kelly, Michael Craig-Martin, Richard Wentworth, Yehuda Safran and later Lisa Milroy and Cornelia Parker), and most historical accounts have emphasized the importance of the principal, Jon Thompson, and the influence of the artist and teacher Michael Craig-Martin in the nurturing of 'young talent'. Thompson instituted an open-studio system in which traditional divisions between departments of painting, sculpture and photography etc. were abolished, enabling students to move and work between – or combining – different media and 'genres'. In consultation with their artist/tutors, students were

encouraged to structure their own courses and participate in intensive critical exchange, independent thinking and diversity of expression. It might be argued that, in its ideal form, this encouragement of independent thinking and diversity provided the spaces in which (previously marginalized) women and artists of colour could rise to prominence, helping to produce a 'de-masculinization of creative potential'. Again, the detailed history remains to be written, but such conditions do seem to have enabled the early careers of artists such as Abigail Lane, Anya Gallaccio, Fiona Rae, Sarah Lucas, Sam Taylor-Wood, Jane and Louise Wilson, Cathy de Monchaux and Fiona Banner.

According to Craig-Martin, the exceptional academic freedom within art schools in Britain from the 1960s to the mid-1980s helped to place these institutions at the 'critical centre' of the British art world. He has argued that one of the reasons why so many Goldsmiths graduates of the late 1980s had a profound impact on international perceptions of British art 'was that they continued the critical dialogue that had characterized their education into the art world beyond the school. Every exhibition, every interview, every social event became an opportunity to extend awareness and to discuss ideas, feelings, concerns and values.'[39]

Despite the importance of Goldsmiths College in the nurturing of this dialogue, other British art schools undoubtedly figured as part of Craig-Martin's 'critical centre', including (in London) the Royal College of Art (where Whiteread, Emin, Jake and Dinos Chapman and Gavin Turk – among others – worked as post-graduates) and Chelsea School of Art (where an earlier generation including Helen Chadwick, Shirazeh Houshiary and Anish Kapoor studied), Central St Martin's and the Slade. But one of the key features of the so-called 'Goldsmiths phenomenon', imaginatively pursued by teachers such as Craig-Martin in the early 1990s, was the encouragement of the schools' relationship with collectors and dealers.[40] However, it is this very relationship, which contributed to the early marketability and visibility of the work of several artists discussed in this collection, which has recently been critiqued as blocking creativity among a new generation of students. Some have argued that the commercial successes of the graduates of the early 1990s have numbed a new generation of students into the relentless pursuit of a Brit art 'house style', relatively empty of innovatory strategies and critical concerns.[41]

Since 1990 Goldsmiths graduates have constituted a significant proportion of the artists shortlisted for the annual Turner Prize, organized by the Tate Gallery. Established in 1984, this award is made to British artists under the age of fifty[42] for a body of work shown during a specified period of twelve months. Since 1991, when Channel 4 took over sponsorship, the prize and its televised award ceremony has generated endless controversy, attracting condemnation from conservative reviewers (Brian Sewell's columns in the London *Evening Standard* jump to mind), frenzied trivia in the tabloid press and pages of copy from professional critics and writers. Some critics have seen recent shortlists as confirming the ubiquitous prevalence of high art lite and the triumph of neo-conceptual art, although it is also widely acknowledged that the popularity of the Turner Prize has contributed to a steady increase in Tate Gallery attendance figures.[43] Nomination for the Turner Prize, then, has become a guarantee of

dramatically increased public awareness of the artists involved, although, over the past few years, several other art world competitions have competed for media attention, including the annual Jerwood Painting Prize and Becks Futures Awards.[44] While the award may act as a crude barometer of curatorial, economic and critical values within the 'official' art world, it could be seen (for better or worse) to have significantly affected public perceptions of the work of women within the contemporary British art scene. In 1999 Nicholas Serota, director of the Tate, reviewed some of the most notable changes in short lists since 1984. Apart from the change in the average age[45] since 1991, he noted:

> Even more striking was the fact that two of four nominees [in 1991] were women. In the first four years of the prize, before the formal shortlist was abandoned for the years 1988 and 1989, only two women had been nominated compared with twenty-one men. By contrast in the years 1991–98 fourteen of the thirty-two nominees were women... . Quite suddenly, it seemed that art could be young, female and directly connected to the viewer's daily experience.[46]

Between 1991 and 2002 nineteen of the forty-four nominees have been women, which constitutes a slightly lower percentage than the 1998 statistic. Despite such vagaries, this award has marked a dramatic shift in the public fortunes of – and prominence accorded to – certain women artists, albeit a visibility intricately tied to the exhibiting policies of major public and private galleries and the tastes and preferences of the Turner Prize juries, chaired each year by Serota.[47] But the representation of new British art as somehow 'female' might be seen as a compensatory over-reaction to significant developments around 1997–99. Exceptionally, in 1997, the four shortlisted artists were women: Gillian Wearing, Cornelia Parker, Christine Borland and Angela Bulloch. However, an equally revealing statistic is that since 1984 only two of the nineteen prize winners have been women, namely Rachel Whiteread in 1993 and Gillian Wearing in 1997. According to this statistic, the coveted prize, in the form of a cheque for £20,000, is nearly ten times more likely to go to a male artist. Visibility, then, must be conceived of as a question of degree – a fluid and contradictory process which responds in complex ways to art world discourse and the broader cultural field.

Theory and practice

Although three black artists have now been nominated for the Turner Prize (Chris Ofili, Steve McQueen and Isaac Julian), women of colour have yet to appear on the short lists, despite the rise to prominence of black women artists in Britain in the 1980s, when their work gained mainstream visibility and won major awards. For example, Maud Sulter's *Zabat* (plate 1.5) won the New Contemporaries Award in 1989 and was purchased by the Victoria and Albert Museum, London. This visibility was enabled through strategic alliances of theory and practice in art projects and activities by black women artists. These

included curating exhibitions such as Lubaina Himid's landmark *Thin Black Line*, organized for the Institute of Contemporary Arts in 1985, setting up independent venues from The Elbow Room to Rich Women of Zurich, arranging events and publishing exhibition catalogues and collections of essays (Sulter's *Passion: Discourses of Blackwomen's Creativity* was published by Urban Fox Press in 1990). Such activities foregrounded the practice, theory and politics of art by women of colour, whether Asian, African or Afro-Caribbean.

If the relationship between art and theory has been contested within debates about 'white' feminism, so too has the broader relationship between feminism, women's art and art writing. In 1995 Janet Wolff called for 'a real collaboration' between the feminist artist, critic and academic, acknowledging that in some cases these may be combined in the same person (as academics and artists may also write as critics). The plea was provoked by her observations in the mid-1990s that significant schisms had emerged between feminist theorists, artists and critics around a range of parallel oppositions identified in women's practice. These binaries are summarized as: ' "scripto-visual" work [of, for example, Mary Kelly] versus painting; deconstruction versus celebration [of, for example, Judy Chicago]; theory versus experience; elitism versus accessibility'.[48] Wolff suggests that such theoretical oppositions are often unsustainable. She notes slippages that often take place in the formulation of such oppositions, arguing that there is no single 'correct' feminist aesthetic.[49] Wolff's plea for collaboration acknowledges the self-serving dangers inherent in the 'academicisation of feminism', while also identifying a need for intellectual work 'in the academy and outside, which is grounded in practice and the object'. This collection of texts was conceived of with a similar sense of the need to acknowledge the important role of theory in the interpretation of a material art practice, while not demanding that those practices must be theory-based at the point of production.

Marsha Meskimmon's essay 'Corporeal Theory' on Christine Borland's *Winter Garden* engages head-on with the problematic relationship of contemporary feminist theory with art practice. Echoing some of Wolff's concerns, she suggests that Borland's work invites feminist art critics and historians to move beyond the dualism that polarizes theory and practice. Through analysis of the artist's complex (corporeal) evocation of woman, she posits a notion of theory as not 'a pre-determined interpretive frame', but rather part of a project which is capable of creative development and change as it encounters different objects and ideas. Meskimmon argues for the mutually transformative possibilities of practice and theory at what she calls the 'in-between of female subjectivity' – beyond the bounds of a single discipline.[50]

Stallabrass has argued that a key characteristic of 'high art lite' is its dogged resistance to theoretical interpretation, identified as part of a 'deliberate' artistic strategy proclaimed or managed by the artist. This collection seeks to open up debate around these issues, suggesting possibilities for analytical and theoretical approaches which are concerned with themes of difference, identity and aesthetic mediation. While the author and her experiences (or 'confessions') are often visible in the 'texts' which are considered here, issues of artistic intention are rarely viewed unproblematically, as is evidenced in Lisa Tickner's interview with Cornelia Parker, which thoughtfully situates Parker's work in relation to

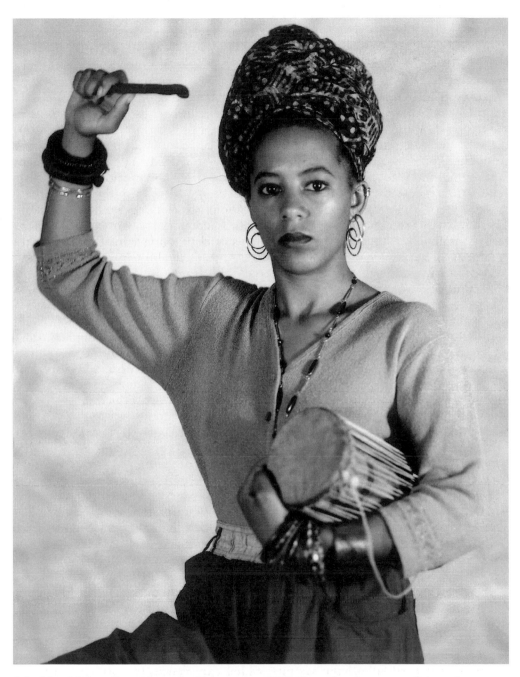

1.5 Maud Sulter, *Erato*, from the *Zabat* series, 1989. Reproduced courtesy of the artist.

her declared intentions. Similarly, Fionna Barber's interview with Alice Maher explores ideas of multiple female identities and Maher's ambivalence around readings of 'female Irishness'. As both interviews reveal, the artists' strategies of self-narration can suggest shifting identities (both aesthetic and cultural) and complex historical narratives.

The work of artists such as Emin or Lucas has been vulnerable to both art-historical philistinism and journalistic moralizing. The provocative deployment of domestic and sexual themes, and the promotion of a grungy, irreverent artist in the work of both artists has been seen by some as gesturing towards postmodern and feminist concerns, but ultimately saying nothing and resisting serious analytical exploration.[51] However, some recent writing on both Emin and Lucas has sought to shift the debate away from a now increasingly outmoded notion of shallow 'bad girl' art. Matthew Collings's book on Sarah Lucas reassesses his protagonist (perhaps controversially) within a formalist context.[52] The recent theoretical work on Emin emerging from feminist art history, by Rosemary Betterton, Deborah Cherry and Lorna Healy among others, also offers possible critical routes for rethinking earlier debates. For example, in her essay 'Why is my art not as good as me?' (2002), Betterton has considered Emin's engagement with popular culture and 'bad girl' behaviour in the context of recent feminist debates. She argues that Emin is 'consciously engaged in sexual politics', and that her use of themes and techniques (such as the confessional), which are traditionally gendered as feminine, 'would be impossible without the histories of feminist debate and practice that preceded it.'[53] Cherry's article 'On the move: *My Bed* 1998–1999' explores the potential for meanings in the different narratives (journalistic, confessional, historical) that have circulated around Emin's notorious installation, arguing that to view the work merely in terms of the dysfunctional femininity of a 'bad girl' is to miss the allusions to intermediality, diaspora (the artist's father is Turkish Cypriot) and troubling issues of sexual difference.[54] Hopkins's essay 'Drunkenness' in this collection raises the related problem of representations of feminine alcoholism as indicators of sexual difference, citing media coverage of both Emin and Lucas which emphasizes their shared love of alchohol and cigarettes. However, such representations can carry contradictory meanings. The idea that women rather than men are publicly embracing inebriated overindulgence breaks a traditional social stereotype, but, at the same time, signals that excessively 'bad' behaviour which is reserved for 'girls'.

Over recent years, much theoretical debate has flourished around the problematic notion of 'Britishness' as a label, which homogenizes both the artistic and ethnic diversity which it seeks to embrace.[55] It has also been identified as a label which has been hijacked by the mass media in the pursuit of a chauvinistic and self-conscious idea of 'Britishness' in the global marketplace. For the purposes of this introduction I have been using the term 'British' as a loose working category which largely references an educational, institutional and exhibiting culture which has nurtured the (visible) art of the 1980s to the present in Britain. Essays have been selected which both explore and problematize that category, framing those explorations around issues of gender and ethnicity. Several of the artists whose work is discussed here have worked

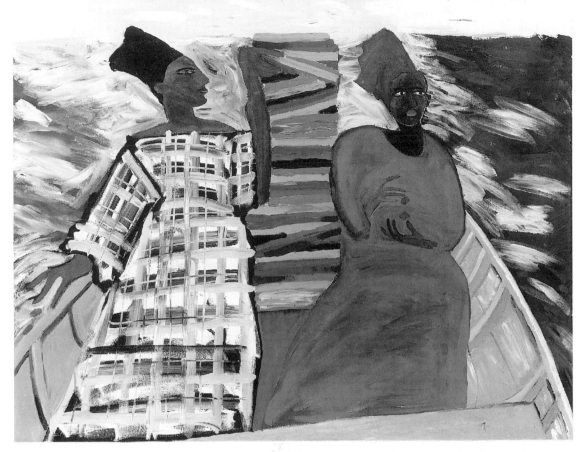

1.6 Lubaina Himid, *Between the Two my Heart is Balanced*, 1991. Acrylic on canvas, 152.4 × 121.9 cm. London: Tate Gallery.

and/or exhibited in Britain, although they were not born in Britain, and/or their work references colonial and diasporic identities which have been little acknowledged within the media-focused notions of 'Brit art'. Thus Jane Beckett's essay 'Lubaina Himid's *Plan B*: close-up magic and tricky allusions' examines the complex narrative and visual strategies deployed by the artist as she reflects on place, time, scale, geography and belonging, the slipperiness of borders, especially in a time of war. In her essay on moti roti's performance/ installation *Wigs of Wonderment* (1995), Dorothy Rowe explores an art practice which took place outside the institutionalized spaces of Brit art and which was informed by debates about 'Britishness', diasporic identities and hybridity. Barber's interview with Alice Maher explores some parallel – and 'uneasy' – issues of political, national and 'feminine' identity in the artist's engagement, in her choice of subject matter, with Irish, Celtic and 'Anglo-Norman' histories. Barber and Maher examine the potential dangers of being identified as an 'essentially' Irish artist, and the implications of this for perpetuating a British colonialist view of the 'primitive' Irish artist, outside the British mainstream.

17

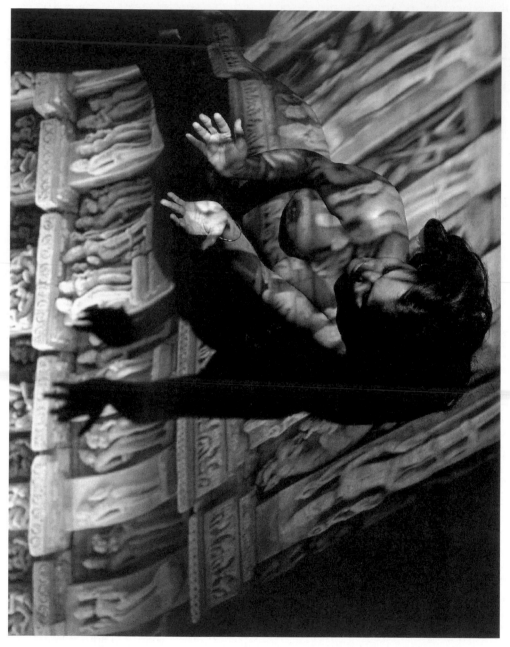

1.7 Sutapa Biswas, *Synapse IV*, 1992. Black-and-white photograph, 141 × 107 cm. Copyright © Sutapa Biswas.

In their discussion of the work of the American artist Kara Walker, Michael Corris and Robert Hobbs, address the representation of 'black' identity and the thorny problem of racial and gendered stereotyping. Walker's art has been exhibited widely in America and Britain, and the controversies it engenders carry resonances for some contemporary British artists of Asian or Afro-Caribbean descent who have engaged in diverse ways with the representation of race, ethnicity and femininity, including Sonia Boyce, Lubaina Himid (plate 1.6), and Sutapa Biswas (plate 1.7).[56] Corris and Hobbs explore issues around Walker's representation of racial stereotypes and the imagery of abjection as a means of rethinking notions of black identity. In their discussion they examine the possible ideological ramifications of her work in the 1990s, when 'a post-Civil Rights, African-American identity had become a full-blown identity.' Echoing the concerns of other essays in this book, the authors engage with the complex social, psychological, political, gendered and aesthetic concerns which help both to determine an artistic practice, and to inform and enrich our interpretation of that practice. While this collection does not offer the reader any one theoretical model or 'language' with which to conceptualize the diverse range of practices explored, it does seek to position an (albeit entangled and unstable) notion of 'difference' at the forefront of debates about contemporary art.

Gill Perry
The Open University

Notes

I would like to thank Lisa Tickner, Maureen Paley, Richard Salmon, Dave Mabb, Fionna Barber and Iwona Blazwick for their suggestions on the material gathered for this introduction. Special thanks must also go to Steve Edwards, Niru Ratnam and Deborah Cherry for their helpful comments and criticisms of an earlier draft.

1 M. Catherine de Zegher (ed.), *Inside the Visible: an elliptical traverse of 20th century art in, of, and from the feminine*, Cambridge, Mass. and London, p.20. The complexity and contingency which underpin any concept of 'difference', and the dangers of reductive formulations of 'women's art practice' are thoughtfully explored in Griselda Pollock's important text *Differencing the Canon: Feminist Desire and the Writing of Art's Histories*, London and New York, 1999.

2 For accounts of reactions in the local and national press, and of the controversy in general, see James Lingwood (ed.), *Rachel Whiteread: House*, Phaidon with Artangel, London, 1995.

3 In the same publication Whiteread's acknowledgement cites (apart from Artangel) the financial support of Becks and Tarmac. The support of the latter generated a good deal of political debate around the moral legitimacy of the work (see especially Iain Sinclair's essay 'The house in the park: a psychogeographical response', in Lingwood (ed.), *Rachel Whiteread: House*, pp. 12–33). She also includes 'A big thank you to 5,000 people, including many local school children, who petitioned Bow Council, as well as everyone who visited, debated, enthused and wrote about House; to Michael Jopling MP, Hugh Bayley MP and

Mildred Gordon MP for Tower Hamlets who tabled the early day motion in the House of Commons.' (back of title page)

4 Lingwood, *Rachel Whiteread: House*, p.8

5 See p. 327 and below note 25 for references to the British 'blue-chip' sculptors of the preceding generation.

6 Briony Fer (among others) has explored these and other aspects of Whiteread's work. See, for example, the final section (p.162ff) of her *On Abstract Art*, New Haven and London, 1997, and 'Treading Blindly, or the Excessive Presence of the Object', *Art History*, vol. 20, June 1997, pp. 268–88.

7 Owens's essay, 'The Discourse of Others: Feminists and Postmodernism', in Hal Foster (ed.), *Postmodern Culture*, London and Sydney, 1983, pp. 57–77, has been widely cited as one of the first texts which identified and explored the importance of feminism within postmodern practice and theory.

8 Foster, *Postmodern Culture*, p.71.

9 Foster, *Postmodern Culture*, p.61.

10 Owens was responding here to an article of 1982 in which Benjamin Buchloh discusses the manipulation of the languages of popular culture in the work of Dara Birnbaum, Jenny Holzer, Barbara Kruger, Louise Lawler, Sherrie Levine and Martha Rosler ('Allegorical Procedures: Appropriation and

Montage in Contemporary Art', *Artforum*, vol. 21, no. 1, September 1982, pp. 43–56). Owens argued that Buchloh does not grant adequate significance to the fact that each of these artists were women, emphasizing rather their 'male genealogy' in the conventions of Dada montage.

11 The list of important contributions to this discourse is endless, but any list of influential recent art-historical writing should include the names Linda Nochlin, Griselda Pollock, Amelia Jones, Carol Duncan, Whitney Chadwick, Abigail Solomon-Godeau, Anne Wagner, Lisa Tickner, Katy Deepwell, Tamar Garb and Briony Fer, among others.

12 de Zegher, *Inside the Visible*, p.37.

13 The term 'bad girls' originated in an American context when it was used as the title of an exhibition of feminist art at the New Museum of Contemporary Art in New York in 1994.

14 In the case of Sam Taylor-Wood, this grouping is more relevant to her work from the early 1990s, including her infamous photograph *Fuck, Suck, Spank, Wank* of 1993.

15 *High Art Lite: British Art in the 1990s*, London and New York, 1999.

16 Such forms of criticism have been deployed by many critics and writers apart from Stallabrass. See, for example, Eddie Chambers's review of Duncan McCorquodale *et al*, 'Occupational Hazard', in *AN Magazine*, June 1998, p.25. More dismissive – and infamous – journalistic encounters with the yBa phenomenon have emerged regularly from Brian Sewell, art critic of the *London Evening Standard*.

17 *High Art Lite*, p.2. Stallabrass describes 'yBa' as 'a media confection, a useful logo' and gives the examples of Jordan Baseman, Tomoko Takahashi and Rut Blees Luxemburg as examples who are not British by birth. There are many other names which could be added to that list, including Mona Hatoum, Luc Tuyman and Wolfgang Tillmans. Issues of ethnicity and ideas of 'Britishness' will be discussed later in this introduction.

18 *High Art Lite*, p.158.

19 *Early One Morning*, curated by Iwona Blazwick at the Whitechapel Gallery, London, 2002, exhibited works by Shahin Afrassiabi, Claire Barclay, Jim Lambie, Eva Rothschild and Gary Webb.

20 Stallabrass's analysis of contemporary British art has been challenged from some other positions, including an ongoing and intellectually energetic debate (on the philosophical Left in the English-speaking world) around the concept of the 'philistine'. Since John Roberts and Dave Beech published their article 'Spectres of the Aesthetic' on the new art in Britain in *New Left Review*, no. 218, July/August 1996, pp. 102–127, debate has raged around the characterization and role of the 'philistine' in the production and reception of contemporary British art. In response to this article see, for example, Julian Stallabrass, 'Phoney War', *Art Monthly*, no. 206, May 1997, pp. 15–16. For a fuller exposition of these debates, and a defence of the position taken by Roberts and Beech, see Dave

Beech and John Roberts, *The Philistine Controversy*, London and New York, 2002.

21 Susanna Beaumont, 'Crisis Britannia' in supplement to *The List*, April 2000, p. 4.

22 Some issues around gendered production and consumption of British art are discussed in Rosemary Betterton's article 'Undutiful Daughters: Avant-gardism and Gendered Consumption in Recent British Art', in *Journal of Visual Culture in Britain*, vol. 1, no. 1. 2000, pp. 13–29.

23 The women exhibitors reveal some interesting inclusions and 'omissions'. An older generation was represented by Paula Rego, Susan Hiller and Phyllida Barlow, but now-prominent figures such as Rachel Whiteread, Mona Hatoum and Gillian Wearing were absent.

24 Quoted by Beaumont, 'Crisis Britannia', p.4.

25 Most historical accounts and exhibition catalogue essays map out the conditions of private collecting and the art schools, especially Goldsmiths, as key factors in the emergence of the yBa phenomenon. See, for example, essays by Norman Rosenthal, Richard Shone, Martin Maloney and Lisa Jardine in *Sensation: Young British Artists from the Saatchi Collection*, London: The Royal Academy, 1997. For a critical account of the political and collecting interests of Charles Saatchi, see Rita Hatton and John A. Walker, *Supercollector: A Critique of Charles Saatchi*, London, 2000.

26 The Lisson Gallery, one of the most prominent galleries of the 1980s, counted Tony Cragg, Art and Language, Anish Kapoor and Richard Deacon on its books.

27 Schubert had already taken on two women in the 1980s: Alison Wilding in 1987 and Bridget Riley in 1987/8.

28 More recently, Jane Hamlyn and Sadie Coles HQ (whose gallery opened in 1995) have also been active in the promotion and exhibition of work by women artists. For example, Hamlyn took on Tacita Dean in 1997, Fiona Banner in 1997 and Cornelia Parker in 1995, and Sadie Coles signed up Sarah Lucas in 1995.

29 For example, Catherine Lampert was director of the Whitechapel Gallery, London between 1988 and 2001, when she was succeeded by Iwona Blazwick, who had previously been head of exhibitions at Tate Modern. Julia Peyton Jones has been director of the Serpentine Gallery since 1991 appointing Lisa Corinne as exhibitions officer in 1996 (a post Corinne held until 2001). Francis Morris has been senoir curator at Tate Modern since 2000.

30 Maureen Paley, interviews with Gill Perry, 28 November 2002 and 14 January 2003. Before establishing her current gallery Interim Art, Paley worked from 1984 as a consultant promoting certain artists. In the 1980s these included, significantly, Hannah Collins, Susan Hiller and Helen Chadwick.

31 Richard Salmon, interview with Gill Perry, 4 December 2002.

32 Apart from winning the Turner Prize at the age of twenty-nine, she became the first woman to represent Britain at the Venice Biennale in 1997.

33 'The Mother–Daughter Plot', in *Art History*, vol. 25, no.1, February 2002, pp. 23–46.

34 In 1988 Wilding was the only woman nominated in a lengthy short list comprising: Richard Hamilton, Richard Long, Lucian Freud, Boyd Webb, David Mach, Richard Wilson and Tony Cragg, who won the award. In 1992 she was shortlisted alongside David Tremlett, Damien Hirst and that year's winner: Grenville Davey.

35 Tickner, 'The Mother–Daughter Plot', p.28.

36 Tickner, 'The Mother–Daughter Plot', p.28.

37 The recommendations of the government study, the Coldstream Report, of the 1960s were seen by some to have helped to secure an art school education as a viable alternative to a university degree, and to have encouraged artists rather than art teachers to become responsible for teaching. Art school education policy and the effects of the Coldstream Report are discussed and critiqued in a student-led publication of 1978: Dave Rushton and Paul Wood (eds), *Politics of Art Education*, Edinburgh.

38 Richard Shone, 'From "Freeze" to House', in *Sensation*, p.19.

39 Michael Craig-Martin, 'The Role of Art Education in Britain since the Sixties', in *Vision: 50 Years of British Creativity*, London, 1999, p. 154. Craig-Martin was a tutor at Goldsmiths 1974–1988, and Millard Professor 1994–2000.

40 For British art world institutions and key figures, see Louisa Buck, *Moving Targets 2: A User's Guide to British Art Now*, Tate Publishing, 2000.

41 Such arguments have been put forward by the artist and lecturer David Mabb in an interview with Gill Perry, 10 December 2002.

42 This age limit was instituted in 1991 in a bid to place the emphasis on youth. Stallabrass charted the average age of the nominees since the establishment of the prize in 1984, showing that while in 1989 the average age was fifty, in 1991 it was thirty. *High Art Lite*, p.177. See also Virginia Button, *The Turner Prize*, Tate Publishing, 1997.

43 Stallabrass has made similar points, *High Art Lite*, pp.177 and 172. We should note, however, that the opening of Tate Modern in May 2000 was also a significant force in increasing attendance figures, which peaked during 2000–2001.

44 Many critics have commented on the competitive prize culture which these awards have spawned. Some of these criticisms are cited in Tom Morton, 'Everyone's a Winner', in *Tate: International Arts and Culture*, 2002, no. 2, Nov/Dec, pp. 70–5.

45 See note 42 above.

46 Nicholas Serota, 'The Turner Prize', in *Vision*, p. 193.

47 Some interesting statistics on jurors, exhibition venues and dealers implicated by the awards are provided in Tom Morton, 'Everyone's a Winner', pp. 75.

48 Janet Wolff, 'The artist, the critic and the academic: feminism's problematic relationship with "Theory", in Katy Deepwell (ed.), *New Feminist Art Criticism: Critical Strategies*, Manchester and New York, 1995, pp. 14–19. I must also acknowledge the important work published on and around these issues over the past twenty years by Griselda Pollock, among others. Many of her recent publications have addressed the relationship of feminist theory to problems of canonicity and the idea of the modernist canon, including *Differencing the Canon: Feminist Desire and the Writing of Art's Histories*, London, 1999.

49 Wolff in Deepwell (ed.), *New Feminist Art Criticism*, p.16. Griselda Pollock has explored the problematic practice of modernist 'painting', its appropriation by women artists and its relationship with feminist aesthetics in her essay 'Painting, Feminism, History', in *Looking Back to the Future: Essays on Art, Life and Death*, G+B Arts International, 2001, pp. 73–111.

50 In her recent book *Women Making Art: History, Subjectivity, Aesthetics*, London and New York, 2003, Meskimmon explores further this notion of theory as an active process which 'emerges from the positioning activities of knowledge projects', and which 'locates [the theorist] as a partner in dialogue with woman making art rather than in the position of a privileged interpreter' (p. 4).

51 *High Art Lite*, pp. 91–6.

52 *Sarah Lucas*, London, 2002.

53 Rosemary Betterton, '"Why is my art not as good as me?": Femininity, Feminism and "Life-Drawing," in Tracey Emin's Art', in Mandy Merck and Chris Townsend (eds), *The Art of Tracey Emin*, London, 2002, pp. 23–9. See also Lorna Healey's essay 'We Love You, Tracey' on Emin's use of popular culture, *The Art of Tracey Emin*, pp. 155–72.

54 Deborah Cherry, 'On the Move: *My Bed*, 1998–1999', *The Art of Tracey Emin*, pp. 134–54.

55 Stallabrass has explored this problem in *High Art Lite*, chap. 8, pp. 225ff. Debates around ethnicity and the problem of 'Britishness' have also featured prominently in the British journal *Third Text*, especially in articles by Kobena Mercer, Rasheed Araeen among others.

56 It has been argued that important developments in the conceptualizations of ethnicity that took place within the art practices of British artists such as Himid, Boyce, or Biswas in the 1980s paved the way for more diverse notions of black experience which underpin recent works by artists such as McQueen or Ofili. I am indebted to Niru Ratnam for sharing these arguments with me from his forthcoming thesis, 'Contesting Art History: Black British and Asian Artists in late Twentieth-Century Britain', Courtauld Institute, London.

2

'Out Of It': Drunkenness and Ethics in Martha Rosler and Gillian Wearing

David Hopkins

Towards the end of Malcolm Lowry's *Under the Volcano*, widely regarded as the pre-eminent account of alcoholism in modern fiction, the book's anti-hero Geoffrey Firmin muses in the midst of a Mexican Fiesta on his past indulgences:

> …and now he saw them, smelt them, all, from the very beginning – bottles, bottles, bottles, and glasses, glasses, glasses, of bitter, of Dubonnet, of Falstaff, Rye, Johnny Walker, Vieux Whisky, blanc 'Canadien', the aperitifs, the digestifs, the demis, the doubles. … the bottles, the bottles, the beautiful bottles of tequila, and the gourds, gourds, gourds, the millions of gourds of beautiful mescal. … How indeed could he hope to find himself to begin again when, somewhere, perhaps, in one of those lost or broken bottles, in one of those glasses, lay, for ever, the solitary clue to his identity.[1]

To drink obsessively, to be an alcoholic, is to lose self-possession, to become deliriously enslaved. In the West people from all social classes drink to the point of illness but it is the poor who are seen to drink with a particular vengeance. Morality has traditionally set up its stall next to the spectre of lower-class drunkenness. The Temperance movements of the nineteenth century, for example, were set up to improve their drunken fellow mortals. Pathological drunkenness, ultimately, is a negation of the social sphere. Unless you are in the same state, the ready response is to laugh at, ignore, or pity, the stumbling drunk. There is a sense in which those who are permanently in drink's grip appear to lack willpower. They remind us of what it would be like to let go; we too could be like that. If, in the past drunks were at least treated with tolerance, recently state attitudes have hardened. From time to time drunks are cleaned out of the cities, swept off the streets. For instance, in the early 1990s there was a campaign to purge London's Strand of its down-and-outs. They got too close for comfort.

In terms of art, particularly recent art practice, alcoholism presents a subject which can appear, like a drinker's glass, to be challengingly loaded or disappointingly empty. There is an entire history of art dedicated to drink and drinkers – the absinthe drinkers of Degas and Manet, the dandyish indulgences of Gilbert and George. In the case of Manet's *Absinthe Drinker* (1858–9,

rejected by the Paris Salon of 1859), the image of the marginalized alcoholic offered a means of oblique social critique and to some degree underlined the artist's social apartness. It was, in that sense, a signifier. It had status. But it is difficult in contemporary culture to make the alcoholic signify. The alcoholic's contemporary social role, as I have already suggested, amounts to a blank. Synonymous in Britain with the underclass – and therefore unable to appeal to the virtues that the tolerant middle class might have found in working-class virtues such as unaffectedness or honesty – the alcoholic bum is virtually a non-being. Inarticulate. Nothing.

The dialectic of fullness and emptiness with which I have been toying – which itself describes the alcoholic state – lies at the heart of one important milestone in the art of the recent past employing alcoholism as its theme: Martha Rosler's *The Bowery in Two Inadequate Descriptive Systems* of 1974. This work is full to the gills with wit and allusion and yet completely renounces its own resources of representation. By contrast, Gillian Wearing's recent video work *Drunk* of 1997–9, my other point of reference in this essay, may be said to teeter on the edge of articulacy, to be almost as incoherent as its subjects. Yet it may also offer new resources of representation.

Blotto, sloshed, canned, stewed, out of the picture, plastered. … In 1974 such words and expressions, denoting the state of drunkenness in terms of American slang usage, cut a colourful swathe through the more sober pronouncements of the second-generation Anglo-American conceptualism of the period. The words were piled up on top of each other, forming wobbly poetic edifices, as panels accompanying prosaic photographs in Martha Rosler's 24-panel photo-installation dedicated to representing, or failing to represent, the Bowery, home to New York's skid-row alcoholic community (plates 2.1, 2.2 and 2.3). According to Rosler, the piece was first shown in 1975 in San Francisco, and both participates in and critiques the American conceptualism of the period.[2] Bearing witness to the fact that Rosler was at that time as interested in performance poetry as she was in the more rarefied protocols of an often renunciative, iconophobic conceptualism (later described by her as 'self-referential or nihilistic, constrained and stingy or just plain irrelevant'),[3] the words operated as analogues for the mobility of discourses surrounding the bums who populated the Bowery. They loitered next to the poignantly empty spaces, in the accompanying photographs, which the bums themselves should have occupied. As Rosler has written: 'There is a poetics of drunkenness here, a poetry-out-of-prison. Adjectives and nouns built into metaphoric systems – food imagery, nautical imagery, the imagery of industrial processes, derisive comparisons with animal life, foreignisms, archaisms, and references to still other universes of discourse – applied to a particular set of beings, a subculture of sorts, and to the people in it.'[4] Whilst language thus summons up idiom, context, power relations and so on, the images function dialectically in terms, as she puts it, of 'radical metonymy'. All we get are deserted doorways, shop fronts, façades – the places in which down-and-outs normally sleep – with the occasional beer or whisky bottle left as a reminder. Such images, she asserts, 'are not reports from a frontier, messages from a voyage of discovery or self-discovery.'[5] Like the words placed across from them, they are rather

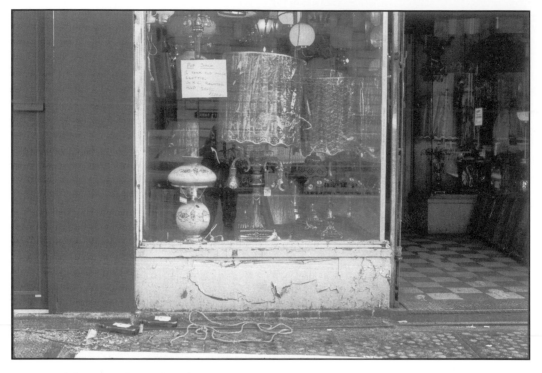

2.1 Detail from Martha Rosler, *The Bowery in Two Inadequate Descriptive Systems*, 1974. Black-and-white photographs mounted on black panels, print 20.3 × 25.4 cm. Reproduced courtesy of the artist.

extrapolations from a pre-existing discourse. This time, however, the discourse is primarily an aesthetic one, that of photography.

It is here that Rosler starts to close down on her project from within. Photographically, the project represents a kind of terminus. There are several key points of reference, all of which she has acknowledged, if not expanded on at length. The most obvious perhaps is Walter Benjamin talking about Eugène Atget's Paris:

> He looked for what was unremarked, forgotten, cast adrift, and thus such pictures ... work against the exotic, sonorous names of the cities; they pump the aura out of reality like water from a sinking ship ... Atget almost always passed by the 'great sights and the so-called landmarks'; what he did not pass by was a long row of boot lasts ... or the tables after people have finished eating and left, the dishes not yet cleared away... all these pictures are empty ... empty the triumphal steps, empty the courtyards ... They are not lonely, merely without mood: the city in these pictures looks cleared out, like a lodging that has not yet found a tenant.[6]

If the tramp or bum was in danger of becoming a little too auratic Rosler got rid of him or her, leaving only the context, the detail. In a sense, *we* must inhabit the pictorial space. Walker Evans also seems to have been firmly in her mind.[7]

```
squiffy  snozzled    screwed

bleary-eyed

glassy-eyed

cross-eyed

cock-eyed
```

2.2 Detail from Martha Rosler, *The Bowery in Two Inadequate Descriptive Systems*, 1974. Black-and-white photographs mounted on black panels, each print 20.3 × 25.6 cm. Reproduced courtesy of the artist.

The deliberately artless frontality of his images, which partly came courtesy of Atget, informs all her images, but it is more Evans's links with documentary aesthetics that are at issue. Part of Evans's project had been to dignify the image of the Southern American sharecropper of the Depression era. However, in her writings, Rosler constantly berates the liberal ideology underlying images of social victims. She writes: 'The liberal documentary assuages any stirrings of conscience in its viewers the way scratching relieves an itch and simultaneously reassures them about their relative wealth and social position.'[8]

In the final analysis, images of victims are seen as instantiating the status of their subjects *as* victims, a conviction which led Abigail Solomon-Godeau, in a later essay on documentary ethics, to pose the key question:

> We must ask whether the place of the documentary subject as it is constructed for the more powerful spectators is not always, in some sense, given in advance. We must ask, in other words, whether the documentary act does not involve a double act of subjugation: first, in the social world that has produced the victims: and second, in the regime of the image produced within and for the same system that engenders the conditions it then re-presents.[9]

25

Rosler herself expresses the point about subjugation more bluntly. The bums she invokes may be 'a surreptitious metaphor for the "working class" but they are not to be confused with a social understanding of the "working class".'[10] Bums, she ironically asserts, are 'perhaps, finally to be judged as *vile*, people who deserve a kick for their miserable choice'.[11]

Here then are the reasons for the refusal that is embedded in Rosler's project, its acknowledgement of a double inadequacy. To quote her again:

> *The Bowery in Two Inadequate Descriptive Systems* is a work of refusal. It is not defiant antihumanism. There are no stolen images … what could you learn that you didn't already know? If impoverishment is an issue here it is more the impoverishment of representational strategies tottering about alone than that of a mode of surviving. The photographs are powerless to deal with the reality that is yet totally comprehended-in-advance by ideology, and they are as diversionary as the word formations – which at least are closer to being located within the culture of drunkenness rather than being framed on it from without.[12]

This could also be read as an oblique response not just to documentary traditions but to the recent imaging of the alcoholic tramp's condition in the works of the then emergent British artists Gilbert and George. Three years prior to the production of *The Bowery* Gilbert and George had performed their *Living Sculpture, Underneath the Arches* at the Sonnabend Gallery, New York. It transposed the sunny alcoholic haze of two tramps living underneath the railway arches, as immortalized in Flanaghan and Allen's music-hall song, onto an image of robotic civic conformity and outdated gentility. Gilbert and George had subsequently been producing photo-installations documenting their own sacrificial immersion in alcohol, a world of unsteady bodies and blurred perceptions, of picturesque East End pubs, seen through a glass darkly. Not for Rosler their vicarious low-life tourism, their dandyish sampling of social hybridity, their terrible ironic indifference, their art suits.

We now associate that period of the mid-1970s in Britain and America with the dying embers of an old-style Leftism. In *The Bowery* Rosler posed a question that was paradigmatic for a subsequent generation of artists. But she also closed down on representation in a way that equated with the social nullity of her alcoholic subjects. The gauntlet was thrown down. How could new representational strategies be developed which did not merely exoticize capitalisms' victims, consigning them to what Rosler called a 'safari of images'?[13]

Simplifying enormously, it could be argued that these moral or ethical dilemmas merely festered during the 1980s, or rather congealed into a forbidding 'political correctness'. Images of low life, of alcoholism, became problematic. Hence they tended to disappear, or to be dealt with textually, informationally. In so far as issues of class marginalization were confronted head-on – by, for example, Jeff Wall – 'actors' rather than real persons tended to appear in manifestly 'constructed' tableaux, which acknowledged the heavily coded nature of pictorial representation.[14] In a tale that is now overly familiar, and which I will not deal with here in any detail, the 1990s, in London in

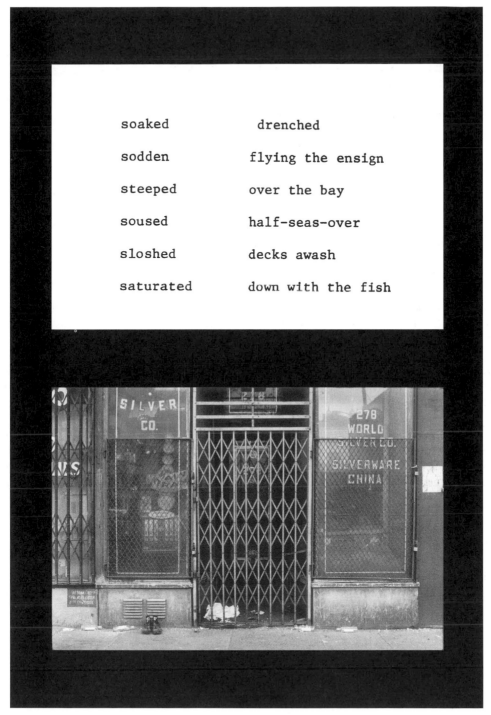

2.3 Details from Martha Rosler, *The Bowery in Two Inadequate Descriptive Systems*, 1974.
Black-and-white photographs mounted on black panels, each print 20.3 × 25.4 cm.
Reproduced courtesy of the artist.

2.4 Gillian Wearing, *Drunk*, 1997–99. Video still from DVD 3-screen video projection, 20 mins. Reproduced courtesy of the artist and Maureen Paley Interim Art, London.

particular, saw a return to images of working-class culture, of addiction to cigarettes or other drugs, of laddish rudery and so on, as part of the endlessly raked-over yBa phenomenon. Whether understood in Hal Foster's psychoanalytically inflected terms as part of a 'return of the real' which, after the late 1980s plunge into abjection, broadly partakes of a bringing to the surface of repressed, simulacral materials, or in John Roberts's terms as a re-experiencing of the pleasures of the demotic (even in full awareness of capitalism's alienating trajectory), as a reaction to the academicization of a theory-strangled postmodernism, much 1990s art appears blithely impervious to the strictures of a figure such as Martha Rosler.[15] Between 1997 and 1999 Gillian Wearing, an artist who should not simply be assimilated into the yBa phenomenon but who has nevertheless been identified with it, produced a three-screen video work, entitled *Drunk*. All Rosler's demons were suddenly released. A gaggle of sloshed, sozzled, pissed, wrecked, steaming, rat-arsed – but this time London-based – alcoholics stumbled and swayed through a work of 20 minutes duration (plates 2.4–2.7).[16] The drunks in the piece – who were actual drunks, not actors as in certain other Wearing videos – could hardly be more insistently visible, however much they were 'out of it'. The work therefore begs to be seen as an historical pendant to Rosler's. At the same time it re-opens the questions about representation that she shut down. How effectively it does this provides the theme for the latter half of this essay.

Shown for the first time in New York in 1999, and subsequently at the Serpentine Gallery, London, and Musée d'art moderne de la ville de Paris early in 2001, *Drunk* has already received some art world exposure.[17] For those who have not viewed it, however, its clear-cut structure lends itself to the following textual break-down:

1. Three screens. George (as I have discovered), longish hair, early to mid-thirties, alone on right-hand screen, deeply drunk. Larger than life size. In black and white, silhouetted against a neutral surround; white paper backcloth, white floor. Obviously a studio set-up. He puts on his shirt, slowly, meditatively, as though for the first time. Image fades.
2. Three drunks busily drinking, guzzling, on all three screens. Symmetrical. George at the centre. His legs give way. He sinks to the floor, far gone. Screens go blank.

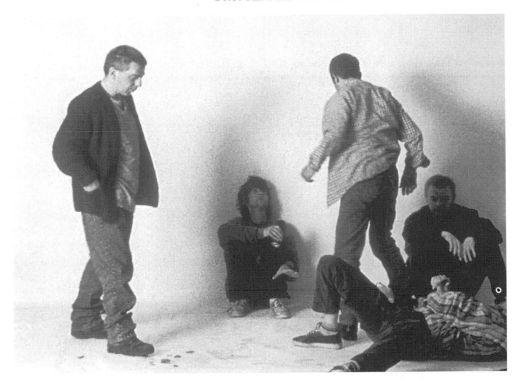

2.5 Gillian Wearing, *Drunk*, 1997–99. Video still from DVD 3-screen video projection, 20 mins. Reproduced courtesy of the artist and Maureen Paley Interim Art, London.

3. In centre screen, drunken guy in baseball cap taunts petulant woman who sits, legs stretched out, on the floor. She kicks out at him ineffectually. He pokes her head, continues to taunt. There is some muffled dialogue: 'You wind me up' etc. They suddenly disappear.

4. A tall, gangly male appears on the right-hand screen. As though in a trance, he totters unsteadily from side to side. Momentarily he looks like a silent movie comedian. Losing his balance, he falls out of frame.

5. Another drunk wanders across all three screens, out of one and into the next, and exits at the far right edge.

6. Dramatic image of George, lying across the floor in the centre screen, evidently unconscious, out of it. Suddenly the prostrate figure appears across all three screens, panoramic, close-up (plate 2.4). Vaguely religious. (More of this later.) The image disappears.

7. A group of drunks, arm in arm, carouse across all three screens, from left to right.

8. Cut to the same group, contained in the centre screen (plates 2.5 and 2.6). Long take, in which a drunken brawl breaks out. Aggressive character in checked shirt (possibly ex-army) picks fight with taller guy. They maul each other in slow motion. Another guy mediates. Screen blanks out.

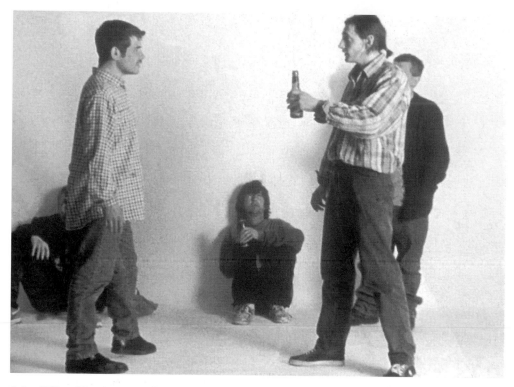

2.6 Gillian Wearing, *Drunk*, 1997–99. Video still from DVD 3-screen video projection, 20 mins. Reproduced courtesy of the artist and Maureen Paley Interim Art, London.

9. Silent comedian figure blunders in from right. Wanders across all three screens.

10. Cut to centre screen. Aggressive character in checked shirt embraces a standing George. They prop each other up, mumble, the aggressive guy, suddenly affectionate, strokes George's hair. Male intimacy. Dissolve.

11. Two figures enter from left. One, who appears less drunk, accompanies the other into the centre screen, and then appears to goad on his companion, who staggers into the right screen and disappears out of frame.

12. George and another companion stagger from left and collapse into the right-hand screen. They fall out of frame, almost like stage drunks. Screen goes blank.

13. Centre screen blank with heads and shoulders of two figures on flanking screens. On the left, a woman. Quite wealthy-looking, but far gone. She keels over completely out of frame. On the right, George again. He yawns, falls asleep, dribbles. Head slumps forward. The camera remains trained on him. Almost forensic. He yawns again. Time passes. We hear an ambulance siren in the distance. Sudden intrusion of the outside world.

14. Cut to right-hand screen. George, upright again, pisses abjectly against the white backdrop. Like a small boy. Slowly does himself up. Steadies himself against the backdrop. Screen suddenly blanks out. The end.

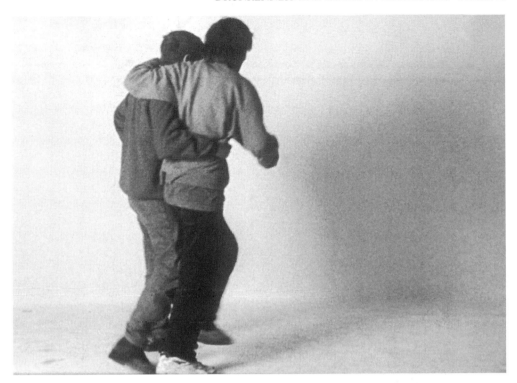

2.7 Gillian Wearing, *Drunk*, 1997-99. Video still from DVD 3-screen video projection, 20 mins. Reproduced courtesy of the artist and Maureen Paley Interim Art, London.

Even from this short, note-form description it should be possible to gain a sense of the piece. In complete contrast to Rosler's *The Bowery*, it homes in on, and aestheticizes, its subjects. With regard to the representation of the drunks, whom Wearing got to know gradually over the two-year period spent assembling the video, the artist herself has made analogies with the works of Brueghel, specifically his drawings.[18] A comment Wearing has made about the genesis of *Drunk* is particularly interesting in this respect. Noting that at a certain point in the filming for the piece, one of the alcoholics, Lindsey, had died, stimulating her to produce a short video dedicated to the dead woman as an offshoot project, Wearing recalled, 'Originally I'd thought the film would show something more raucous and carnivalesque, but it became much more melancholic.'[19] The melancholic aspect will assume significance later in this essay, but for the moment it is Wearing's invocation of the 'carnivalesque' which seems not only to reinforce the Brueghel-like ambience of certain sections of the video (for instance, the brawling scene) but to summon up a literary allusion that she might at the very least have had a passing awareness of. This is *Rabelais and his World*, Mikhail Bakhtin's monumental study of carnival's historical role in northern Europe as a boisterous reversal of official forms, the translation of which was very much 'rediscovered', by academics and artists alike, in the broader context of the fascination with Bataillean 'transgression' in the late 1980s and early 1990s.[20]

31

Continuing the logic of the debt to Brueghel, painterly or graphic allusions have also been rife in comments Wearing has made about the overall construction of the piece. Unlike earlier videos such as *10-16* of 1997, where painstaking devices such as lip-synching were employed, the artist was freer here to reflect on aesthetic decisions. She has talked of editing as 'choosing the right brushstroke to make a form'[21] and stated more explicitly, 'The takes I filmed made me think of sketches, of drawing, which led me to choose black-and-white.'[22] If such comments summon up nostalgia for the 'auratic' pre-photographic comforts of painting, whilst Wearing retains a nostalgic photographic 'look' by using black and white, she compounds the sense of traditionalism by asserting that the decision to place the drunks in a neutral setting had the effect of turning them into archetypes: 'I didn't want to show them in their flats or their normal haunts … I wanted to show something more timeless and universal.'[23] The figures in Brueghel's paintings again spring to mind, although one senses that the artist sees them ahistorically as mere aesthetic templates.

Universality … timelessness … the language is almost naive to ears attuned to post-1970s art discourse, and, like Rosler, we would have to ask how such universalizing intentions bear down on Wearing's subject matter. The drunks after all were not actors, but were compelled, by virtue of *being* drunk, to act out a form of pantomime. As the French critic Jean-Charles Masséra notes, 'Are we in the presence of a choreography of alcoholism? An experience of the pure appearance of bodies under the effects of alcohol? People no longer under the effects of history? People too drunk to be conscious of the effects of history, or even of their own story.… oblivion of historical conditions.'[24] And he caps this with the question: 'Can the exhibition of poverty or the drunken state (great classics of European painting) really return to the museum in any other mode than that of reification or spectacularisation?'[25]

After this the ethical objections come thick and fast. Does Wearing's work not re-confirm the powerlessness of her subjects? Is it not objectifying or forensic – a word I used in my description of the piece – in its fixation on the slowed-down and skewed locomotion of the drink-sodden, so that, at times, the drunks look like spiders struggling to extricate themselves from a blob of spittle or to dry out their limbs after being sluiced with bath water. It is tempting here to contrast Wearing's work with that of the 1990s English photographer Richard Billingham. Lower-class alcoholism is again at issue in Billingham's photo-essay of 1996 *Ray's a laugh* but the alcoholism is that of Billingham's father Ray, so that, while the aestheticizing tendencies at work in these colour photographs might still be deemed problematic, the author at least has some experiential (or rather familial) affinity with his subject.[26] And yet Wearing is disarmingly direct about what she is doing. She openly admits to the unequal starting position from which she pursued her drunken quarry. She talks candidly of being attracted to people who have 'very low defences'.[27] Yet presumably the low defences of her drunks were lowered further by the alcohol with which she rewarded them.

Wearing's frank admission of a kind of amoral curiosity is striking, and distinctive to her. It is interesting that, in terms of photographic conventions, she

has seemed to welcome comparisons with Diane Arbus, the figure who constitutes the most obvious bête noire of Rosler's project.[28] But Wearing's unapologetic voyeurism opens onto an issue which further extends this discussion: her vicarious identification with the drunks. In several interviews Wearing has talked about her personal shyness, her realization that 'because I'm very reserved I'm attracted to people who show a lack of restraint.'[29] The drunks may be unrestrained, but their inarticulacy clearly parallels that of Wearing. Frequently, in the video, the drunks appear reduced to an absolute helplessness – brought back, as it were, to some irreducible human condition – as for instance, when George urinates at the end of the piece. But is Wearing not in danger here of the most spurious species of projection, which ultimately relies on an extremely hackneyed expressivist aesthetics? Utilizing a theoretical amalgam of Thomas Crow, William Empson and Clement Greenberg, Julian Stallabrass has argued that much recent British art can be seen as dubiously implicated in an expression of the 'urban pastoral'. He defines this as a transposition into contemporary metropolitan idioms of the traditional category of the 'pastoral' whereby the 'folk wisdom of simple people is adorned with the refined expression of the gentleman', adding that 'Pastoral is plainly an art that is about common people but not for or by them.'[30] On this reading, therefore, the subjects of many of Wearing's videos are demonstrably allowed to have their own voice – to speak in the voice of 'common humanity' – whilst this very strategy of empowerment is undercut by her acute awareness of the elite discourse in documentary aesthetics set in motion by Rosler.[31]

It might be asserted in Wearing's defence that, understood properly, her work actually reflects the socially engineered vicariousness that has characterized recent 'reality TV' docu-soaps in Britain ranging from *Castaway* to *Big Brother*. Certainly she has pointed to forerunners in the genre – such as Michael Apted's *Seven Up* of 1964 or Rita Watson and John Roddam's *The Family* of 1974 – as her privileged aesthetic reference points.[32] In other words, she has keyed her work to precisely those modalities of social identification, projection and confession that the mass media, however problematically, has turned to, partly on the back of the assumed failure of the reformist documentary ethos.

The fact that Wearing's subjects – in pieces such as the *Signs* photographs of 1992–3 or *Confess all on Video* (1994) – enunciate their own discourse signals a kinship with populist television. This suggests that Wearing's work is capable of having a currency outside specialist art circles. But the irony of *Drunk*, of course, is that the drunks cannot articulate themselves, or at least not in the terms of normative social exchange. Perhaps the heightened theatricality of *Drunk* is understandable in terms of this paradox. The piece is stuffed with the signifiers of communication – exaggerated gestures and so on – without anything being said. This theatrical dimension of *Drunk* is one of its most obvious features. The three screens virtually function as centre stage and wings with the performers frequently entering and exiting from the sides (Wearing has expressed admiration for the pared-down quality of Samuel Beckett's stage-craft).[33] More broadly, the editing and sequencing seems keyed to the mood swings of the characters, and to the rhythms of alcoholic behaviour, as Wearing herself has indicated in acknowledging that 'I was drawn to the idea of

emotional swings with a cyclical pattern to them.'[34] Hence *Drunk* seems to acknowledge the obsessively confessional media culture we are in, but paradoxically, turns the confessors into overly demonstrative babblers. In the sense that it confounds any expectations on our part of communication, let alone self-revelation, from its participants, it is a self-reflexive move for Wearing, a move which implicitly counters critical claims that her practice has too easily lent itself to being hijacked by the 'culture industry' (a possibility that has indeed been borne out in the co-option of her strategies in television advertisements). The piece's excessive performativity is interesting, incidentally, in relation to a series of paintings, collectively entitled *Capital*, produced by Mark Wallinger, Wearing's one-time partner, in 1990. Possibly alluding to Rosler, Wallinger presented a series of down-and-outs posed in front of the imposing entrances to city banks. Each of the models was, in fact, a friend of the artist, a fact which underscored their performative roles as 'social actors' and helped exonerate Wallinger from Rosler's charge of voyeurism.[35]

A clear line of demarcation is emerging between Wearing and Rosler. Accepting that photographic conventions, or at least those associated with modernism, are unworkable, Wearing returns, anachronistically, to a language of theatricality (though not, of course, in Michael Fried's sense) and of the painterly. This is not simply a rejection of 'political correctness', although works such as Rosler's clearly bred a kind of anxiety of representation which Wearing almost symptomatically shakes off by allowing her drunks to be excessive or slapstick. The allusions to the antics of silent screen comics, which I mentioned in my earlier synopsis, do not seem accidental in this context. Frequently one gets a sense during *Drunk* that its protagonists are, effectively, acting out their drunkenness, and this allows them a flicker of social agency in terms especially of the complex modes of class mimicry – and of self-mimicry – that are integral to British humour. In this respect parallels are thrown up with other contemporary British artists who look towards silent or music hall-trained comics, ranging from Steve McQueen's reliance on Buster Keaton in his video-loop *Deadpan* (1997) to Mark Wallinger's homage to Tommy Cooper in *Regard a Mere Mad Rager* of 1993. In its cultural context Wearing's work has to be seen as an attempt to break through an impasse. Technical anachronisms, or the desire not to be pinned down to medium are part and parcel of this. Wearing herself objects to being thought of as a video artist and certain commentators on *Drunk* have noted an urge to negate the medium, to achieve an unmediated intensity. If Rosler foregrounded her means of representation with all the stringency of a Bertholt Brecht, Wearing appears blithely to assume that her medium can function transparently. But there is a knowing disingenuousness on Wearing's part with regard to the rigours of post-conceptualist critical discourse, as though only the brittlest of means could force through some other order of identification with the disempowered.

In a sense this is desperate. And Wearing runs the risk of simply re-capitulating things that have already been done by other artists. In certain works she has virtually over-identified with social outsiders, as in the video work *Homage to the woman with the bandaged face who I saw yesterday down Walworth Road* of 1995 (plate 2.8) which involved her walking the streets with

2.8 Gillian Wearing, *Homage to the woman with the bandaged face who I saw yesterday down Walworth Road*, 1995. Video still from video projection, 7 mins. Reproduced courtesy of the artist and Maureen Paley Interim Art, London.

her face almost completely covered by bandages in order to emulate the experience of a similarly shrouded woman whom she had glimpsed fleetingly. In other works she borders on the postmodern thematics of the denial of authorial 'presence', enacting a form of socially inflected self-abnegation. In *Dancing in Peckham* of 1994 (plate 2.9) she denies us access to any 'core' self, submitting her intense interiority – as she dances to the music in her head – to almost forensic external judgements made on the basis purely of appearances. This seems strikingly close to what is happening in *Drunk*.

Perhaps what emerges most strongly from what I am reading as a symptomatic attempt to surmount Rosler's effort at closure is a certain quality of pathos. It is interesting here to return to the dramatic sixth section of *Drunk* (as outlined in the earlier synopsis), the point at which George's prostrate body is first pictured in the centre screen and then brought up close across all three (plate 2.4). This device seems almost deliberately heavy-handed. There is almost certainly an echo of Hans Holbein's *The Body of the Dead Christ in the Tomb* (1522), a work which was the subject of an important essay by Julia Kristeva, much reprinted in recent years, dealing with melancholia.[36] As mentioned earlier, Wearing's own understanding of *Drunk*, in the course of its making, seems to have been bound up with a shift from the 'carnivalesque' to the 'melancholic' and it is hard to resist the idea that she ran the intellectual gamut

2.9 Gillian Wearing, *Dancing in Peckham*, 1994. Video still from video tape, 25 mins. Reproduced courtesy of the artist and Maureen Paley Interim Art, London.

2.10 Minerva Cuevas, *Drunker*, 1995. Single-screen video with written texts inside framed aluminium light boxes, 70 mins, dimensions variable. Reproduced courtesy of Galeria Kurimanzutto, Mexico City. Copyright © 1999 Minerva Cuevas.

2.11 Minerva Cuevas, *Drunker*, 1995. Single-screen video with written texts inside framed aluminium light boxes, 70 mins, dimensions variable. Reproduced courtesy of Galeria Kurimanzutto, Mexico City. Copyright © 1999 Minerva Cuevas.

of early 1990s' British art-intellectual discourse from the transgressive excesses of Bakhtin's Rabelais to the abject low of Kristeva's study of depression. And yet *Drunk* is anything but 'literary'. It functions, if anything, as a telling travesty of the final lines of Kristeva's essay on Holbein's images of Reformation humanity. Situating these disabused images of human suffering on what she calls 'the threshold of nonmeaning', Kristeva writes, 'No exalted loftiness toward the beyond. Nothing but the sober difficulty of standing here below. They simply remain upright around a void that makes them strangely lonesome. Self confident. And close.'[37]

This brings us round, inevitably, to a recognition in Wearing's work of a submerged sense of mourning for the image of the ennobled victim in modernist photography that Rosler had shut down on. In line with Foster, one senses a kind of skewed, simulacral re-run of a previous order of representation.[38] Furthermore this seems connected to certain forms of abject identification and over-identification, to reprise my earlier term, which are current in contemporary art. For instance in *Drunker* (1995) – in the spirit, perhaps, of the quotation with which this essay started – the Mexican artist Minerva Cuevas drank her way down a bottle of tequilla whilst writing repeatedly 'I'm not drunk … I drink to forget … I drink to remember' and so on. The performance was recorded on video in real time, with the artist retaining no memory of her actions in the last twenty minutes (plates 2.10 and 2.11).

More to the point, perhaps, is an almost burlesque treatment of drug and alcohol dependence in certain areas of yBa-related art in the past decade or so. Possibly the most celebrated instance of this was the spectacle of Tracey Emin drunkenly storming out of an earnest Channel 4 television discussion of the Turner Prize in 1997, although numerous films and articles dedicated both to Emin and to her friend Sarah Lucas have attested to their shared love of alcohol and cigarettes. What is particularly noticeable here is that it is women, rather than men, who are shown positively to embrace the idea of overindulgence, derailing lingering assumptions that women are fundamentally more health-conscious (and hence abstemious) than men, for whom the combination of self-abuse and bohemianism are sanctioned by tradition.

This phenomenon can be addressed more clearly by looking at a genre of cigarette-related imagery in the output of male and female yBas. In 1992–3 Damien Hirst, by far the most 'public' of the younger 'Freeze generation' yBas, produced a number of works which explored an ambivalence towards cigarettes. In *Died Out, Explored* and *Died Out, Examined* (1993), for instance, 'fag ends' were laid out prosaically in rows in shelved cabinets, whilst in a *Parkett* magazine insert of 1992 photographic images of pristine cigarette packets and lighters were juxtaposed with abject images of overstuffed ashtrays.

A little later Sarah Lucas, who had been producing a fascinating sequence of mannish self-portraits, came up with an iconic image of herself, with a cigarette hanging defiantly from the corner of her mouth – complete with a long, drooping, tail of ash – on the cover of *the idler*, a cult magazine (plate 2.12).[39] What was interesting here was that Lucas's image, however much it relied on American-derived 'slacker' iconography, could be seen, like other self-portraits of the period, as provocatively (and perhaps problematically) sexually

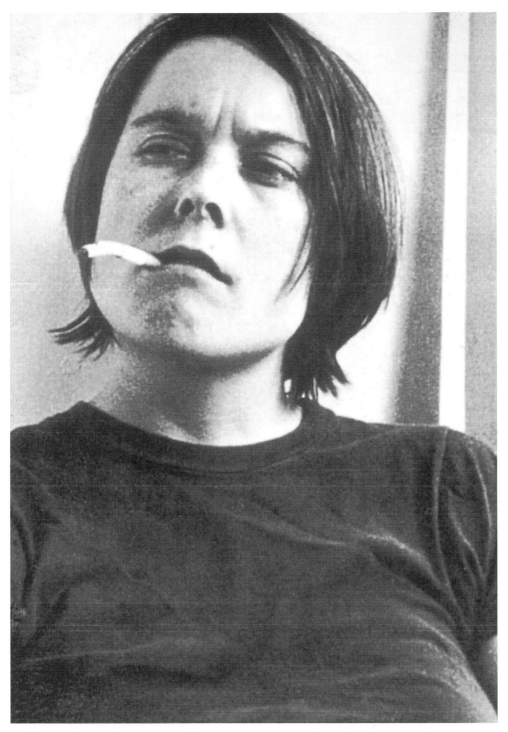

2.12 Sarah Lucas, *Fighting Fire with Fire*, 1996. Black-and-white photograph, 152.5 × 122 cm. Reproduced courtesy of Sadie Coles HQ, London. Copyright © 1996 Sarah Lucas.

ambiguous, usurping something of the 'laddishness' then identified with male peers such as Hirst.[40] (This appropriation of the male position, as I have argued elsewhere, might be even more at issue in the Lucas–Emin collaboration *Shop* [1993], which involved the two artists running a shop in East London and producing merchandise sporting sexual repartee, which virtually amounted to a form of reverse-sexism).[41] Hence the image of the female artist–smoker – which Lucas was to revisit on other occasions – could be seen as highly strategic in relation to the dominant re-mobilization of laddish working-class tropes among male artists.[42] Significantly, there was much media discussion in the early 1990s about increased cigarette consumption among women relative to men, not least because, although smoking had long been seen as detrimental to the health of both sexes, women were seen as risking gender-specific outcomes, such as spontaneous abortion, infertility and premature menopause.[43] Whatever moral scruples were raised, however, the phenomenon also, perversely, signalled an increasing social equality between men and women. The American pro-smoking writer Richard Klein, for instance, asserted, 'The degree to which women have the right to smoke is an unmistakable indicator of the general equality they have achieved, a test of their full membership in civil society.'[44]

Given that Lucas has often admitted to a broad interest in feminist debates as they stood in the late 1980s and early 1990s, it may well be that her riposte to her male artistic peers had a wider political charge.[45] Some of her works even suggest an outright ridiculing of the male position. In *Get Off Your Horse and Drink Your Milk*, a set of four photographs of 1994, a slightly flabby naked male torso is supplied with digestive biscuits and a full milk bottle as stand-ins for testicles and penis respectively (plate 2.13). The implication, needless to say, is a metaphorical flip from potency (the container brimful with white fluid) to male infantilization (mother's milk). The aggressivity underlying works like this strongly suggest that Lucas was adopting the role of what psychologists have come to characterize as the working- or under-class 'ladette'.[46] In 1994 two writers in the *Sunday Times*, for instance, noted an unaccountable increase in young women 'attracted to street thuggery, the traditional occupation of the dead-end male', noting that 'Images of uncompromising and aggressive women have never been more prevalent … The latest icon, Tank Girl, a shaven-headed, beer-swilling feminist superheroine, has been lifted from comic book obscurity to become a Hollywood action woman.'[47]

However alarmist this language may be, it is evident that Lucas may well have been identifying (or perhaps over-identifying, in an essentially parodic fashion) with a politically inflected desire among lower-class women to usurp the characteristics of their sexual opposites. To return to Wearing at this point, she significantly produced a video in 1994–5 focusing on 'air guitar' performances by rock fans (entitled *Slight Reprise*, a reference to a feedback-swamped recording of *Voodoo Chile* by Jimi Hendrix), which might be seen as ridiculing a species of (regressive) adolescent male behaviour, although with far less aggressivity than Lucas. In *Drunk* itself there may be an echo of such preoccupations. As noted earlier, the piece ends with an infantilized George, his adult self-control annihilated, urinating in front of the camera. More to the point, though, is Wearing's overall authorial stance in relation to her drunken –

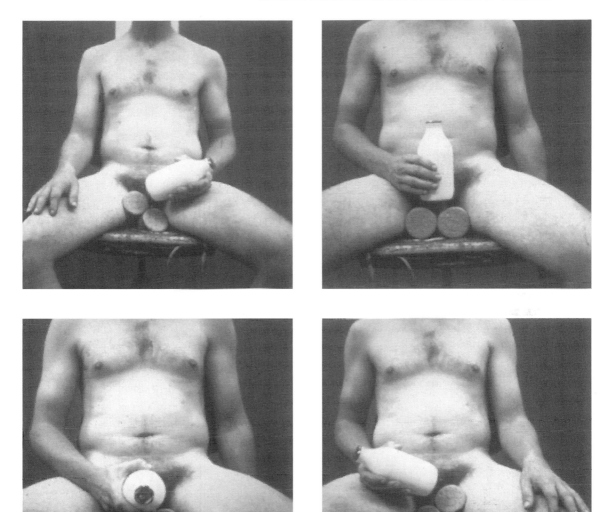

2.13 Sarah Lucas, *Get Off Your Horse and Drink Your Milk*, 1994. Four colour photographs. Reproduced courtesy of Sadie Coles HQ, London. Copyright © 1994 Sarah Lucas.

predominantly male – subjects. As a female author who countenances, and possibly empathizes with, an almost ritualized surrender to alcoholic oblivion – at a time when there was much outrage in Britain over the alcohol abuse indulged in by its male football fans when travelling to matches abroad (a confirmation of the view, long held by mainland Europeans, that the British are unable either to drink wisely or to 'hold their drink') – Wearing implicitly 'masculinizes' herself. And she does so as an unequivocally 'British' artist.

Whatever its resonance in terms of 1990s gender politics, *Drunk* must finally be understood as dedicated to mobilizing the tropes of working-class or underclass self-annihilation and redemption (the latter in view of the Holbein allusion mentioned earlier). Most of all the work seems pledged to the thematics of an absolute powerlessness. We revisit that experience of inarticulacy that Wearing has seen as foundational for her practice, this time perhaps as a form of class symptomatology bound up with her own experience growing up in a working-class environment in Birmingham. At times a kind of rage comes to the surface in her recollections: 'I used to mumble and never finish my sentences. I didn't like language. At college I used to cut up books.'[48] Although Wearing herself avoids overt social claims, there is a sense in which the social dysfunctionality and befuddlement of her drunks stands for a wider voicelessness.

The 1980s and early 1990s were a period, of course, in which a once-vocal British working class were both metaphorically and physically relocated. (This process was apparent, for instance, in the development of such areas as the London Docklands. A representative of the London Docklands Consultative Committee reported to the Institute of British Geographers in January 1989 that the high investment of public funds was benefiting incoming middle- and upper-class residents whilst long-established working-class families were being forced to move).[49] At the same time, it was a period when 'care in the community' policies for dealing with the mentally ill were adopted in Britain and America, with the effect that the socially maladjusted or incapable were virtually forced to live out their bewilderment on the streets. In many instances alcoholism becomes the refuge of the mentally ill when they are forced to cope with urban survival. In this latter respect there might be said to be a further unremitting level of 'exposure' in Wearing's video, which alerts us to the way in which certain people are compelled publicly to enact their wretchedness.[50]

There is a danger here, of course, of too easily mapping the experience of down-and-outs onto that of more socially responsive or more genuinely incapacitated groups of people, but there is undoubtedly an elegiac quality to *Drunk*, taken as a whole, which can be read as allegorizing processes of social mourning and the longing for reinstatement of community, however abject the forms taken by the latter might be. Counterbalancing this, the other pole of Wearing's practice envisions the possible emergence of new modes of social identification and interactivity, as glimpsed in the early 1970s television documentaries she has cited as her privileged sources. The problem that emerges here, of course, is one of distance. In line with critics of Wearing, who see her work's almost instant assimilation into advertising as an outcome of the fact that it so plainly plays by the mass media's rules, we would have to ask how deeply these new modes of interaction are already enmeshed in market structures. But, as I have suggested earlier, there are signs that Wearing is beginning to thematize this critique within her output in any case. At the time of writing, her latest full-scale video work since *Drunk* is *Broad Street* (2001), which consists of an installation of six video films documenting the heaving, cacophonous night life to be encountered in central Birmingham's discotheques and streets. Among other things the piece reveals how the desires (and frustrations) of young people are regulated by the 'entertainment industry'.[51]

So, how do we read *Drunk*? It is undoubtedly a 'difficult' work. It is fragile both aesthetically – in terms of its post-conceptualist anachronisms – and ethically. It objectifies its subjects, confirming them as 'victims', whilst melancholically over-identifying with them. It runs the risk of de-historicizing the experience of its subjects, but speaks volumes about the condition of 'Britishness' – in terms of class and gender roles, as well as national identity – in the 1990s. In the end there is no easy resolution to the questions I have posed in this essay. But rather than close down on Wearing, as some critics have, largely on ethical grounds, it seems to me that her work deserves far greater critical scrutiny than it has so far received. A new form of identificatory imaging of the social margins may be struggling to born here: a 'poetics of drunkenness', to reprise Rosler's terms, 'from within the culture of drunkenness rather than being framed on it from without'.[52]

David Hopkins
University of Glasgow

Notes

A shorter version of this paper was originally given at the *Photography in a Post-Medium Age* conference at Tate Modern in June 2001. My thanks to Briony Fer and Margaret Iversen for inviting me to contribute, and to Gill Perry for enthusiastically supplying a home for the piece in this publication. I delivered the paper as a lecture last year at Glasgow School of Art and at the Slade School of Fine Art, University College London. Many people offered interesting comments and points of information on those occasions but I am grateful especially to Ross Birrell, Duncan Forbes, Amna Malik and Andrew Brown.

1 Malcolm Lowry, *Under the Volcano*, London, 1967, reprinted 1993, pp. 292-3.

2 For Rosler's recollections of the early showings of the piece, see Benjamin Buchloh, 'A Conversation with Martha Rosler', in Martha Rosler, *Positions in the Life World*, ed. Catherine de Zegher, Birmingham and Vienna, 1998, p. 44. For Rosler's more general attitude towards conceptualism, see the same interview, pp. 32-45.

3 Rosler, *Positions in the Life World*, p. 33.

4 Rosler, 'In, around, and afterthoughts (on documentary photography)', in Richard Bolton (ed.), *The Contest of Meaning: Critical Histories of Photography*, Boston, 1992, p. 324.

5 Rosler, in Bolton (ed.), *The Contest of Meaning* p. 324.

6 Walter Benjamin, 'A Short History of Photography' (1931) as translated in David Mellor (ed.), *Germany: The New Photography 1927–33*, Arts Council of Great Britain, 1978, p. 69.

7 See Rosler, *Positions in the Life World*, p. 38.

8 Rosler, in Bolton (ed.), *The Contest of Meaning*, p. 306.

9 Abigail Solomon-Godeau, 'Who is Speaking Thus? Some Questions about Documentary Photography', in *Photography at the Dock: Essays on Photographic History, Institutions and Practices*, University of Minnesota Press, 1991, p. 176.

10 Rosler, in Bolton (ed.), *The Contest of Meaning*, p. 322.

11 Rosler in *The Contest of Meaning*, p. 322.

12 Rosler in *The Contest of Meaning*, p. 322.

13 Rosler in *The Contest of Meaning*, p. 321.

14 This is not meant to suggest that artists in the 1980s were any less socially motivated than their predecessors, but to indicate that, given a widespread sense of the instability of signification, many artists tended to sidestep the dangers perceived to be inherent in 'straight' depictions of class (Victor Burgin in particular). There were notable exceptions. One might, for example, point to Terry Atkinson's return to figuration in his early 1980s paintings relating to the mobilization of working-class labour during World War I. Another very different example might be Jo Spence's attempt to create an alternative 'family album' where the artist herself is often posited as a 'victim'. (See Jo Spence, *Putting Myself in the Picture: A Political, Personal and Photographic Autobiography*, London, 1986.) Here the whole thrust of the practice is towards laying bare the mechanisms of oppression as they are installed in the seemingly innocuous province of family photographs, and hence re-empowering the subject of the representations.

15 See Hal Foster, *The Return of the Real*, Boston, 1996, esp. chap. 5. For Roberts, see 'Pop Art, the

Popular and British Art of the 1990s' in Duncan McCorquodale, Naomi Sidefin and Julian Stallabrass (eds), *Occupational Hazard: Critical Writing on Recent British Art*, London, 1998, and 'Mad For It! Philistinism, the Everyday and the New British Art', *Third Text*, no. 35, Summer 1996, pp. 29-42.

16 In *London: The Biography*, London, 2000, Peter Ackroyd provides a lexicon of current London-based slang relating to drunkenness: ' "soaks", "whets", "topers", "piss-heads" and 'piss artists" are "boozy", "fluffy", "well-gone", "legless", "crocked", "wrecked", "paralytic", "rat-arsed", "shit-faced" and "arse-holed"'. He goes on to explicate, how, among the estimated one to two thousand down-and-out alcoholics resident in the City of London, a whole patois relating to their lifestyle is in operation. Places where they congregate are called 'the Caves, Running Water, or the Ramp'. The vagrants themselves have nicknames: 'No-Toes, Ginger, Jumping Joe and Black Swan' (p. 359).

17 The details of the London and Paris showings, for which there were related catalogues, are as follows: *Gillian Wearing*, London: Serpentine Gallery, 16 September-29 October 2000; *Gillian Wearing: Sous influence*, Paris: Musée d'art moderne de la ville de Paris, 10 March-6 May 2001.

18 See 'Gillian Wearing in Conversation with Carl Freedman', in *Gillian Wearing*, exhib. cat., London, 2000, unpaginated.

19 'Gillian Wearing in Conversation with Carl Freedman' in *Gillian Wearing*. The piece dedicated to Lindsey, a four-minute video entitled *Prelude*, was presented alongside the Paris showing of *Drunk*. It consists of a slowed-down piece of footage of Lindsey talking and swaying with drink in hand. Lindsey's twin sister, whose existence Wearing was unaware of prior to Lindsey's death, provides a moving commentary on her dead sister as part of the soundtrack accompanying the piece.

20 Mikhail Bakhtin, *Rabelais and his World*, trans. H. Iswolsky, was originally published by the MIT Press, Boston, in 1968 and republished by Indiana University Press, 1984.

21 'Gillian Wearing in Conversation with Carl Freedman', in *Gillian Wearing*, exhib. cat., 2000.

22 'Gillian Wearing in Conversation with Carl Freedman', in *Gillian Wearing*, exhib. cat., 2000.

23 'Gillian Wearing in Conversation with Carl Freedman', in *Gillian Wearing*, exhib. cat., 2000.

24 Jean-Charles Masséra, 'If I were you, but you're not. Critique of decontextualisation', in *Gillian Wearing: Sous influence*, exhib.cat., Paris, 2001, p. 61.

25 Masséra, in *Gillian Wearing*, exhib. cat., 2001, p. 65.

26 Richard Billingham, *Ray's a laugh*, Zurich, Berlin and New York, 1996.

27 *Gillian Wearing*, exhib. cat., 2000, unpaginated.

28 Rosler discusses Arbus, alongside the likes of Gary Winogrand and Lee Friedlander, in relation to John Swarkowski's 'connoisseurship of the tawdry' in her 'In, around, and afterthoughts (on documentary photography)', in Bolton (ed.), *The Contest of Meaning*, pp. 319-21. Wearing discusses her relation to Arbus in an interview with Donna de Salvo in Russell Ferguson, Donna de Salvo, and John Slyce, *Gillian Wearing*, Oxford, 1999, p. 6.

29 *Gillian Wearing*, exhib. cat., 2000.

30 Julian Stallabrass, *High Art Lite*, London, 1999, p. 239.

31 For Stallabrass on Wearing, in relation to the 'pastoral', see Stallabrass, *High Art Lite*, pp. 248-9.

32 See, for instance, 'Donna de Salvo in conversation with Gillian Wearing' in Russell Ferguson *et al*, *Gillian Wearing*, p. 15.

33 See 'Gillian Wearing in Conversation with Carl Freedman', in *Gillian Wearing*, exhib. cat., 2000.

34 *Gillian Wearing*, exhib. cat., 2000.

35 For reproductions of Wallinger's paintings, plus an interesting commentary on them by Jon Thompson, see *Mark Wallinger,* exhib. cat., Birmingham: Ikon Gallery and London: Serpentine Gallery, 1995, pp. 13-14.

36 Julia Kristeva, 'Holbein's Dead Christ', trans. Leon S. Roudiez, in Julia Kristeva, *Black Sun: Depression and Melancholia*, New York, 1989. Incidentally, the symbolic gravitas of the image of the prostrate George was reinforced, in the Paris showing of *Drunk*, by the inclusion of a thirty-minute DVD work, at the end of the show, entitled *Fell Asleep*, in which film of the sleeping George was juxtaposed with an image of a figure lying in an open coffin.

37 Kristeva, *Black Sun: Depression and Melancholia*, p. 138.

38 Once again I have in mind the thesis of chap. 5 of Hal Foster's *The Return of the Real*.

39 For examples of Sarah Lucas's self-portraits of 1993-4, see *Parkett*, no. 45, 1995, pp. 97-105.

40 The sexual ambiguity of the image has led to some interesting critical responses. See, for instance, Collier Schorr's lesbian-oriented reading in her 'The Fine Line Between This and That', *Parkett*, no. 46, December 1995, p. 100.

41 See my 'Women Behaving Badly: Dada Girls and Boys and yBas', *Art Monthly*, no. 236, May 2000, p. 4 and *passim*.

42 With regard to Lucas's later autobiographical uses of cigarette imagery, she produced a wax cast of her own mouth, with a real cigarette protruding from it, in *Where Does it All End?* of 1994-5. Later, in 1998, she produced a photographic self-portrait entitled *Smoking* which, as I argue elsewhere, makes use of a canonical Surrealist image by Man Ray, overlaying its aura of avant-garde sophistication with demotic preoccupations such as lifestyle, cigarette addiction and so on. See my 'Douglas Gordon as Gavin Turk as Andy

Warhol as Marcel Duchamp as Sarah Lucas', *Twoninetwo: Essays in Visual Culture*, Edinburgh Projects (Edinburgh College of Art), no. 2, 2001, pp. 99-100.

43 One American report, for instance, noted that, although male smoking prevalence dropped by 24 per cent between 1965 and 1993, the prevalence of female smoking dropped by only 11 per cent during the same period. See Giovino, Schooley, Zhu *et al*, 'Surveillance for Selected Tobacco Use Behaviours. 1900-1994', *Morbidity and Mortality Surveillance Summary*, no. 3, 1994. For a more general discussion of the return to smoking in the 1990s, with a British emphasis, see Matthew Hilton's conclusion to his *Smoking in British Popular Culture 1800–2000*, Manchester University Press, 2000, pp. 245-56.

44 Richard Klein, *Cigarettes are Sublime*, London, 1993, as quoted in James Walton (ed.), *The Faber Book of Smoking*, London, 2000, p. 159.

45 For Lucas on Feminism, see, for instance, the interview with Jan Van Adrichem, 'Where Does it All End?', *Parkett*, no. 45, 1995, p. 88.

46 See, for example, Steven Mucer, '"Ladette", Social Representations and Aggression. (Aggressive behaviour by girls and women)', in *Sex Roles: A Journal of Research*, January, 2001.

47 J. Burrell and L. Brinkworth, 'Sugar 'n' spice … but not all nice', *Sunday Times*, 27 November 1994, p. 16.

48 'Gillian Wearing in Conversation with Carl Freedman', in *Gillian Wearing*, exhib. cat., 2000, unpaginated.

49 Arthur Marwick, *The Penguin Social History of Britain: British Society Since 1945*, 3rd edn, London, 1996, p. 330.

50 A precedent for Wearing in this connection would be Gavin Turk's waxwork self-portrait as a down-and-out or vagrant, *Bum*, of 1998. (In a trio of related photographs - collectively entitled *Oi!* - this figure is further objectified by being viewed from different angles. The analogies with Wearing's concerns in *Drunk* are striking.)

51 See Pedro Lapa, 'A darker place than night', in *Gillian Wearing*, exhib. cat., Museo de Chiado, Lisbon, 2001, pp. 5-17.

52 Rosler in Bolton, *The Contest of Meaning*, p. 322.

3

A Strange Alchemy: Cornelia Parker

Interviewed by Lisa Tickner

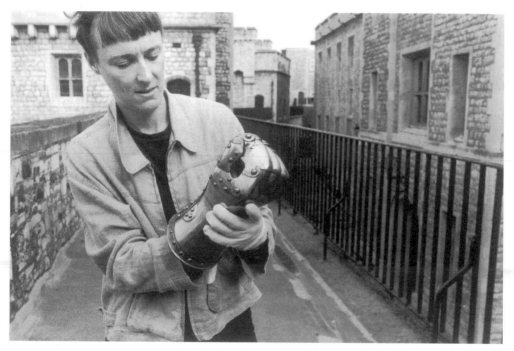

3.1 Gautier Deblonde, *Cornelia Parker*, 1999. Reproduced courtesy of Gautier Deblonde.

Cornelia Parker was born in Cheshire in 1956 and raised with two sisters on her parents' smallholding. She studied at Wolverhampton Polytechnic (BA Hons., 1978) and Reading University (MFA, 1982). She first came to prominence with *Thirty Pieces of Silver*, commissioned by the Ikon Gallery, Birmingham (1988–89), and *Cold Dark Matter: an Exploded View*, an installation at Chisenhale Gallery, London (1991). In 1995 she collaborated with Tilda Swinton for *The Maybe*, at the Serpentine Gallery, London, and in 1997 she was shortlisted for the Turner Prize. Cornelia Parker lives and works in London, and is represented by the Frith Street Gallery.[1]

Formation

LT: *What made you want to be an artist, and what did you think that was?*

CP: I think it was freedom, the idea of it being the most liberated thing you could do. I had a very physical upbringing. It was almost a peasant existence, working on a smallholding and living in a tied cottage. I was involved in very repetitive tasks like milking cows, planting, scything hay, stringing up tomatoes … play was something I had to sneak off and do. And I think art seemed to be almost like grown-up play, something that was about freedom of ideas, freedom of expression, and something I could imagine myself doing. As an adolescent, it seemed to me pleasantly anarchic, exactly the thing your parents didn't want you to do. But I hadn't spent my childhood going to museums and looking at art at all.

In one interview you spoke about making sculpture as carrying on from childhood tasks – stringing up pieces of chalk or wood not so different from stringing up tomatoes – so if it was play, it wasn't an escape from hard work.

It was making sense of the hard work. If you're growing tomatoes you work hard to plant the seeds and grow the plants and then you eat the tomatoes and in ten minutes you've eaten what it took you a whole year to produce – which is fine, and good, and I enjoyed the hard labour, but I wanted it to translate into something more permanent and less useful, or something that went beyond sustenance but might feed you in another way.

It would be you, wouldn't it, by being yours? Presumably anyone with the right skills can grow tomatoes, but the tomatoes don't say, 'I'm the tomatoes that Cornelia grew.' You're making something that outlasts the season.

But also you can break the rules, because you have to do certain things to grow tomatoes, but I didn't have to follow those kinds of rules in art. I felt – naively – that art was something without rules, but of course you impose your own. It was good to create my own parameters within which to explore anything that interested me in life. The work was a kind of waste product of that. I never thought of it as being a sort of pinnacle, it was almost something I shed. Every bit of the process is there, and I like that; I like people seeing the journey you've made. I like the use of physical objects in place of metaphorical representations. And then I didn't have any technical expertise in sculpture, having transferred from painting, but in my childhood ad-hocism had been the order of the day. We had no money, so you had to re-use things. My father was a bad carpenter and would make shanty-ish outhouses out of bits of other stuff, and so the idea of improvisation was very much part of my upbringing. I was also very interested in Edward de Bono's book *Lateral Thinking*, which I read when I was about eighteen. He talks about holes. He says that to be an expert you have to dig a very deep hole, but that if you do this it's difficult to get out of it and look around; to dig a different hole would be almost impossible for an expert.

Thinking laterally means thinking creatively, rather than just learning the contents of an existing hole. So you dig lots of holes that could become connected and that way you might discover something new.[2]

How did your parents feel about you going to art school?

I think they thought that it was a waste of time. They still don't quite get it. My mother keeps presenting possible other careers that I could have. I think it's to do with being freelance and not having a 'proper job', but I think they feel threatened by it too. They're *Daily Mirror* readers from working-class backgrounds and the world of art and museums is baffling. One of the things that lured me into art was the attraction of another kind of space, a space of vision and creativity. It seemed a very enriching world to me and that was the world I wanted to be in, rather than in the drudgery of peasant farming which is where I come from. As soon as I gravitated towards sculpture I found my spiritual home.

This was pre-Saatchi and the Young British Artists. It wasn't a world of material riches or celebrity, was it?

It's more a philosophical thing, you know. I had – still have – quite a romantic conception of what an artist should be. You devote your life to something that's enriching for your spirit. I never expected to make any money out of it. Perhaps I just wanted it for my own psychological wellbeing.

Gender

LT: *How did being a woman figure for you?*

CP: I've very much resisted, in the past, having my work written about under the umbrella of women's issues or women's rights, because I really wanted to be part of the mainstream, and also I'd always ignored the fact that I was a woman, probably because it was ignored when I was a child. I was brought up as a surrogate son. (My sisters used to have lipsticks and dolls as birthday presents and I'd get wellington boots and wheelbarrows.)

You thought of yourself as a person making art, not as a 'woman artist'?

I still want that to be the case. Actually I think it's quite obvious that my work's made by a woman, when you look at the form and sensibility of it, but it's not something I want consciously to mine. It narrows the way people look at the work and I'd rather the work be as open to interpretation as possible. I was in *Sculpture by Women* at the Ikon Gallery, Birmingham, in 1983 and I remember having doubts about that. I was asked at the symposium how I'd suffered as a woman and I quite honestly said that I didn't feel male chauvinism had played any part at all. I hadn't been subjugated by my tutors. There were two students

in my year who got firsts and I was one of them. The toughest response to my degree show came from a young lecturer who said, 'I really like it but don't you think it's a bit feminine?' I said, 'Thank you very much.' I took it as a compliment, though it wasn't meant that way.

A few years earlier there wouldn't have been any question of seeing it as a compliment.

I was in a sculpture department in the 1960s and it was a very unsympathetic environment, quite misogynist, in fact. In the 1970s you must have been a student against a backdrop of emerging debates around art and gender. For better, on the whole, in that these were real issues and interesting questions were being explored. But for worse, I suppose, if some women felt they'd swapped one set of constraints for another: the constraints of being a woman under a 'masculinist' regime for the constraints of being a woman obliged under a set of feminist expectations to articulate femininity in a recognizably political way.

Wolverhampton School of Art was pretty macho. It wasn't the norm for women to make sculpture. The tutors weren't too aware of a feminist agenda and I had a blind spot about it, too. But all credit to them: even though they hinted that the things I was making out of paper or wire were maquettes that I could make more seriously in metal later, when I said, 'No, this is it, I'm trying to dematerialize things, I couldn't possibly make them more substantial', they obviously recognized that the materials I was using were somehow inherent to my sensibility. I never felt knocked back by the situation, even though it wasn't the most enlightened art school. But I think what I do – what I've always done, perhaps subconsciously – is develop blind spots to screen out what I don't find relevant. You're always developing strategies to be creative and bat off tyrannies of one kind and another. For example, Goldsmith's was the last place I was teaching, and if there'd been a tyranny when I was at art school to do with materials and technique, I felt at Goldsmith's College there was a tyranny of art criticism and theory. First-year students were spouting Lacan but couldn't actually make anything.

What kind of work has been influential for you?

All kinds of work. I've always been interested in other art forms – contemporary dance, experimental theatre, independent film – they've all been sources and as inspirational as, say, Piero Manzoni or Yves Klein.

What about other sculptors who came to prominence in the 1980s, such as Tony Cragg and Richard Wentworth?

Yes, both of them: Tony Cragg for his use of materials and Richard Wentworth, again, for his materials and his wit. There's a wonderful British tradition that's been generally influential – a post-Moore tradition in its use of materials and fragments and floor-pieces – a tradition that's also wrapped up in language and I

like that, it's a very British thing.[3] I was never into Moore and Caro and the sculptural lump. I was much more into what was going on in Italy, France or America. I'm a great admirer of Duchamp but I love the idea of the 'unmade' more than the readymade. I've always loved found objects but for me it's important to do something to them: I have to kill them off, so that I can remake them.

I was interested in Arte Povera and ephemeral materials, in Manzoni and in Oldenberg. I thought it was funny, his thing with the hard and the soft, and his writing was so refreshing. Warhol's never been a particular favourite except for his films, like *Sleep*. (I like the way he puts something in front of the camera and just lets it *be*.) But I don't often read about art. I look at it, but I don't want to saturate myself with the theory of it. I get inspiration from reading about science in the newspaper or perusing objects in a street market. I've learned more about sculptural space or technique in the real world than in a sculpture class.

This seems to me the first generation of women artists to have grown up as it were with both parents, with role models of both sexes, and the effect of this has been not to discover or promote a separate maternal tradition – Virginia Woolf's 'Thinking back through our mothers' – so much as to offer a new kind of freedom with the heritage of fathers and brothers. So that Rachel Whiteread's Untitled: One Hundred Spaces *owes something to Eva Hesse and something to Bruce Nauman and can even be read as a wry and grateful homage to both.[4] I wondered if this meant anything to you? All the artists we've talked about, as it happens, have been men.*

Yes, but I think we're all made up of male and female parts in our psyches and we manifest whatever, depending. Yves Klein, Bruce Nauman, James Turrell: men like these might have a really feminine sensibility, not the Henry Moores or the Anthony Caros. Nauman was important: *Space Under My Hand as I Write*, for example, this inverse of the lump, inverse of the grand gesture. I was just intuitively drawn to these people because they were making things that were vaporous and not earth-bound, and that's to do with sensibility. I was trying to capture that. If I could have made things out of steam or gauze, I would have.

So it's not a biological or experiential femininity; it's a kind of discursive femininity. It's about what language organizes at any given moment as more 'feminine' attributes or sensibilities, and that might also connect to the materials you use and your interest in things that are left over, marginal or negative. There is a way of thinking about those things, traditionally, as on the side of the feminine.

I also think works of art are physical manifestations of thought processes and I do feel women think differently, in a more round-the-houses kind of way. I never want to go there too much in discussing it, but the whole idea of formal issues to do with the lump or the anti-lump is somewhat gendered. The idea of installation art is quite feminine. It's a feminine art form because it's inclusive and you walk into it; it's not going to the centre just to look at this lump in the

middle. And I think the air around, the leaves on the trees and blades of grass, this fluid, atmospheric sense of the relations and exchanges between things, is a model of the way I think, and I think it's quite a feminine way of thinking. It's always this anti-centre thing. So when you have something like the exploded shed in *Cold Dark Matter* (plates 3.4–3.6, pages 376 and 379), you have a light bulb in the centre. You're very aware that there's something in the centre but it's the thing that's blown it apart. The shed is porous; you can see through it; there's light radiating through the walls; it's not this dark bunker. The desire to make things imperfect or porous or break the mould of the cliché – I'm very often concerned with the cliché or the monument – that's something that recurs.

The shed is interesting in those terms. Some of your works I think of less in relation to gender alone and more in relation to the family context. The components of Thirty Pieces of Silver *(plate 3.2, page 372) are largely familial and aspirational. Traditionally, it was families who had houses with gardens and garden sheds. The silver belonged to the house, to domesticity and the side of the feminine. The shed was a bolt hole. It was a masculine rite of passage to grow to adulthood and a shed of your own. We know this from our childhoods but it's also evident in the hobby magazines of the postwar period. (My mother was the gardener and the shed held her gardening tools and seed packets but really it was my father's bunker and the only place he could smoke.)*

That's the kind of interpretation I'm always trying to avoid: the shed is the male domain and therefore … All along I've been very aware of these things in my work, and sometimes I play with them just to myself, but it's something I never really talk about. I don't talk about personal issues or psychology. It's always about maintaining a space for the work. You're a person interpreting it, but I'm always preserving its flexibility, its breathing space.

Politics

LT: *I wanted to ask you about politics. You've talked before about how critics linked* Cold Dark Matter *to the IRA bombing campaign, and about how, when you were in Argentina, 'monument-on-a-plinth' sculpture was associated with totalitarianism and installation with a kind of anti-consumerist democracy: 'a return to when art belonged to everyone'. But that's not actually what the work's about for you, is it?*

CP: No. If you're going to make an explosion happen, you have to think carefully about who is going to help you with that, and the British Army offered the most interesting scenario. If you want to talk about Ireland, or the idea of boys blowing up the boys' domain, you can do that. In Argentina they asked me if the explosion was a political piece, and I said, 'Well, it depends on the viewer.' I don't want it to be very specifically this or that. Explosions are happening all the time all over the world, in fiction, on TV, in films, in wars, in

51

cartoons. It might be a psychological state, an inner explosion. If you have an object and you blow it up and suspend it in a gallery, it becomes a universal explosion. It has space in it and people can project onto it. A monument is a fixed space. I want the opposite, an anti-monument, an implosion, a repositioning.

And then I think being an artist is such a political thing in its own right. Just the fact that you're doing what you're doing is a political act, but I'm always trying to maintain a certain openness to interpretation. I want the work to tell *me* things, to surprise *me*, so that the work is a kind of waste product from a process, an inquiry you started when you didn't know the answers at all. Later, in retrospect, you can talk eloquently about it but when you're in the middle of it you can't. That's why I very rarely take on commissions (*Breathless*, for the V & A, was an exception).[5] I don't want to be defending what I'm going to do while I'm still finding out what it is, and I don't want to make interior decoration, though the work might be very decorative at times.

You've been quite explicit about coming out of a sculptural tradition that's opposed to monuments, that works directly with matter and physical processes and the associations of everyday things. There's a double heritage here, it seems to me, in that women artists have come to prominence in a period in which traditional monuments have seemed inadequate to the traumas of history and the Holocaust has provoked a whole series of anti-monuments.

My desire, by making work, is to try to absorb the world. Sculpture was always about making these permanent, solid things. For a long time my work has been about trying to erode monuments, to wear them away and to digest them, and then create a moment, a fleeting thing. I had monuments falling. Instead of being huge edifices that go upwards towards the sky, they were falling down towards the centre of the earth. It was about suspending, having the pedestal as a kind of rain of wires instead of a solid base. Nothing was solid, nothing was fixed, everything had a potential to change, so it was the opposite of the monument; it was the moment.

I wondered what would you do if you were offered the fourth plinth in Trafalgar Square, whether that would be too monumental a thing to do?

I don't know. It's hard to say off the top of my head. It would be a very interesting thing to do. I think the Wallinger and Whiteread projects were fantastic. I'd most probably blow it up, make it into powder, send it up in fireworks or send it into space, ship it out of there ...

Thirty Pieces of Silver

LT: Thirty Pieces of Silver *consists of a thousand pieces of steamrollered silver and silver plate, gathered into a grid of thirty gleaming discs suspended a little above the floor (plate 3.2). Gravity seems suspended, too, though there's no illusion: we see the wires. Close-up there's a tea-tray, a sauce-boat, some cutlery; in the distance there's just a series of silvery marks in the air. It's been called an 'upside-down, ethereal forest' by one writer and a 'mesmerizing low-lying cloud layer' by another.[6] For me, it's a Monet, a surface of shimmering lily pads and puddled water in a downpour of glimmering filaments. The grid is rational but the sensation dizzying. The plane of silver discs emerges from beneath our eyeline; they hover above our feet but below our centre of gravity. The shadows beneath each glittering pool unsettle our focus. And the constituent objects – some puzzling, some recognizably flattened, blueprint versions of their former selves – tug at the strings of two kinds of mental process: the physiological process by which we read retinal images as three-dimensional forms and the psychological process by which household objects are imbued with value and meaning beyond their everyday function.*

This was, after all, domestic, aspirational silverware of a certain period: candlesticks, trophies, teapots, toast racks, napkin rings, cake-stands, sauce boats, fish knives – the kinds of objects bought as wedding presents, marking rites of passage for our parents and grandparents. Alan Bennett, remembering his childhood, talks of this 'embarrassment of cake-knives and even cake-forks … coffee spoons for the coffee we never drink; sugar tongs for the sugar lumps we never use', the fish slice 'pristine in its original box', his mother's silver-backed hairbrush dusty and unused on the dressing table. These apparently surplus items endowed class and respectability but seemed to him as a child an indictment of the family, 'a dossier of our unsuccess'.[7] If it's 'an image of squandered wealth and utility', the wealth is limited and so is the utility.[8]

You laid it all out in a silver stream on a country road and had it flattened with comic-strip violence by a steam-driven traction engine (plate 3.3).[9] This was a kind of performative prologue to the installation, originally included as a prefacing photograph. The title summons the idea of betrayal. Crushing the silver was a betrayal of its formal integrity but also of its private, sentimental and memorializing significance for a thousand lost and departed owners: the daughter's symbolic rejection of domestic niceties, perhaps (you've claimed to have a horror of domesticity); the betrayal of one set of use values in the interests of another (the valuable uselessness of art).

You said that the silver was much nicer once you'd flattened it.

C.P: Yes. Most of it was inexpensive silver plate, though there are one or two real antique things in there that I realized were worth a lot of money – the odd Georgian candlestick or two – but good, I don't mind. I always thought of *Thirty Pieces of Silver* as being like a triptych – the piece, the photograph and the title – like a tragi-comedy. You get the comedy of the Tom-and-Jerry death,

you get the tragedy of the biblical title, and then you have the piece, which is almost in limbo between them. There's always a kind of wry humour in my work, but I don't want it to overwhelm the pathos, and I play with cliché and nostalgia and romanticism and all those things we rather like but don't want to admit to. You know, 'I rather love this Georgian teapot but I'd rather have it damaged because it's okay for me to like it then.' So it's my fear of the bourgeois, perhaps. There's definitely a thing about class but again it's a subtext, not the main issue.

Did you mean the viewer to walk through the piece? It's a very different experience being in it, negotiating the suspended discs and setting the wires trembling, from having to view it from the front like a tableau.

You used to be able to. When I first showed it at the Ikon there were 3 ft spaces between the discs; at the Serpentine in 1998 they were down to 2 ft but you could still walk through it; when it got reduced to 1 ft at the Tate, you couldn't. I was very unhappy when I realized they'd put barriers up, but they have these huge school groups going round and it's too hard to police: kids would get tangled up in the wires. I said, 'Well, if you have to have a barrier, have a fine cable so it doesn't interfere with the piece'. Usually I don't like barriers round anything.

There's been so much discussion of the role of the grid in twentieth-century art that I was intrigued to see it when I looked up. Of course it's implicit in the piece, in the 5 × 6 layout of regular units, but because you're suspending things, the grid becomes explicit when you look up. It both is and isn't part of the work. It's a support, an installing 'mechanism', and anathema to sculptural purists because it undermines the object's autonomy.

When I first suspended works at home I just screwed them straight into the ceiling, so I had hundreds of hooks in the ceiling. *Thirty Pieces of Silver* at the Ikon was the first piece for which I had to deal with a glass roof, and there was no way I could put hooks straight into that, so obviously I had to devise a structure that could hang from anywhere. I think that's the thing I'm least happy with – the structure on the ceiling. For the first sculpture I suspended, I actually started off with a blank sheet of paper on the ceiling. It came from a drawing, so I put my drawing paper on the ceiling and screwed screws into it and wires and the thing that hung from it was the drawing. The wires were the drawn lines.

Does it go dull? Does it have to be polished when it's out?

I like the idea, as long as it's up, that it should just tarnish. It's only ever been shown for a maximum of six weeks so far but the Tate are showing it for nine months, and when they asked me, I said that I was quite happy for it to go black. That's the material, that's what it does – it starts off really shiny and dulls with time and eventually goes black. I like this durational thing. It starts off beautiful and becomes ugly. Actually I like the tarnish more than the shininess.

54

3.2 Cornelia Parker, *Thirty Pieces of Silver*, 1988. Crushed silver plate suspended on wire, dimensions variable. Reproduced courtesy of the artist and the Frith Street Gallery, London.

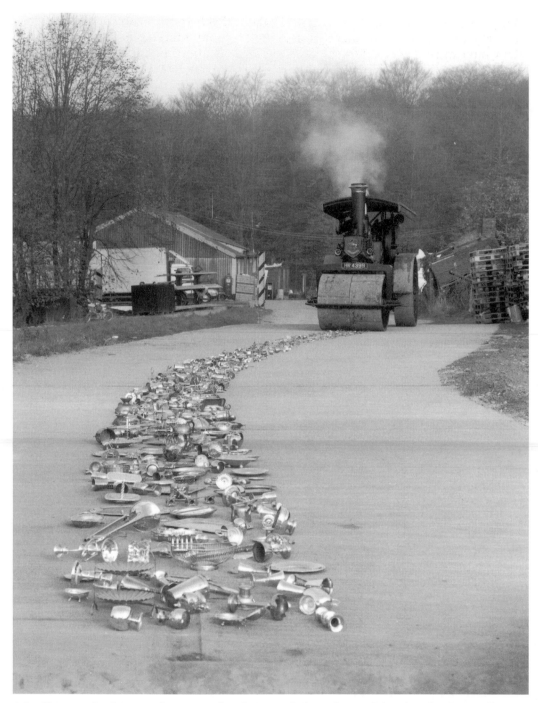

3.3 Photograph of soon-to-be-steamrollered pieces of silver plate, exhibited at the Ikon Gallery, Birmingham with Cornelia Parker's *Thirty Pieces of Silver*, 1988. Reproduced courtesy of the artist and the Frith Street Gallery, London.

But tarnish goes through ugly stages. It's about this betrayal of the materials. I'm not religious but I was brought up a Catholic, so my thinking is often peppered with biblical references. *Thirty Pieces of Silver* is about betrayal, about money and death and resurrection, so I've destroyed these objects and resurrected them and polished them up and then let them tarnish. They're suspended and they're 'in suspension'. They're ruined, but they're waiting to be reassessed in the light of their transformation. I like the complexity of that, the reverberations through the materials and the title and the simple layout of the piece. But I don't like dust collecting under it; the space has to be kept really clean.

You've made a number of works using tarnish and you've talked about it being the silver 'breathing'. It's very different from the idea of a patina on bronze, isn't it?

Tarnish is one of those things that doesn't have value, that people don't want and find ugly to look at, and so as a material I find it fascinating. It's somehow like the Turin Shroud: you've got this trace, or you've taken away this surface, this thing you don't want, and then you present the tarnish as almost the soul of the object. It's something I'm very drawn to. I did that piece called *Twenty Years of Tarnish (Wedding Presents)*. The wedding goblets were given to me to squash but they had this fantastic patina and I just felt, well, that it'd taken a long time to accrue, and it was just as important as the object it'd accrued on because it's sort of about neglect … Silver is just a wonderful material. I've got these little shavings, *The Negatives of Words*, which are sparkly, but they'll become tarnished, and then they'll be the tarnished negatives of words, which I think is even more eloquent. And then I've done silver things like *Measuring Liberty with a Dollar*, which was in a show touring America and I noticed that it had started to tarnish a bit, but I really like the idea of dollars tarnishing, of liberty tarnishing, because of the duality of idea and material. And I've collected tarnish on handkerchiefs in a series called *Stolen Thunder: Tarnish from Guy Fawkes' Lantern, Tarnish from Charles Dickens' Knife, Tarnish from the inside of Henry the Eighth's Armour* and so on. Rather than collecting the gloss of fame, I'm interested in collecting its shadow.

Cold Dark Matter: An Exploded View

LT: Cold Dark Matter *(plates 3.4 and 3.5) began with a garden shed, filled with the kinds of lumber that accumulates in sheds: gardening tools, a wheelbarrow, prams, walking sticks, old toys, sporting equipment, household objects exiled from the house – a mix of the outdoor and the washed-up – together with a volume of Proust's* Remembrance of Things Past *and an obscure memoir entitled* The Artist's Dilemma. *The shed was photographed at Chisenhale Gallery in the space where it would subsequently be reassembled, and then taken away to be blown up by the British Army School of Ammunition. The fragments were collected by a platoon of soldiers and returned to the gallery, where this*

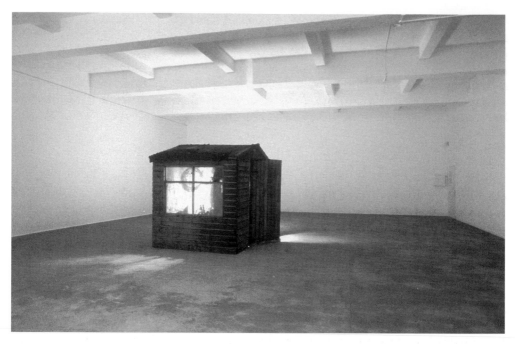

3.4 Cornelia Parker, *Cold Dark Matter: An Exploded View*, 1991. Garden shed and contents installed at Chisenhale Gallery before explosion. Photo reproduced courtesy of the artist and the Frith Street Gallery, London.

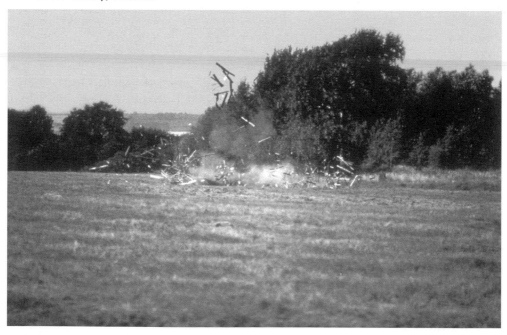

3.5 Cornelia Parker, *Cold Dark Matter: An Exploded View*, 1991. Garden shed and contents being exploded by the British Army. Photo reproduced courtesy of the artist and the Frith Street Gallery, London.

'embarrassment of dubious riches' was suspended around a 200 watt light bulb like 'a constellation of burnt-out stars, stray planets and dead asteroids.'[10] *(plate 3.6). The process of violent destruction and loving recreation, of chaos and contingency redeemed by order and necessity, is visibly present in the end result: a purposeful suspension of fragments, like a flashback or memory trace, projects an extraordinary play of shadows on the gallery walls and floor, such that the interplay of chance and necessity becomes one of the things the work's about.*

CP: It was about a lot of things. The work points out into the world, or inwards into your psyche, and I like to do both. The explosion might be looking at the universe, at the Big Bang, but it might also be looking into an inner psychological state. *Cold Dark Matter* is a scientific term for the material within the universe that we can't see and can't quantify, but it also means something psychological, something upsetting (as in 'what's the matter?'). So, cold dark matter is in the universe, but it's also in the mind.

It's an almost absurd literalization of the 'exploded view' that you find so often in old encyclopaedias, but it isn't explanatory, it's destructive, though it goes on to make something new and very beautiful out of the fragments.

I've always been fascinated by old encyclopaedias, with their exploded diagrams and confident explanations of how things work (electricity, weather, volcanoes, machinery, the cosmos), primates trudging up the evolutionary slope, the Statue of Liberty set for scale against Everest, that kind of thing.

The text is always patiently expository and the illustrations inadvertently surrealist.

With mysterious and ambiguous titles. Different associations converge. But the shed also represented the home. The project had to do with living in Leytonstone when houses were being knocked down to build the M11 link road, which made me think about transience and ephemerality. I really wanted them to blow up a house, but I felt that was going too far.

At Chisenhale the fragments still had the smell of the explosion on them. At the end of the exhibition they were taken down and, with nothing but the institutional record to identify them as 'art', stored in cardboard boxes under a stairway until taken in – given refuge and a permanent status as art – by the Tate collection.

What I love about it is that it's getting older. In a hundred years' time it will be a 112 year-old explosion. The Tate curators have talked to me about conservation and whether or not it's got woodworm. I love the idea that an explosion might have woodworm.

Both those pieces, Cold Dark Matter *and* Thirty Pieces of Silver, *are extraordinarily beautiful. Various critics have remarked on the violence of your*

processes – crushing, shooting, burning, exploding – and on the paradoxical grace and delicacy of the final work. But perhaps the work moves us precisely because of the way in which destructive impulses are succeeded by patient and loving reparation. Since, according to the psychoanalysis of Melanie Klein, we all go through infant phases of fantasized attack and remorseful reparation (and since, in the Kleinian view, reparation is the basis of artistic activity), the paradox isn't a paradox at all. Art is always making something out of nothing, of course, but there's a slapstick relish to the ways you make that 'nothing' in the first place, creating your materials out of the destruction of everyday objects. Employing army explosives experts or a vintage steamroller or the Victorian lifting mechanism in Tower Bridge is taking more than a sledgehammer to crack a nut. Tessa Adams has suggested that your work is exemplary in playing out the relations between destruction and reparation and that this has certain consequences for the viewer. It's exhilarating to identify with acts of destruction at a safe distance from guilt and harm, and it's gratifying to share in the fantasy in the process of reparation by which damage is made good.[11]

Well, it's certainly about resurrection. You have life and death and then resurrection. But Tessa was using the themes of my work in very particular ways as a model for her PhD in psychoanalysis. It's a model. But I don't want the work to be filled up with that. People might take it literally when it's not meant to be.

Though I have to say that I think Cold Dark Matter *and* Thirty Pieces of Silver *embody that Kleinian model incredibly well. There's a very snug fit, which is not to say that that's what they are, or all they are, as works of art.*

Well, I know. I'm always trying to put things back together again, giving things a second life. But I don't want it to be the heavy theorizing that everyone's drawn to, and from then on it's only interpreted in that way.

In a sense the final stage in the process, the public stage, is completed when viewers recognize damaged fragments as successfully transposed into a newly created whole, and when institutions frame and care for the work as art.

When the Tate bought *Thirty Pieces of Silver* they made this beautiful crate, in which every object had a little space cut out for it in foam, and they've got a special blanket to keep the tarnish at bay, which is fantastic but very funny when you think what the poor thing's been through.

This interest in transformation is at the heart of your work. Sometimes it's been understood in terms of psychoanalysis, as we've seen; sometimes in terms of a sculptural tradition that's primarily concerned with material process; and sometimes in terms of analogies from myth, religion and science. You've talked about the impact on you as a teenager of seeing Bernini's seventeenth-century Apollo and Daphne *in the Villa Borghese, Rome, a piece of gravity-defying, virtuoso carving capturing the moment of transformation from flesh to laurel.*

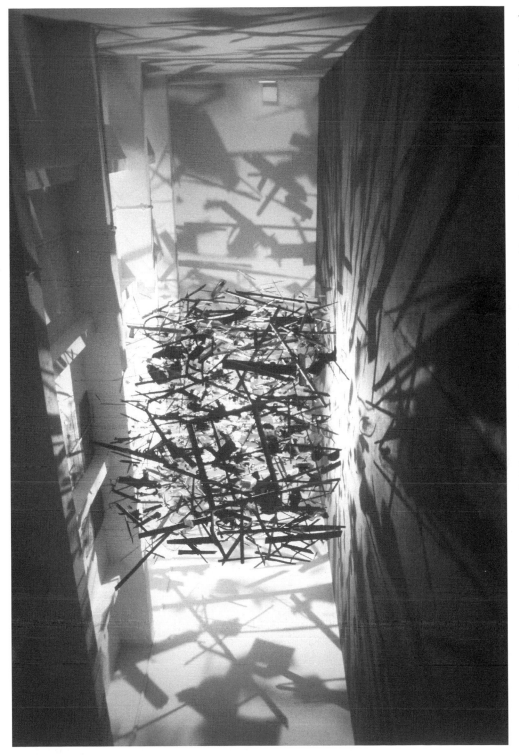

3.6 Cornelia Parker, *Cold Dark Matter: An Exploded View*, 1991. Garden shed and contents blown up for the artist by the British Army, the fragments suspended around a light bulb, dimensions variable. Photo reproduced courtesy of the artist and the Frith Street Gallery, London.

You were brought up a Catholic and you've often related your work to religious ideas of transubstantiation and resurrection, and specifically to relics, the affectively charged fragment that stands for the absent whole. You're fascinated by the provisional nature of matter, but when it comes to science, it's partly a sub-atomic physics of waves and particles that comes to mind, and partly a seventeenth-century moment when science, magic, alchemy and art were more closely entwined (so that Christopher Wren could be an astronomer and emerge as something like an empirical scientist as well as an architect).

I'm fascinated by that period of time, by those polymaths. I'm very jealous of it because people could have all these different lives, and now we're forced into specialisms, and that's why, even as an artist, I resist being forced into any category other than 'artist'. I'm not a painter or a sculptor or a conceptual artist or a word-and-image artist. Why do people have to invent categories? I've always resisted that. I enjoy making art because I can do a residency at the Science Museum or visit churches or argue with NASA; I can draw from all kinds of sources and not be an expert in any of them. I've too grasshopperish a mind to be an expert at anything but I can touch on lots of things and make something that might be a little nugget or amalgam of those things as a way of understanding the world.

Well, I learned about fulgurite from you. It seems such a wonderful metaphor for what you do, which is to have an idea strike and take form, but then to détourn it – just twist it slightly – so that it's no longer as neatly nested in its associations or function. Minimal intervention, maximum metaphoric richness.

What you get with fulgurite is a piece of glass. Lightning strikes the sand in the desert, creating a piece of glass that's a cast of the shaft of lightning, and it's a really lovely thing. It's a fusion, a record of the expended energy. It takes a split second to make, and this violent event produces this beautiful filigree object, a little spine of glass like vertebrae or a sea urchin. Usually no one knows it's there; it's just buried. I looked at fulgurites in the Natural History Museum because of a piece of work I wanted to make with sandcastles and lightning. Time … I like time as a material. To watch a line form on your forehead takes a long time, that's incremental. It's incremental things that excite me.

There's also the forensic, which is the trace taken out of time, to which great weight is attached, like the feathers from the pillow on Freud's couch, or the micro-photographs of Einstein's equations.[12] It's about finding materials and processes that will work absolutely at the same moment in formal and cognitive terms.

Yes. Take the formal arrangement of *The Negatives of Words*.[13] I asked this engraver to save his silver for me, and originally, when I got them – these tendrils of silver swarf – I was thinking I could lay them all out, like an alphabet, but I found that too contrived, and in the end I just put them in a little pile. But it's curious all the ways I thought of arranging them. If I were to lay them out

individually, each one would have its own shape and space, but that would be a different kind of piece. I wanted something that looked as though it took a split second to put down, which was the opposite of how laboriously they'd been made, as the negatives of something considered, even monumental. In projecting the *Feather from Freud's Pillow* I was interested in the idea of finding a tiny bit of forensic information, a little piece of dust or fibre or feather that I could trap in a glass slide and project.[14] You adjust the projector so that the light is refracted around the object rather than projected through it. It's like standing inside an electron microscope. You can inhabit the space of a little bit of fibre from Freud's couch stretching across a room. This feather has heard as much as Freud has. It's heard stories that would make your hair curl: so it's this combination of what the material is; how you arrange it formally; what sensations you have; what title you give it.

Is there anything specific you'd like to say about your use of titles? They play a very important part in the work, don't they, condensing or displacing the associations of particular objects and materials, setting up chains of thought?

I use found objects and I very often use found titles. *The Earth's Grip on All of Us* and *Matter and What it Means*: these come from chapter headings in old encyclopaedias. *Neither From Nor Towards* is from *Burnt Norton*: T.S. Eliot is a writer I love and plunder for titles. Sometimes I use the same ones over and over again (*Another Matter, Avoided Object*). I like puns (*Mass*, for example, the charcoal piece made from the remnants of a church struck by lightning). I write phrases and things in sketch books rather than drawing. Words are just another material – like found objects. And materials have histories of discovery and use. Of course it's very strange when you show work abroad and they translate the titles underneath. Some things are just not translatable, and maybe the puns don't work in another language. But it's important that an audience has the gist of what's there and what the material is, so usually there's a reference to process in the title. That's what I'm really interested in. Process is what excites me.

Do you think this interest in unusual processes (shooting, exploding, crushing, drawing wedding rings and teaspoons into fine wire), together with the collaborations it requires (the British army, Hatton Garden silver engravers, the Freud Museum, Colt Firearms, NASA), and your interest in everyday objects and waste products as raw materials, is linked to an ambivalence about sculptural technique?

There was a tyranny of technique in sculpture when I was at college, and I bypassed that by doing painting for the first half of my degree. I just felt there was an awful lot of incidental technique out there in the world – you know, buses going over melted tarmac and making a mark, that sort of thing – and I just wanted to trap or harness that. In a way it was really liberating because I couldn't carve and I couldn't model and I couldn't cast.

Did you try any of these things?

I was very interested in casting. I was making some Bruce Nauman- or Rachel Whiteread-like pieces, casting underneath floorboards, that sort of thing – the rougher the better, digging a hole and casting the hole. It was anti-technique.[15] Then I bought a lead soldier casting kit and used it to make casts of my collection of architectural souvenirs, and I was very bad at it, so I produced successively degraded casts. Squashing and throwing things off cliffs was an extension of that because I was always damaging things by mistake anyway so I thought I'd make a feature of it. I'm quite a clumsy person and to make things that were perfect was hard so I went the opposite way. It was very liberating to be about the opposite of perfection. I'm much more interested in a broken string of pearls than in a pearl necklace. If the pearls are intact you know exactly what sequence they're going to be in and what they signify, but if they're broken they've got potential. Something that's damaged is freed up for work; you can do something with it; it's been liberated from its *track*.

In Suit, Shot by a Pearl Necklace *(1995), the companion-piece to* Dress, Shot with Small Change (Contents of a Pocket) *(1995), you used pearls as bullets.*

I'm very interested in the pearl necklace, a bit like the silver. I was round the back of the Aldwych the other day, where the Inns of Court are, and there are these shops that sell pearl necklaces for lady barristers to wear. Pearls are clichéd, a common currency.[16] I like this idea of the pearl necklace being a very sweet, benign thing that becomes malign when you use the pearls as missiles shot through a gun that could kill someone.[17] I looked at hundreds of second-hand suits and hundreds of dresses for that piece. It's very hard to find the archetypal suit and the archetypal dress because you have a picture in your head of what it should look like and it's hard to get something that fits, but the pearls and the money, I like those because they're clichés.

It's Mummy and Daddy isn't it?

Yes, perhaps. Though it's less that for me. My mother never wore pearls and my father would never wear a suit. It's more to do with power. Pearls and money are about power and respectability. But I like using all these little things that are somehow clichéd and therefore they're bound to be about class and gender. When I made the piece called *Shared Fate*, using the guillotine from Madame Tussaud's, I used a tie and a loaf of bread and a newspaper and some cards, and I heard this group of German collectors going round the Serpentine Gallery saying, 'This is obviously anti-men, a symbolic castration' – well, it's one interpretation, but it certainly wasn't what I was thinking of. Actually I tried out lots of things but the guillotine wouldn't chop half of them. It's pretty blunt.

The Maybe

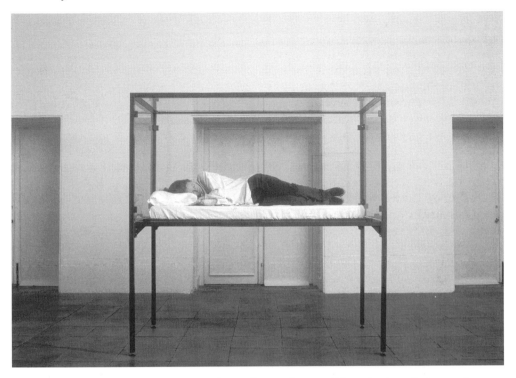

3.7 Cornelia Parker – Tilda Swinton, from *The Maybe*, a collaborative installation at the Serpentine Gallery, London, 1995. Photo reproduced courtesy of the artists and the Frith Street Gallery, London.

LT: *In 1995 you collaborated with the actress Tilda Swinton on a performance and installation for the Serpentine Gallery. For seven days Swinton lay asleep in a glass case in the central gallery (plate 3.7). In the surrounding rooms a variety of objects were installed in a series of vitrines: a fragment of the aircraft in which Charles Lindbergh crossed the Atlantic; the quill with which Dickens wrote* Edwin Drood; *Lord Nelson's cutlery; Michael Faraday's spark apparatus; Charles Babbage's brain; John Wesley's spur; Queen Victoria's stocking; Wallis Simpson's ice skates; Winston Churchill's cigar stub; the piece of tapestry worked by Edith Cavell before her execution; the rug and pillow from Freud's analytic couch; Wilfred Owen's manuscript poem 'Strange Meeting'.*

Here was a heterogeneous collection of apparently nondescript objects given resonance and meaning by your labels (deliberately placed a little distance away). And here was a series of chance encounters, imaginary encounters between the ghosts of the past and encounters with the dead in the minds of the living. As Guy Brett put it, the trigger wasn't simply the material object but the object and label together: a 'strange alchemy' which showed how the artist, 'by interference in the material world, also interferes in mental structures'.[18]

65

CP: Tilda had an idea to do a performance where she slept as a Snow White character – a fictional character – but through our collaboration it changed to her sleeping as herself.[19] The label on her case read 'Matilda Swinton (1960 –)'. Some people thought she was an imposter or a waxwork but she was really 'there', as a non-performing performer, a sort of absent presence. I created an installation around her in the form of a reliquary. Some of the items looked very inconsequential, so that people would walk past, find out what something was, and go back saying, 'Oh God, is that really the quill with which Charles Dickens wrote his last novel?' I was trying to make, with the work, a representation of how you feel about the ephemerality of life.

You selected the objects from various museums and they became eloquent stand-ins for figures and moments from the past (as long as the viewer did the necessary imaginative work, they were ripe for projection). This didn't involve the violent preliminaries of Thirty Pieces of Silver *or* Cold Dark Matter.

Previously I'd placed a history on the object. I'd steam-rollered it or thrown it off a cliff. In *The Maybe* the history of the object had been conferred by someone else, and my role was to isolate these objects and put them together like sculptural material. By placing Queen Victoria's stocking next to Wesley's spurs, you could imagine the darned hole having been made by the spur. Faraday's spark apparatus placed beside Babbage's brain hints at a Frankenstein monster. I liked playing around with these little histories. I wanted to breathe new life into these objects by their juxtaposition and their relation to Tilda, living and breathing only a few inches away. I was interested in an orchestration of objects, in the sense that each object is itself, its own sound, but that all the objects together create something larger than the sum of the parts.

Tilda's living presence enhanced the pathos and frailty of the objects. Perhaps she dreamed them, or dreamed the narratives of the past in which they'd had a functioning place. It was very unsettling looking at her. You couldn't look at her as an exhibit: she was a human being. But you couldn't look at her as a human being without feeling guilty. This was an art gallery. We were licensed to look. But she couldn't look back and sleeping is private: the simplest involuntary movements cast us as uneasy voyeurs (voyeurs who would also be outlived by our possessions). Some visitors were apparently incensed that the 'star' of the show was not performing, was doing nothing, but sleeping is not really doing nothing. Brett quotes Heraclitus: 'Men asleep are labourers and co-workers in what takes place in the world'; and you've been quoted as saying that it's often when you close your eyes that your real work gets done.[20] Perhaps the objects are sleeping too, co-workers in our imaginative landscapes, so that a museum is more a machine for memory and reverie than a mausoleum.

Tilda stood in for everyone; she was still alive, like us, where all the other objects belonged to dead people. She was curiously absent but we all are for

eight hours out of every twenty-four. We spend a lot of our lives asleep and I wanted to create a monument to that, but people don't think it's important somehow, that it's just wasted time, another thing that's discarded.

It seems to me that for a long time the more ambitious pieces, although they're not traditional sculptures, have needed the traditional gallery setting. It's the visual and institutional context of the gallery that frames 'actual things' (however richly associative) as items to contemplate.[21]

Well I do love the white space, though for years I made site-specific work which doesn't often get reproduced.

Several of your works – and you're not alone in this – offer, on one level, a quite self-conscious reprise of twentieth-century modernism, and this backward glance, this wry homage, invokes another kind of framing for work in the present.[22] Cold Dark Matter *can look like an abstract expressionist drawing - Hartung, say;* Room for Margins *(the Turner canvas linings) look like Rothko;* Mammoth Hair Drawing *or* Exhaled Blanket *look a bit like Cy Twombly or Jackson Pollock – that common metaphorical reference to Pollock's 'skeins of paint' collapsed and literalized in threads. And then the* Pornographic Drawings, *perhaps because you selected the ones that looked fairly biomorphic, are rather reminiscent of Georgia O'Keeffe, or at least of that kind of sexual and reproductive imagery. And I wondered if you had any conscious sense of redigesting this material, because there seems to be a strand here that's to do with recapitulating the modernist icons of the recent past.*[23]

Well, I do nod to all these people. *Mass* is an even more abstract image than *Cold Dark Matter* (which looks like that in a photograph, rather than in the flesh). The black charcoal against a white ground is very much like an abstract expressionist work and it's even been shown in a painting show at Site Santa Fe. Most of my works are drawings in a way. The blank sheet of paper is the room.

Also you've made works called Black Abstract *and* White Abstract *and* The Fly that died on Donald Judd, *so there's a kind of teasing flirtation with the modernist tradition.*[24]

It's a bit of a joke really because they're loaded material, they're not abstract at all. They're as literal as you can get. I deliberately demystify what my materials are. They are what they are what they are. If you want it to be abstract, then it's abstract; it's there for you to hang your hat on – but I play with the whole thing about abstraction and representation because I love that slippage: that a tangle of wire is an abstraction, like a drawing, but really it's a teaspoon that's been 'drawn' to the height of Niagara Falls. Because I've had an art background I can't pretend that I'm a naïve artist and so I do make the nods to Rothko or Abstract Expressionism but it's almost incidental, you know. I see it there, so when I was in the Tate Conservation Department and saw those canvas linings I thought they looked a bit like Rothkos and chose to present them in that way.

But it's still a subtext. It's not the main agenda. It's a kind of playfulness with the associations.

There's also been a lot of discussion of the viewer in relation to installations. You've talked about the viewer expending a 'strenuous dispersal of mental energy'. Is it important to you that an installation usually produces a rather different experience for the viewer, one that's been seen either as more phenomenological or more 'cinematic', that requires a viewer, as Alex Potts puts it, to move between focused and diffused attention? And is viewing the smaller works, like Avoided Objects, *different from experiencing the larger installations?*[25]

I suppose the small works are less 'visual' but they're usually grouped together in a kind of flexible installation. You experience the larger suspended work much more physically, whereas, with the small works, it's a more mental, interior thing. I always describe it as the difference between extrovert and introvert. Sometimes you want to shout out loud, make a dramatic statement, and sometimes you want to whisper. It's like going to a very loud concert or reading a book. For years I was just making the large-scale works and that's what people wanted and expected, and I got frustrated because I found there were small, intimate things which kept getting sidelined.[26] People were always presenting me with large spaces, which was great, but it wasn't always what I wanted to be doing. From each piece I felt there was a kind of fall-out, a debris or residue, that wasn't being picked up.

In either case, with the installations or smaller works like Avoided Objects, *we're presented with a relation between materials, processes and cognitive affect. The object is made and unmade, materially and semantically. The consequence is that however else we're placed, whatever the personal meanings we bring to the work, it puts us in an emotional space between chaos and cohesion, destruction and (temporary) resolution, death and life, but life with the caveat that matter forms and disperses, that ashes return to ashes and dust to dust.*

I like gravity, because gravity keeps us on the surface of the earth. Without gravity we'd fly into space. We always have this tense relationship with the surface of the earth; we stand on it till we die, and then we're somehow inhaled back into it as dust. My work deals with ambivalence, with opposites, with inhaling and exhaling, with things disintegrating and reforming, with killing things off, as if they existed in cartoons, and then resurrecting them, so that one set of references replaces another.

The last thing I wanted to ask you about was motherhood. Blue Shift *(plate 3.8) coincided with the arrival of Lily Pearl Parker Moriarty McMillan. I wondered if that had changed anything. This must seem a stupid question because, of course, having a child changes everything, but I was thinking particularly of the themes in your work, and of your sense of your relation to the earth as very*

3.8 Cornelia Parker, *Blue Shift*, 2001.
Cotton nightgown worn by Mia Farrow in
Roman Polanski's *Rosemary's Baby* (1968).
Photo reproduced courtesy of the artist and
the Frith Street Gallery, London.

transitory. Our lives are still our lives and they still end, but once you have a
child there's an expectation that they'll survive you. You've made something out
of nothing, you and Jeff.

Grown from seed, just like something at the market garden. I didn't think I was
going to have children, and I had this huge schedule of work already in place
that went on right up until she was born. So there was a huge amount of stress,
and the first few months are very chemically challenging. When I was pregnant I
bought the shift that Mia Farrow wears in *Rosemary's Baby*. It's a very clever
film: she could be giving birth to the devil or just being hormonal. It could be in
her mind. It's a psychological thriller rather than a horror film. In a way I was
obviously dealing with my own anxiety about being pregnant, but it was also
typical of me to go and buy this nightgown because I was doing a show in Turin.
I saw the shift and its sweat stains as the inverse of the Turin Shroud: the
opposite of the Immaculate Conception, a rape that ends with the birth of the
devil. There was also a sound piece in the show that incorporated a real
recording of poltergeist activity: slippers being thrown and stones falling and in

between a girl was crying. I had a photograph of all the objects and the pink slipper on the wall. And there was a silver jug I'd thrown in anger and damaged a few years earlier. So the whole show together – the nightgown behind perspex, illuminated from behind so that it was quite ghostly – produced quite a spooky atmosphere. It was a pretty hormonally challenged show.

I'm sure my work's going to change formally, just because my time will be more limited. At the moment I just want to get on and make some work, something physical – not necessarily large-scale installations but something that's less interior, as it were. The trouble with installations is that they're very labour intensive. A museum may take care of it but otherwise I have to remake a work each time it goes up, and I don't always want to be putting up work I made ten years ago. I want to make new work. The trouble with suspended work is its physicality. It just requires all this hard labour, it's like the seasons again, it's like planting vegetables: you have to start again from scratch.

Someone once asked you if success was a burden and you said 'maybe a bit', thinking of the temptations of richer materials. Do you think it's been invigorating in other respects.

Well, yes, although I never used to think about it until I had a car accident in 1994. I was in hospital for months with a broken pelvis and up to that point I had no interest in commercial galleries or even in the longevity of my work. I preferred to teach and make my work and not be worried by market forces. Until I was shortlisted for the Turner Prize I wasn't represented by a gallery. It was my own choice, but it became untenable. Being nominated for the Turner Prize made a huge difference. Now I'm very pleased that I can afford to have time off to have a daughter and in the end collectors are custodians of your work. They're a very important part of the whole ecosystem. So no, I haven't got any problem with success: it's great.

I felt very much before I had children that time was like a bolt of cloth. There might be more or less of it but it had an even consistency, whereas once I had children time was like an unpicked garment. You had to think, 'Well, this is a sleeve, what can I do with a sleeve?' Or, 'This is a bigger bit, this is a morning, a bit that goes right across the shoulders, I might be able to do something with this.' I can really only grasp something between 10 am and 1 pm, although I can read a book that's not too demanding after 6 pm.

I'm very much like that. At the moment I feel as though I'm talking a lot about work rather than making it, which is frustrating.

But don't you think these moments are often quite fertile, in ways one doesn't necessarily understand at the time? I don't know whether the car crash was like that for you, but things that actually knock you sideways, that come out of left field, are sometimes quite productive in prodding a reassessment of the path one was treading.

Well, I hope so. Necessity is the mother of invention, which is why I'm trying to be a bit more brutal with my time. In the end you really want the work to be able to say things for you. You'd like the work to be your voice.[27]

Lisa Tickner
Middlesex University

Notes

Thanks are due to the artist for her time and her willingness to engage in conversation about her work, and to the Frith Street Gallery, London, for help with the illustrations.

1 This is an edited version of a conversation that took place in February 2002. It focuses inevitably on a limited number of works, and readers are referred to recent catalogues for further information and colour reproductions. These include *Cornelia Parker: Avoided Object,* Cardiff: Chapter, 5 October–24 November 1996; *Cornelia Parker*, Boston: The Institute Of Contemporary Art, 2 February–9 April, 2000; *Cornelia Parker*, Serpentine Gallery, London. 11 May–14 June 1998; *Cornelia Parker*, Torina: Galleria Civica d'Arte Moderna e Contemporanea, 28 April–17 June 2001. I am especially grateful to Vanda Wilkinson at the Ruskin School of Fine Art for a copy of the Serpentine Gallery catalogue (now very elusive).

2 'You cannot dig a hole in a different place by digging the same hole deeper. Vertical thinking is used to dig the same hole deeper. Lateral thinking is used to dig a hole in a different place': Edward de Bono, *Lateral Thinking: A Textbook of Creativity* (1970), London, 1990, p. 12. Looking at *Lateral Thinking* again, I could see its relevance to Parker's fondness for the knight's move, and to the condensed, subversive, associative poetry of her work. For de Bono, insight, humour and creativity are linked in the necessary restructuring of fixed and rigid patterns of thought (p. 10). Lateral thinking enhances the effectiveness of vertical thinking. '*Vertical thinking is selective, lateral thinking is generative.* Rightness is what matters in vertical thinking. Richness is what matters in lateral thinking.' (p. 37) He proposes a new word, PO, to counter 'no' and as 'a laxative to relax the rigidity of a particular way of looking at things' (pp. 211–19). The implication is that this is one of the things that art's for. PO has affinities with poetry, 'where words are used not so much for their own meaning as for their stimulating effect' (p. 215). In the case of Parker, everyday objects are used not so much for their function as for their stimulating affect (their 'meanings' derive from both these things). Parker talks of 'cross-pollinating objects'. Her materials are simultaneously physical and semiotic, as art's materials generally are, but manipulated in ways that prompt us to recognize the fact, and to extend our own capacities for insight, humour and lateral thinking.

3 Work by sculptors such as Cragg, Wentworth and Bill Woodrow combined found objects with conceptual titles. It was visibly different in material and technique from Moore's cast bronzes or Caro's welded steel, and it opened out onto social and political issues largely ignored in postwar British sculpture. It was sculptural rather than conceptual, but it registered the impact of art's 'linguistic turn' and the dematerialization of the object evident from the late 1960s onwards.

4 *Untitled (One Hundred Spaces)*, 1995, consists of one hundred resin units. I explore this work in 'Mediating Generation: the Mother–Daughter plot', *Art History*, vol. 25, no. 1, February 2002, pp. 23–46.

5 *Breathless (Fanfare)* was commissioned by the Victoria and Albert Museum as a permanent installation in its new British Galleries. In some ways a reprise of *Thirty Pieces of Silver*, it consists of silver-plated brass-band instruments crushed by the lifting machinery of Tower Bridge (an exemplary piece of Victorian engineering). The work is suspended between two floors so that the viewer looks down on a fanfare of silvery instruments from above, and up at their tarnished underbellies, silhouetted against the ceiling, from below.

6 Antonia Payne, 'Neither From Nor Towards', in *Cornelia Parker: Avoided Object*, exhib cat., Cardiff, 1996, pp. 39-50 (quotation on p. 39); Anne Bourbeau, 'Cornelia Parker: The Arts Club of Chicago', *New Art Examiner*, vol. 28, no. 2, October 2000, pp. 54-5 (quotation p. 55).

7 Alan Bennett, 'An Ideal Home', in *Telling Tales*, London, BBC Worldwide, 2000, p. 37.

8 Nancy Princenthal, 'Cornelia Parker: The Dream Life of Objects', *Art in America*, September 2000, pp. 113–16, p. 115: 'An image of squandered wealth and utility, *Thirty Pieces of Silver* is nonetheless tantalizing, as of a banquet of riches sequestered, but also polished, by memory.'

9 As originally installed in the Ikon Gallery in 1988, *Thirty Pieces of Silver* included a photograph of the steamroller, bringing forward what writers call the

'back story' and keeping in view a performative element in the work. Parker sees this image as 'optional' and it was not included in the installation at Tate Britain in 2002. The Ikon also exhibited twelve pairs of 'before' and 'after' images of items that had been crushed.

10 Adrian Searle in *Cornelia Parker: Cold Dark Matter: An Exploded View*, exhib. cat., London: Chisenhale Gallery, 18 September–27 October 1991, n.p. The catalogue contains photographs of the actual explosion and its effects on a few individual items as well as an installation shot. It also carries a discreet acknowledgement: 'Garden Shed supplied by Skindles, Woodbridge.' (Parker had earlier intended to blow up the furniture, cutlery and crockery of a dinner setting.)

11 Tessa Adams, 'Cornelia Parker: the Enactment of Destruction and Restitution', in *Art and Psycho-analysis*, special issue of *Issues in Architecture and Design*, vol. 4, no.1, 1995, pp. 30–50. Adams points out that in both these pieces Parker enacts violence vicariously: 'it is as if she called upon this patriarchal force … to become the agent of her phantasized attack on the "maternal body".' (p. 35) And she makes a further distinction. In her view the destructive impetus of the 'paranoid-schizoid position' is stronger in *Cold Dark Matter*, whereas the reparative impetus of the 'depressive position' is more evident in *Thirty Pieces of Silver*. The later work plumbs earlier, more 'primitive' depths of subject formation. Adams sees this pull between the split, paranoid-schizoid state and the integrative-reparative dynamic as evident in the titles them-selves, *Cold Dark Matter* invoking the non-body, or the dead body, and *Thirty Pieces of Silver* (through a Christian narrative), the body's salvation. For further discussion of contemporary women's work from a Kleinian perspective, see Mignon Nixon, 'Bad Enough Mother', *October*, no.71, Winter 1995, pp. 70–92. And for a rather different framing of Parker's work in relation to the sublime, see Paul Crowther, 'The Postmodern Sublime: Installation and Assemblage Art', *Art and Design*, vol. 10, January/February 1995, pp. 8–17. *Cold Dark Matter* might seem to approximate to Edmund Burke's existential sublime, invoking a kind of delighted horror, but Crowther is interested in Parker's work in relation to the Kantian sublime, which, in his view, 'hinges on a relation between perceptual and imaginative excess and rational containment' (p. 11).

12 *Einstein's Abstracts* (1999), photo-micrographs of the blackboard covered with Einstein's equations from his Oxford lecture on the theory of relativity, 1931, reproduced in *Cornelia Parker*, exhib. cat., Boston: the Institute Of Contemporary Art, 2 February–9 April 2000. On the forensic trace (which is different from the relic) and the viewer–detective, see Peter Wollen's essay 'Vectors of Melancholy' in *Scene of the Crime*, exhib. cat., ed. Ralph Rugoff, Los Angeles: Armand Hammer Museum and Cultural Center, in association with

MIT Press, Cambridge, Mass., 1997, pp. 23–36. Wollen discusses a new connoisseurship requiring 'an acute sensitivity to the trite, the futile, the banal, and the insignificant' arising out of conceptual art and the documentation of early performances (p. 32). I owe this reference to my colleague, Jon Bird. Parker draws implicitly on both the relic and the forensic trace. Both are indexical and metony-mic (contiguous parts standing for wholes). Both invite projection. Both can be 'utterly mundane and yet charged with a surplus meaning that eludes our visual inspection and so seems vaguely uncanny' (Ralph Rugoff, 'More Than Meets the Eye', in *Scene of the Crime*, p. 82). But relics require veneration and emulation where traces require deciphering; relics are mystical, traces are physical; relics (there are exceptions) summon exemplary individuals, traces promise the means of unravelling past events.

13 *The Negatives of Words* (1996) is a piece using swarf produced by the engraving of com-memorative silver. It is reproduced in *Cornelia Parker*, exhib. cat., Torino, 2001.

14 *Feather from Freud's Pillow* (1996) is reproduced in *Cornelia Parker: Avoided Object*, exhib. cat., Cardiff, 1996.

15 Both flattening (Parker) and casting (Whiteread) are forms of anti-technique, in the sense that each process is apparently mechanical rather than idiosyncratically expressive. Both produce some form of 'Other' to an originating object by working, physically, from it or on it. In each case one of the things that the work requires of a viewer is the ability to respond to its present appearance as (the visual embodiment of) the consequence of its history. This is made explicit in *Lost Volume: A Catalogue of Disasters*, an artist's book by Parker, with photographs by Edward Woodman (London, 1993). There is no text. The book consists of photographs of a series of flattened objects, some more legible than others. Two pages at the back, headed 'Contents', contain photographs of the eighteen objects in their original state – and in a different order – inviting us to turn back and match the trophy, bugle, light bulb, pastry, starfish, teaspoon etc. to their flattened selves.

16 The cultivation and then the (glass or plastic) imitation of pearls has destroyed their aspirational value. They retain only a shadow of their earlier association to middle-class, ladylike femininity (twinset and pearls) – enough to ensure their respectability in some quarters and their ironic deployment in others.

17 Parker was actually inspired by the Jacobean playwright John Webster, author of *The Duchess of Malfi* ('What would it pleasure me to have my throat cut/With diamonds?'). But the conceit of *Suit Shot by…* and *Dress, Shot with…* is also Surrealist in its poetic concision and perversity. Christopher Stocks describes Parker as 'Surrealist with a Catholic twist' in 'Unholy Relics', *Modern Painters*, Winter 2001, pp. 32–5 (quotation p. 32).

18 Guy Brett, 'The Maybe', in *Cornelia Parker: Avoided Object*, exhib. cat., Cardiff, 5 October–24 November 1996, pp. 11-20 (p.12). The objects, contiguous with their original owners, become indexical signifiers. Churchill is summoned up by his cigar. But what is really triggered is what we already know or think about Churchill. The sense of contact is an illusion, the objects not so much 'silent witnesses' as the mute recipients of our own projections. Jane Beckett has pointed out that 'In loosening both the apparently familiar figures and the historical figures [who once might have owned them] from the secure ground of recognition, *The Maybe* suggested the precariousness of historical survival as well as the pluralities and insecurities entailed in the processes of historical interpretation.' 'History(Maybe)' *History: the Mag collection*, Hull, 1997, p. 141.

19 Tilda Swinton described *The Maybe* in an interview published in *Creative Camera*, August–September 1995, p. 50. 'The installation will consist of a series of glass cases in which there are a series of objects, and I will be one of these objects… I shall be there as myself and not in any kind of performance mode… [the piece is] about the way in which we as spectators project a kind of authority onto any object with a frame around it.' 'One is going to build a reliquary in essence. A question that we're posing is how much of a relic is a human being?… It's called *The Maybe* because it's not about anything absolute. You can say "I saw Nelson's cutlery set and it looked like this", but how one describes a human being is a mystery to me.' For a deconstructive analysis of 'presence' in this and other installations, see Deborah Cherry, 'Troubling Presence: Body, Sound and Space in Installation Art of the mid-1990s', *Revue d'Art Canadienne* (RACAR), 1998 [2001], vol. 25, 1–2, pp. 12–30.

20 Guy Brett, 'The Maybe', pp. 11–20 (p. 15).

21 Several critics have commented on Parker's affection for the museum format, while observing that her use of objects, labels and vitrines has more in common with the model of traditional ethnographic and natural history collections than with art museums. Lisa Corrin points out that it harks back to the seventeenth-century Wunderkammer, or cabinet of curiosities, not just in terms of layout, but because Parker is interested in the 'rhizomic' associations stimulated by heterogeneous collections of objects before modern disciplinary taxonomies were set in place. Lisa Corrin, 'Up, Down, Charm, Strange (Truth and Beauty)', an interview with the artist in *Cornelia Parker,* exhib cat., London, 1998, n.p. Parker remarked in the course of our conversation that, 'It's hard to curate me, because I have to curate my own work really.'

22 Parker made a conscious move away from abstraction to the use of everyday objects when she came to London in 1984.

23 *Room for Margins* (1998) exemplifies Parker's fascination with traces and her capacity to turn 'the things round the edges' to the centre of our attention. Turner lined his canvases, and Parker discovered these linings in the conservation department at Tate Britain. They bear the shadowy imprint of wooden stretchers and the marks of hanging for decades against a wall (two are reproduced in *Cornelia Parker*, exhib. cat., Torino, 2001). Returned to Tate Britain, they've been promoted to the collection as works by Cornelia Parker (catalogued, for example, as 'from Room for Margins, From "Rough Sea" circa 1840–5. JMW Turner, N05479, Tate Collection (1998) T07641'). *Exhaled Blanket* (1996, dust and fibres from Freud's couch, trapped in a glass slide and projected) and selected *Pornographic Drawings* (1997, ink made from dissolving pornographic videotape confiscated by HM Customs & Excise in solvent) are reproduced in *Cornelia Parker*, exhib. cat., Boston, 2000.

24 All reproduced in *Cornelia Parker,* exhib. cat., Torino, 2001.

25 For recent discussions of installation art, see *On Installation*, the special issue of *Oxford Art Journal*, vol. 24, no. 2, 2001, and in particular two essays: Alex Potts, 'Installation and Sculpture', pp. 5–24 and Briony Fer, 'The Somnambulist's Story: Installation and the Tableau', pp. 75-92. Potts discusses the 'cinematic' spectator on pp. 17-19: 'Distinctively cinematic resources can be seen to have shaped alternatives to the relatively distanced viewing of a stable, self-contained object, the image view privileged by photography.' (p. 18) There is relevant material in the whole volume although Parker's work is not included. Had it been, I imagine that it would have been gathered into Benjamin Buchloh's complaint, that artists such as Rachel Whiteread and Kiki Smith have imbued the phenomenology informing 'much of the best of Minimal and Post-Minimal sculpture' with 'a retrograde appeal of figuration and literariness'. Eva Hesse is included with the Post-Minimalists, but this still seems to risk bracketing out the women in advancing the work of a man who compiles everyday objects in studiedly informal 'altars' and 'pavilions' characteristic of some modes of early feminist art.

26 In a different metaphor, Jane Burton suggests that the 'allusive smaller works stand in opposition to the dramatic larger installations like haikus to sonnets' in 'Exploding on the Scene', *Art News*, vol. 98, part 2, February 1999, pp. 104–106 (quotation from p. 106).

27 Robert Frost, asked what one of his poems meant, is said to have replied, 'You want me to say it *worse*?' I take this from Denise Riley's elegant book, *The Words of Selves: Identification, Solidarity, Irony*, Stanford, 2000, p.18.

4

Antibodies: Rachel Whiteread's *Water Tower*

Sue Malvern

Shortly after she arrived in New York in 1938, Louise Bourgeois made several sculptures on the roof of her apartment block, from the soft cedar wood planks left over from roof-top water towers. Nine years later she wrote *The Puritan*, a story about a man who is so frightened by his love that he disappears. Eventually published in 1990, *The Puritan* begins: 'Do you know the New York sky? You should, it is supposed to be known. It is outstanding. It is a serious thing.' Compared to the Paris sky, which is unreliable and imperfect, damp, grey and contradictory, she describes the New York sky as 'blue, utterly blue', strong and healthy, pure and beautiful.[1]

A more recent project which also brings the skies of New York City into view is Rachel Whiteread's *Water Tower*, commissioned by the Public Art Fund in 1994 and installed on a rooftop in SoHo, New York in 1998 (plate 4.1). When Robert Storr wrote an extended review of the project for *Art in America*, entitled 'Remains of the Day', he remembered the early cedar wood sculptures by Bourgeois, although not *The Puritan*. He saw a connection between the two artists as a consequence of their outsider status.[2] They had both noticed what inhabitants of the city habitually overlook. A similar idea motivates Molly Nesbit's essay, intriguingly entitled 'The Immigrant' and published in the book of the Whiteread project, *Looking Up*. She writes, 'Foreigners have often seen New York's surfaces better. They have the advantage of seeing them afresh.'[3] It seems that, for the native, Whiteread's *Water Tower* has defamiliarized a commonplace object on the New York skyline, bringing it into vision and making it strange.

At first glance, however, *Water Tower*, which was sited on the roof of a seven-storey block on Grand Street for just over a year, looks like a radical departure from Whiteread's customary work. Although it is a cast, taken from the interior of one of New York's ubiquitous and unique water towers, placed on a rooftop against the sky, this work does not, at first glance, index those bodily, domestic and even abject objects for which she is known. *Water Tower* does not fit the Whiteread catalogue of wardrobe, hot-water bottle, mattress, bath or sarcophagus, mortician's slab, table, chair, sub-floor or larger space such as room, house or, in the case of the *Judenplatz Memorial*, 2000, library or bookshelf.[4] Unlike these other objects, *Water Tower* does not register and fill out those spaces often read as metaphors for the human body or as spaces emptied of their occupants who, in their absence, nonetheless leave a trace or an

4.1 Rachel Whiteread, *Water Tower*, installed 1998. Photo reproduced courtesy of the Public Art Fund, New York, copyright © Marian Harders.

imprint of their missing presence. *Water Tower* does not seem to have any direct relationship to the body and it does not occupy the body's props. Viewers could not even get close enough to read its surface. It stayed aloof, above the street. It could only be viewed from a very limited number of places. Because it did not announce its presence, it was easy to overlook. When it became dark at night *Water Tower* disappeared completely. In certain kinds of light or at resonant moments of the day, such as dawn and dusk, it was a photogenic object, sucking the sky into itself. On dull days it looked unremarkable.[5]

Water Tower does not lend itself to the usual readings of Whiteread's works as metaphors of memory, absence and death, which suggest a morphological resemblance between her technical means and the death mask or memento mori of the photograph. One of the most interesting of these readings, by Mignon Nixon, has framed Whiteread's work within a change in direction in feminist practices of the 1990s towards aggression, pain and the drives, paralleling Melanie Klein's shift from neurosis to psychosis, from sexuality to the death drive, in the 1940s and 1950s. Nixon argues that such work functions as a critique of Lacanian feminist work of the 1970s and 1980s and the deconstruction of pleasure and desire. Deploying Klein also allows Nixon to refuse to read such work as a regression to an essentializing, literalist conception of the body, because the temporal concept of 'regression' is irrelevant to Klein's revision of Freud. Rather, the paranoid-schizoid and depressive positions which Klein finds in the infant's early psyche outline an idea of time which is more like space: here, there and gone rather than present, future and past.[6] In Nixon's account Whiteread's work evokes the depressive position and the subject's anxiety and remorse about its own aggression, which involves it in mourning an object that it fears it has destroyed and lost. As in infantile fantasy, Whiteread's work elides the inside and the outside, the body and its supports. It decentres the body in ways which also allow its gendering to be radically rethought. Mignon Nixon writes,

> Organized structurally by position rather than temporally by stage, the Kleinian model displaces concepts of essentialism and regression to open a space in which fantasies of aggression can be examined as structural to the subject of either sex and of any gender, in which the subject of aggression is constituted not in essential but in relational terms.[7]

A Kleinian model also allows us to imagine a history of feminist practice which is not trapped into successive waves of progressive and/or regressive practices. It complicates the relationships between different generations of women artists but it also opens these to be rethought as a matter of something more than oedipal rivalries. The pivotal figure for Nixon, whose article is called 'Bad Enough Mother', is Louise Bourgeois, against whose work and its late reception in the 1980s and 1990s all bodily related feminist practices need to be seen and read. And Louise Bourgeois once wrote, 'You need a mother. I understand but I refuse to be your mother because I need a mother myself.'[8]

However much Whiteread's previous work has been thought about in terms of the body and its drives, *Water Tower* appears to refuse any such embodied

reading. Moreover, its distance and elusive play on presence and absence have given rise to complaint. For example, Jane Harris, in the American journal *Sculpture*, writes that the pleasure of Whiteread's work is that it simultaneously invites and thwarts our identifications with it. *Water Tower*, however, is disappointing because it lacks any psychological charge and its safe distancing, in more than just the sense of being on a roof, makes it 'destined to pass by with little notice'.[9] But this is precisely the point. Whiteread, who says she has 'quite a complex relationship with public sculpture', has deliberately manufactured an object that she describes as discreet.[10] This safe distancing contrasts with her other public project of this period: the *Judenplatz Memorial* in Vienna, first commissioned in 1995 and unveiled in October 2000.

Judenplatz is a controversial project which carries its burden of meaning and memory almost to excess. Originally the initiative of Simon Wiesenthal, it is dedicated to the more than 65,000 Austrian Jews killed by the Nazis between 1939 and 1945, who can never be definitively named or counted. Whiteread's memorial takes the form of an inverted library where the books are made doubly unreadable by being turned around, their page edges, rather than their spines, turned to the outside. The memorial is an impenetrable concrete block, which resembles a bunker, and an implacable presence in the square. Whiteread's memorial, because it foregrounds the technique of casting, figures the idea of absence and emptiness as a focus for mourning.

Unlike her *Water Tower*, the location of which apparently depended only on some practical considerations, such as the availability of a redundant water tank and not being so far off the ground as to be unseeable, the siting of *Judenplatz memorial* is enormously sensitive for two reasons. Firstly, the project was specifically intended to be integrated with the Baroque and neo-Baroque architecture of Judenplatz and to mark the Jewish quarters in the heart of Vienna. When traders in the square feared its impact on the tourist industry, there were proposals made to move it elsewhere; but to place it in a less conspicuous, less specific and therefore less resonant square was not an option. Secondly, its site coincides with the excavated remnants of the synagogue destroyed in the pogrom of 1421. In the course of the project, it emerged that its original proposed site would have meant that it obscured the remains of the synagogue's bimah or preacher's pedestal and it was moved a few feet to accommodate this.

Water Tower is not freighted with the obligations of memory, meaning and site that are implicated in *Judenplatz*. Moreover, unlike *House* (1993), which was bulldozed in 1994, months after its creation, it does not generate complex social and political associations. This has led Jane Harris, for example, to accuse Whiteread of playing it safe and dodging controversy for New York's Public Art Fund. It seemed to writers such as Harris, that for this transatlantic opportunity, Whiteread has cheated her public of its need for complexity and difficulty.

There is no obvious occasion for the *Water Tower* proposal, which does not mark an event or a site. It was an opportunity for a public art project. All such proposals, however, have to negotiate a complex discourse about the critical interventions required by any public art which wants to preserve its credentials. Public art is a sometimes discredited genre because it has been appropriated to

allow the city of late capitalism to accommodate and reconcile its populations to the increasing privatization of public space and agendas of social exclusion and selection. This is acute in New York City, as Rosalyn Deutsche discussed in an essay first published in 1988, because the fabric of the city has been the subject of a vocabulary of urban decay and crisis.[11] Some public art projects are not meant to give offence.

But if public art is intended to show that a beautiful city is also a well-managed and orderly one then its minimal condition is that it needs to be seen to be doing its job. It has to have some mechanism for announcing its presence to the casual passer-by. *Water Tower* is, however, elusive, hard to find (plate 4.2). Even well prepared, equipped with its location and knowing what it looks like, the viewer is taken by surprise when finally happening upon it. Moreover, there was no particular reason for it being where it was. Critical responses which have seen it as an ironic memorial to the heyday of an avant garde that has disappeared from SoHo in favour of Chelsea provide weak justifications and rather vacuous responses to an object which is obviously going out of its way not to offer any of the readings public art is supposed to offer.[12] *Water Tower* is an autistic object. Mute and solitary, it frustrated its audiences because it deliberately resisted a dialogue of exchange with its viewer.

It cannot be the case, as Jane Harris would have it, that *Water Tower* is some sort of inoffensive civic gesture of accommodation because it spectacularly failed to offer itself up to a public. In fact, to realize the project took an enormous investment of labour, technical expertise and funding for something which is a self-effacing, non-presence. As such, it is a technical tour de force. When it was constructed, it was the biggest single resin cast of its type ever made, involving 9,000 lb of liquid resin.[13] It is the largest and most expensive project ever undertaken by the Public Art Fund. Yet, it is a cast of something ubiquitous and banal.

The two most extended critical essays on *Water Tower*, by Storr and Nesbit, both refer to its strangeness, and by implication, the artist herself as a foreign body marked by difference. Storr's essay begins with a lengthy and slightly disparaging discussion of Brit Art or the yBas. Whiteread does not warrant a mention until the second page. The title 'Remains of the Day', refers to Kazuo Ishiguro's novel, a story about English class relations and blind obedience that functions as an analysis of English colonialism. *The Remains of the Day* is also about the disappearance of a social order and at its end the aristocratic country seat, Darlington Hall, is bought by an American. The book of the *Water Tower* project, *Looking Up*, is supplemented by a collection of responses from members of New York's art scene or residents in SoHo. Here there are repeated references to the piece as an 'alien', 'replicant', 'virus' or 'spy in the sky', all things which need to insinuate themselves precisely by not making their presence known to their hosts. Like Storr's and Nesbit's essays, they suggest a certain unease about *Water Tower* as something that haunts or lurks in the city. One of the most interesting statements is recorded by an anonymous passer-by who says it is too dangerous to look at: 'If you look up in New York, people think you're a tourist ... then you make yourself vulnerable on the street.'[14] In effect, to pay attention to *Water Tower* is also to mark oneself out as an alien in the city and expose oneself to danger. What had

4.2 Rachel Whiteread. *Water Tower*, installed 1998. Photo reproduced courtesy of the Public Art Fund, New York, copyright © Peter Fleissig.

4.3 Rachel Whiteread, *Water Tower*, installed 1998. Photo reproduced courtesy of the Public Art Fund, New York, copyright © Peter Fleissig.

started out appearing as a distanced object with no relationship to the body has in some way an impact on the body of the unsuspecting viewer. There is something uncanny about *Water Tower*.

Tom Eccles, director of the Public Art Fund, writes that the Fund deliberately commissions works that are not site-specific in the sense of directly relating to a location. Consequently, its artists tend to work with the typological rather than the historical, and to generate universal rather than local meanings. The works are 'open texts', which invite diverse readings, so that the artists become humanist advocates for democratic values.[15] But despite the largely pragmatic matter of where it ended up, *Water Tower* has again confounded logic. There is nothing quite like Manhattan's forests of roof-top water tanks. There are an estimated 17,000 roof-top water tanks in New York City. Demands on space in the mid-nineteenth century led to an increase in high-rise building in Manhattan and tanks were needed to maintain water pressure. Wood was the most readily available material and carpentry skills were abundant amongst immigrant labour. Water tanks were largely undesigned functional objects which were not meant to be noticed (plate 4.3).[16]

The provision of water supplies to urban buildings was also part of the struggle against infectious contagious diseases in turn-of-the-century metropolises, known as the Domestic Sanitation Movement in England and America. Running water and a sewage disposal system did not just benefit public health; they also reconfigured the modern home and tenement. Cleanliness was closely connected with orderliness and modernity. Hygienic measures also meant social hygiene and control. Bathing ceased to take place in public and became a matter of private cleansing, removing the body's moist dirts and wastes. Two thirds of the water bills in New York currently go to pay for the sewage disposal system for human waste.[17] Standards of water supply and efficient sewage disposal are an index of a nation's or a city's modernity and its cultural status. In 1898 Adolf Loos wrote that the plumber 'is the first artisan of the state, the billeting officer of culture'. His article on plumbers, which concerns anxieties about America and its industrial advantages, concludes:

> Increasing water usage is one of the most pressing tasks of culture. Thus may our Viennese plumbers do their job as fully and completely as possible in leading us to this great goal – the achievement of a level of culture equal to that of other Western countries. For otherwise something very unpleasant, something very shameful, could take place. If [we] continue along at the present rate, the Japanese could attain Germanic culture before the Austrians.[18]

In the Domestic Sanitation Movement the building was described as being serviced like a body with hidden arterial systems regulated by valves and drains.[19] Water is also power and a political system to be streamed, diverted, channelled and stored. It has often been remarked that Alfred Barr's chart 'The Development of Abstract Art' for his *Cubism and Abstract Art* exhibition in New York at MOMA in 1936 makes modernism a matter of unidirectional flowing liquid rivers and channels of influences and confluences. It has been

4.4 Margaret Morgan, *Portrait of a History of Modern Art as Sanitary System*, 1993. Photocopy on vellum, unlimited edition (discontinued), 45.7 × 30.5 cm. Various collections in Australia and the United States. Reproduced courtesy of the artist.

noticed less often how much the chart also resembles a domestic sanitation system. When Margaret Morgan paid homage to Alfred Barr and Adolf Loos in her *Portrait of a History of Modern Art as Sanitary System* or *A Place for Everything and Everything in Its Place*, 1993 (plate 4.4), she diplomatically directed Barr's chart upwards instead of downwards, in case we misunderstand modernism as an enterprise that is heading down the drain.[20]

Alfred Barr was motivated to organize *Cubism and Abstract Art* in 1936 in part by anxiety that America risked appearing to be a provincial backwater unless it got up to date with European modernism. Louise Bourgeois's *The Puritan* tells the story of a perfect man who works in a perfect building until one day someone leaves a door open, 'almost on purpose, as a half instruction to someone passing by to come in for fun' and a woman slips in. She stirs the man's desire and, paralysed by his secret love, he simply withdraws. Bourgeois claims that Alfred Barr is *The Puritan*.[21]

Exiled in the United States, Bourgeois described her cedarwood pieces of the 1940s as memorials to absent friends. Rosi Huhn has argued that these works unmask monumentality to reveal fragility in an anti-fascist gesture.[22] Barr's *Cubism and Abstract Art* was also a project to salvage modernism from the threat of fascism. By putting everything in its place, modernism also keeps some things at bay. Lahiji and Friedman, in their introduction to a collection of essays on plumbing and modern architecture, argue that modernization in the name of hygiene becomes the internalized superego of modernism: 'The superego of the hygienic movement constructs modernity by plumbing the destructive instinct of the pleasure we take in dirt and pollution.'[23] Pollution and dirt are women's, and especially the mother's prerogative. As Briony Fer writes, she is charged 'in both senses of responsibility and impugned guilt ... with the management of dirt'.[24] The Domestic Sanitation Movement specifically targeted the education of women as the figures whose household authority and whose role as mother were the primary mechanisms for spreading the lessons of hygiene.

In 1992 Louise Bourgeois used a wooden water tower, which she says is like a little house, for *Precious Liquids* (also called *Art is the Guarantee of Sanity*). In this claustrophobic work, the precious liquids are bodily fluids – liquids released when muscular tension relaxes. Marie-Laure Bernadac sees *Precious Liquids* as a feminine pendant to Duchamp's *Large Glass*. Flatness is countered by volume, transparency by darkness, dryness by what she calls 'the moist fecundity of motherhood'.[25] Whiteread's *Water Tower* replays some of the references of *Precious Liquids*, countering its dark obscurity with translucency, its interiority with exteriority, its dark secrets with transparency and its fecundity with emptiness. The pristine cylindrical form of *Water Tower* might also refer to Mona Hatoum's *Corps étranger* of 1994 (see plate 1.4, page 325), which translates as strange (or foreign) body. Here, in its dark interior, the viewer is alternately swallowed up and spat out by a monstrous, moist and fragmented female body. The white cylinder of *Corps étranger* has been described as being like a tollbooth or crossing place for a traffic in meaning between intelligibility and legitimacy versus cultural exclusion and displacement.[26]

In one of the collected comments on *Water Tower* in the Public Art Fund's book, the artist Tony Oursler says the work made him think about the relationship of the Old World to the New.[27] The quintessential emblem for this relationship is Bartholdi's *Statue of Liberty*, the immigrant's first sight of the New World. Liberty is the mother of the nation, or possibly Bartholdi's Alsatian mother. She is also an empty body constructed entirely from drapery, lacking flesh and bodily organs. Because the tourist can climb up into her body, as Kaja Silverman would have it, she is 'capable of effecting our imaginary union not only with her, but with the entire nation'.[28] In one of Whiteread's drawings published in *Looking Up*, *Water Tower* swallows up the statue (plate 4.5).

The alternative fantasy about maternal plenitude and a return to the womb is Melanie Klein's emptying of the mother's body. As she writes in the 'Psychogenesis of Manic-Depressive States' in 1935, the infant's sadistic impulses are directed 'not only against its mother's breast, but also against the inside of her body: scooping it out, devouring the contents, destroying it by every means which sadism can suggest'.[29] *Water Tower* enacts its revenge on 'mother' Liberty by engulfing and devouring her, introjecting the object. Klein says the sadistic desire to rob the mother's body of its contents is particular to girls, which gives rise to the child's anxiety lest the mother should rob her of the contents of her own body, and thence to efforts at reparation, making good the fantasy injury done to the mother. For Klein, it is one of the most important incentives for the development in women of the creative impulse and cultural achievement.[30] 'Liberty' was manufactured through the reproduction and enlargement of a model. In a process that bears an uncanny resemblance to Whiteread's signature technique, copper sheets were hammered and impressed into moulds.

In 'Remains of the Day', Storr repeats that old chestnut, borrowed from Rosalind Krauss's essay on Whiteread in *Tate Magazine* (1996), about the artist's debt to Bruce Nauman.[31] He writes 'Whiteread's *Untitled (One Hundred Spaces)*, 1995, is in effect Nauman's *A Cast of the Space under My Chair* (1965–68) multiplied a hundred fold.'[32] He concludes, with a sense of relief, that Whiteread has renewed, rather than broken, the mould of modernism. *Water Tower* plays off and evacuates references to a number of other works by, for example, Bourgeois or Hatoum or the Statue of Liberty, in ways that recall fantasies of destruction and reparation. New Yorkers have seen it as an uncanny object which defamiliarizes, making strange an object that was so obvious it had become invisible. Uncanniness is a feeling of anxiety and unease, operating through mechanisms of doubling and repetition. The old and familiar get seen unexpectedly as alien and strange. The uncanny, it has been said, is something which 'ought to have remained secret and hidden but has come to light'.[33] There is something really rather reassuring in the idea that a modernist object like *Water Tower* can still give rise to anxiety.

Always intended as a temporary project, *Water Tower* is no longer on its roof-top in SoHo. It was purchased and donated to the Museum of Modern Art, New York. When it entered the museum's collections its meanings were altered. Instead of being a discreet, ephemeral object that played on presence and absence, it became a permanent monument in the canon of modern art. *Water*

4.5 Birthday card sent by Rachel Whiteread to Louise Neri, 11 May 1997.

Tower also has an afterlife in the now-canonized photographs circulating in the specialist art press. Most were taken from the private spaces of roof terraces, from positions level with the object as it gathered in light from the sky. These were views quite at odds with the actuality of seeing it from the street. The original, public life of *Water Tower* in its temporary SoHo location high in the sky contributed to the idea of a democratic, anonymous object, waiting quietly to be caught by a passer-by accidentally glancing up. It did not announce to anyone that it was 'art'. Although it resembled the commonplace water towers it was replicating, its translucency was unexpected, taking its casual audiences by surprise with the randomness of its presence. The symmetry of these two views of *Water Tower*, temporary and democratic, and permanent and exclusive, is disrupted by the artist's own postcard image swallowing up the Statue of Liberty (plate 4.5). When Rachel Whiteread amended her postcard 'Greetings from New York. The Wonder City' to send it to Louise Neri (friend and editor of the book planned as the souvenir of the temporary project), she imagined *Water Tower* replacing the Statue of Liberty and made her own work into a landmark and a tourist sight. The artist fantasized about *Water Tower* taking its place alongside the Twin Towers of the World Center, the Rockefeller Center and the Empire State Building, all emblematic New York structures not known for delicacy and discreetness.

Each one of these three images of *Water Tower* generates different readings of the object. Its public image for the Public Art Fund was like a snapshot, seen randomly and democratically from the street. This now belongs to the past and cannot be recovered. Its canonical status as a permanent work has been achieved in the collections of MOMA, New York, an identity which is enhanced by the many professional photographs taken when it was in SoHo, and which often illustrate articles in the specialist art press. The third image as a witty anti-monument is drawn by the artist as a joke to send to a friend and collaborator. This postcard, like many of the original photographs, shows *Water Tower* juxtaposed with the Twin Towers. It is not easy to view these images today without being painfully aware of the loss of Louise Bourgeois's 'pure' and 'beautiful' New York skies.

Sue Malvern
University of Reading

Notes

I am indebted to Malia Simonds and Mayuru Amuluru of the Public Art Fund, New York, to Margaret Morgan, Los Angeles and to Jon Wood of the Henry Moore Institute, Leeds.

1 L. Bourgeois, *Destruction of the Father/ Reconstruction of the Father: Writings and Interviews, 1923–1997*, Cambridge, Mass., and London, 1998, p. 51.

2 R. Storr, 'Remains of the Day', *Art in America*, vol. 87, no. 4, April 1999, p. 154.

3 L. Neri (ed.), *Looking up: Rachel Whiteread's Water Tower. A Project of the Public Art Fund*, New York, 1999, p. 100.

4 Whiteread's *Fourth Plinth* project for Trafalgar Square, London, 2001, is, however, a later work which revisits the preoccupations of *Water Tower*.

5 What has increasingly become the canonical photograph of *Water Tower* on its original SoHo site, for example as reproduced on the cover of the special issue of *Oxford Art Journal*, 2001, on installation, and also the frontispiece for Storr's *Art in America* article, shows the work at the level of the roof. On the body and *Water Tower*, see the comment by Robert Leonard, in Neri (ed.), *Looking Up*, p. 167.

6 See J. Mitchell, 'Introduction', *The Selected Melanie Klein*, London, 1986, p. 28.

7 M. Nixon, 'Bad Enough Mother', *October*, no. 71, Winter 1995, pp. 91, 89, 72.

8 In 1975. Bourgeois, *Destruction of the Father/ Reconstruction of the Father*, p. 72.

9 J. Harris, 'Rachel Whiteread: sponsored by the Public Art Fund', *Sculpture*, no. 18, January/ February, 1999, pp. 65–6.

10 Neri, *Looking Up*, p. 166.

11 See Rosalind Deutsche's discussion of this issue in 'Uneven development: public art in New York City', *October*, no. 47, Winter 1988, pp. 3-52.

12 Storr was one of those who saw *Water Tower* as a monument to the heyday of Soho (see Storr's 'Remains of the Day').

13 It was displaced from its world-record status by Whiteread's *Fourth Plinth* project for Trafalgar Square, London, 2001.

14 Neri, *Looking Up*, p. 166.

15 'Vanishing Point: the making of *Water Tower*', in Neri, *Looking Up*, p. 22.

16 See the essay by Luc Sante, 'Cabin in the Sky', in Neri, *Looking Up*.

17 Neri, *Looking Up*, p. 16.

18 In N. Lahiji and D.S. Friedman (eds), *Plumbing. Sounding Modern Architecture*, New York, 1997, pp. 18-19.

19 See A. Adams, *Corpus Sanum in Domo Sano: The Architecture of the Domestic Sanitation Movement, 1870–1914*, Montreal, 1991.

20 This image was published as part of 'Too Much Leverage is Dangerous' in *Plumbing. Sounding Modern Architecture*. Margaret Morgan is a Los Angeles-based artist. She has a website, http://www.margaretmorgan.com/home.html, which includes sound effects.

21 Bourgeois, *Destruction of the Father/ Reconstruction of the Father*, pp. 51-2.

22 R. Huhn, 'Louise Bourgeois: Deconstructing the Phallus within the Exile of the Self', in C. de Zegher (ed.), *Inside The Visible. An elliptical traverse of 20th century art. In, of and from the feminine*, Cambridge, Mass., 1995, pp. 136-7.

23 'At the Sink. Architecture in Abjection' in Lahiji and Friedman, *Plumbing*, p. 53.

24 B. Fer, 'Poussière/peinture: Bataille on painting', in C.B. Gill (ed.), *Bataille. Writing the Sacred*, London, 1995, p. 162.

25 Marie-Laure Bernadac, *Louise Bourgeois*, Paris, 1995, p. 137.

26 Ewa Lajer-Burcharth, 'Real Bodies: Video in the 1990s', *Art History*, vol. 20, no. 2, June 1997, p. 201.

27 Neri, *Looking Up*, p. 180.

28 'Liberty, maternity, commodification', in M. Bal and I. Boer, *The Point of Theory*, Amsterdam, 1994, p. 26.

29 'A Contribution to the Psychogenesis of Manic-Depressive States (1935)', in Juliet Mitchell (ed.), *The Selected Melanie Klein*, London, 1986, p. 116.

30 'Infantile Anxiety Situations Reflected in a Work of Art and in the Creative Impulse (1929)', in Mitchell (ed.), *The Selected Melanie Klein*, pp. 92-4.

31 R. Krauss, 'Making Space Matter', *Tate*, no. 10, Winter 1996, pp. 33-4.

32 Storr, 'Remains of the Day', p. 106.

33 S. Freud, 'The 'Uncanny' (1925)' [Das Unheimliche (1919)], in *Art and Literature*, vol. 14, *The Penguin Freud Library*, London, 1985, p. 345.

5

Hybrid Histories: Alice Maher

Interviewed by Fionna Barber

Alice Maher was born in 1956 in Cahir, Co. Tipperary, in the Republic of Ireland. Having read for a BA in European Studies at the National Institute for Higher Education in Limerick between 1974 and 1978, she subsequently gained a Diploma in Fine Art from the Crawford Municipal College of Art, Cork, in 1985, and then an MA in Fine Art from the University of Ulster in Belfast (1986). In 1986 and 1987 she was a Fulbright Scholar at the San Francisco Art Institute. Her first major solo exhibition, at the Douglas Hyde Gallery, Dublin, in 1994, was entitled *Familiar.* This was followed by installations and residencies in both Paris and Poitiers, and a series of solo exhibitions in Dublin, New York and London, the most recent being *The History of Tears* (2001) at the Green on Red Gallery, Dublin, the Butler Gallery, Kilkenny and Purdey Hicks Gallery, London. In 1994 Alice Maher was one of three artists to represent Ireland at the 22nd Sao Paolo Biennale, and her work has been shown in numerous group exhibitions of Irish art, such as *Irish Art Now: from the Poetic to the Political* (1999) which toured venues in the United States from 1999 onwards. In 1996 she was nominated for the prestigious Glen Dimplex Award and was elected a member of Aosdana. Alice Maher lives and works in Dublin. She is represented by Purdey Hicks Gallery, London.[1]

Early work and sources

FB: *You began your career as a painter, which seems to be quite removed from the more recent concerns of your work.*

AM: I was and still am interested in art as a language and how that has evolved. But I also began working during the 1980s, a time when painting underwent a huge revival. There was nothing else to do ... but Neo-Expressionism was a very male-dominated practice. It was hard enough to find a niche for oneself there as a woman, which eventually added to my rejection of painting.

And you were also living in Belfast at the time.

Yes, in an anger-filled town; it was just in the air all the time. In this context, given the terrible things that were happening, it didn't seem appropriate to me to adopt a 'cool' language for art. We were all so repressed in so many ways – you were constantly monitoring what you said, where you were. Although this

5.1 Alice Maher, *Icon*, 1987. Mixed media collage on paper, 30 × 21 cm. Private collection, Ireland. Photo reproduced courtesy of the artist.

obviously affected people who were actually from the North of Ireland, I felt as a Catholic from the south that both my language and behaviour were continually curtailed by that continual atmosphere of paranoia and fear.

For a lot of artists in Belfast during the 1980s, particularly Northern Irish men, an engagement with contemporary events meant 'political' painting. Did you have any sense of disjuncture between your own identity and everyday political experience?

Certainly I felt initially that I had more in common with people from places other than the Catholic community in Belfast, whose experience and history was so vastly different from mine. The South of Ireland had gained independence from Britain in 1922, whereas those struggles were still going on for the nationalists in the North. It was a long time before I felt to any degree comfortable going into the nationalist territory of west Belfast, for example; until I gained more of a sense of my own place in things. Of course, as an artist, you were already on the outside, never mind feeling displaced from the political allegiances in Northern Ireland at this time. So doing 'political' painting just really wasn't an option.

That whole experience, living and working in that traumatic situation, seems to have been displaced in your case into something very different – an engagement with religious imagery. There was a lot of anger in your work at that time, which Neo-Expressionism seems to have given you a language to articulate.

Although the language of my work subsequently became much cooler, more distilled, Neo-Expressionism was useful in the series of collages that I made in the mid-1980s, such as *Icon* (plate 5.1) or *Annunciation*, which were based on Renaissance religious paintings. The violence that I associated with these biblical events provided a visual language for a deconstruction of church imagery achieved through tearing up magazines, reconstructing and refiguring… My anger found a more ready direction in relation to what the Catholic Church was doing to women in Ireland. The 1980s was a really bad time for women and their rights throughout Ireland. The feminist movement here was really fighting the battle at the coalface; it wasn't in the abstract at the time. In America by then it was more abstract, in the sense that there was a development of political or theoretical writing about feminism; in Ireland, meanwhile, contraception was just about available and there was no abortion and no divorce. Women were thrown out of their jobs for becoming pregnant; young women died having babies in fields. Ann Lovett, a fourteen-year-old girl, was one example.

But presumably this is where your concerns with wider aspects of female identity developed from.

I started with deconstructing the image of the Virgin Mary, that completely unattainable archetype of female perfection, and then moved on to other aspects of female identity that challenged this in religious imagery, such as Mary

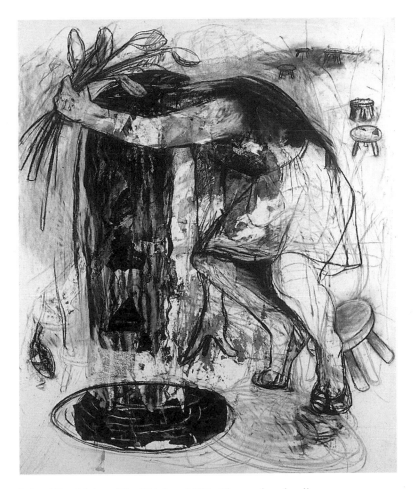

5.2 Alice Maher, *The Thicket*, 1990. Charcoal and collage on paper,
140 × 112 cm. Private collection, Ireland. Photo reproduced courtesy of the
artist.

Magdalene or the Whore of Babylon, both of whom display a sexuality that is
otherwise repressed in Catholicism. This led me to questions of the
representation of the female body. For many women artists this was a subject
so laden with meaning that they couldn't engage with it. I decided, however, that
it was something I wanted to use, but only on very selective terms. I didn't want
to use life models, because of the danger of objectifying them.

In works like the Celebration Robes *or the series of drawings entitled* The
Thicket *(plate 5.2) you developed a way of using your own body, but not as an
object of voyeurism.*[2]

In the *Celebration Robes* my own bodyprint was a basis for imagery which was
added to and worked over. In later works such as the *Ombres* (plate 5.3) there is
a sense that one's identity is being veiled and protected by the imagery itself, in

91

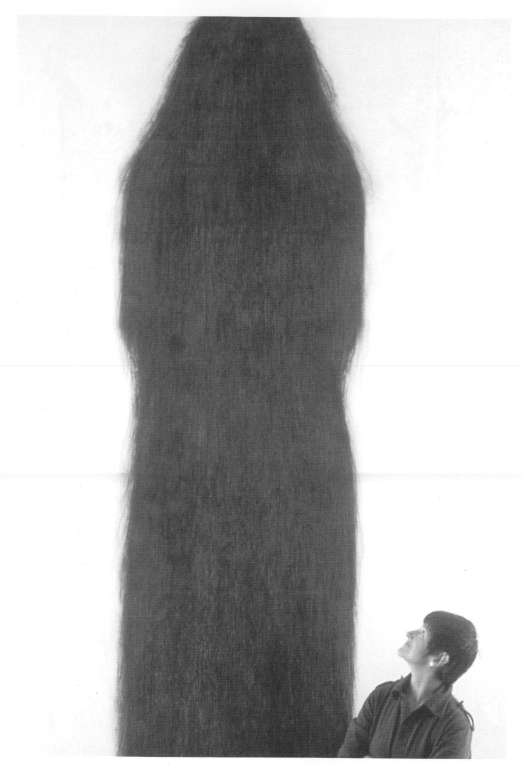

5.3 Alice Maher, *Ombre*, 1997. Site-specific drawing, charcoal on paper, 426.7 × 152 cm. Photo reproduced courtesy of the artist.

this case by hair.[3] In *The Thicket*, I used my body not so much as a model but as a means of providing a sense of inner reality, of how it feels physically to be in the positions of those girls that I drew – lying down, walking around, reaching, looking. I used my experience of being *in* my own body rather than its direct image.

This practice of working from a point of identification rather than objectification is, however, something that runs through your work, in that it also informs your later engagement with issues of Irishness, land and landscape.

Ireland is not just a thing outside my self. I've had this relationship with the land since I was very young, one that's not purely 'intellectual', but also intensely emotional, and, of course, physical. As a child growing up on a farm in Tipperary, you'd spend your time roving across a very old landscape, full of ruins and Norman abbeys as well as fields and wild places. I suppose the ideas of space that are important in my later work come from there too: when you're a very small child the landscape seems so vast, while you're a tiny blip moving through it. But it was also a place associated with labour – you'd be expected to help out with the herding of cattle or whatever. The land would be wind, rain and cold mud, with perhaps a little bit of sunshine. Land equalled physical discomfort not visual satisfaction.

Ethnicity, Hybridity and the Land

FB: *There is, of course, a problem in negotiating ideas of landscape in Ireland derived from the significance that it had in the years of the Irish Free State in the 1920s and 1930s. Landscapes by artists such as Paul Henry or Charles Lamb depicted the remote areas of the Western seaboard, those places reputedly least affected by British rule, as populated by an archaic Irish-speaking peasantry. These images acquired so much significance within a nationalist post-colonial agenda that in a certain way what they represent has become inescapable for Irish artists subsequently. It really became something that artists have had to negotiate.*

AM: That image-making of the Irish landscape also contributed to my moving away from the practice of painting. Rather than making a picture *of* something, objectifying the landscape, I was more interested in getting *inside* the picture and working from there. On occasions, then, the materials I use are taken directly from the land, such as thorns or nettles.

So it's much more about reconstructing a relationship with the land and its multi-layered significance as formative of your identity – so much so that it permeates the whole process of representation for you.

I would hope that that would be read as an anti-Romantic action; making pictures *of* the landscape is something I'd consider to be a relatively pointless

activity. But it's not just the image that has become sanitized; the land itself has become increasingly subject to means of control, through cultivation, the digging of ditches, the pollarding of trees. In comparison, I'm very attracted to the idea of the forest as something beyond control, although in *The Thicket* it figured as a kind of densely concealed hiding place. That series was also one of the many points when erasure has been an important part of the drawing process for me; in rubbing at the surface you're struggling to get into another space, erasing the unnecessary and exposing the core.

The primeval forest also signifies that which remains unconscious, beyond what has been civilized and brought into order.

The forest of fairy tales is a dangerous place, one where nightmares come true. Or one where you come up against things you don't understand or are better off not knowing. It reminds me of the scene in *The Piano* when the woman is being dragged through that root landscape on the way to having her finger cut off – which is *right* in there of course, with Red Riding Hood, the wolf, the forest and the axe!

But in order to re-engage with landscape you had to leave Ireland for somewhere with a very different history and culture. I'm thinking of when you worked in France in 1995–1996.

Yes, I had a residency in Paris, at Ivry-sur-Seine. I started seriously to look on land as a subject at that point. I had the opportunity to make a site-specific work for a lake there, working out of doors. Before that I had been trying to bring landscape *in*doors, into a Fine Art context. Paris also involved a different type of audience: more random or peripheral in a sense – not an art audience specifically. Working outdoors, I also had to adjust my ideas of scale. I decided to develop the idea of the female swimmers that had emerged in the work I did for *familiar*, my show at the Douglas Hyde Gallery in Dublin in 1995. In Paris *Les Filles d'Ouranos* took the sculptural form of a group of heads surfacing from the lake, mirroring the Aphrodite myth – except that there were fifteen heads instead of one!

So once again, as in familiar, *you were engaging with a multiplicity of female identities, rather than with a single, idealized femininity.*

And, of course, the landscape setting for *The Birth of Venus* was important too, as it was in Botticelli's version, although in his version it was idealized and in mine it was actual. Before I went to Paris I had been really been concentrating on the body, but at this point I started to work on its relationship with the land as well. The experience really freed me up to re-consider this again.

This interest in the female figure in the landscape was one that you continued to investigate in the work you did in Poitiers during another residency in 1997.

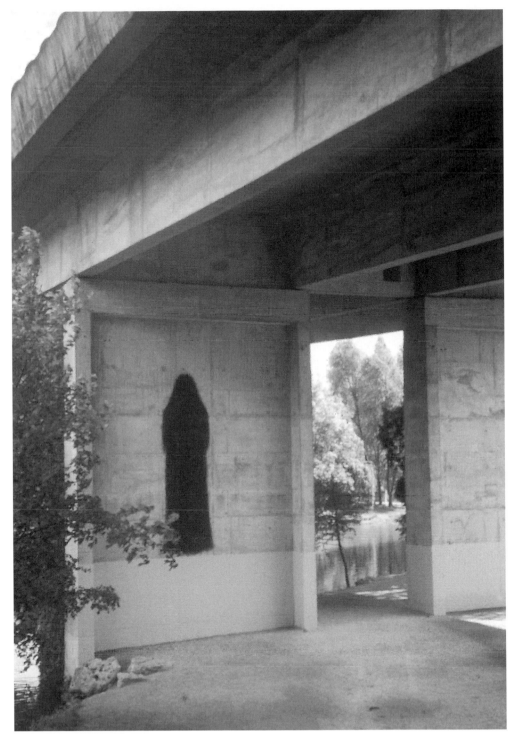

5.4 Alice Maher, *L'Arpent*, 1997. Site-specific drawing, wax crayon, 600 × 150 cm. Under concrete bridge, Poitiers, France. Private collection, Ireland. Photo reproduced courtesy of the artist.

I was very attracted to certain aspects of Poitiers, which I discovered was also known as the 'City of the Three Women' because of its associations with three great female figures – the Abbess Radigonde, Eleanor of Aquitaine and Joan of Arc. The medieval period, with which these women are more closely identified, is one that greatly interests me anyway; it evokes the density of the forest, before the clearings of the Enlightenment, or the Renaissance. The site-specific work I did in Poitiers (plate 5.4), entitled *L'Arpent* (*The Long Acre*) was beside the river this time, rather than in the water itself. I drew a huge shadowy female figure under a reinforced concrete bridge, which people would just come upon when they were out for a walk. This was also underneath the highway that travels over Poitiers – the contemporary world driving over the medieval city. So my figure really did become like a shadow of one of those three women, or maybe of all of them.

That spectral figure beneath the bridge could also be read as evocative of a female unconscious beneath the organized symbolic world; furthermore, it suggests the past, which we relegate to the world of the unconscious, as a trace within the present. But I also wondered whether your work in Poitiers was something that catalysed your interest in the medieval in Ireland.

Yes, because of the connection between France and Ireland in terms of the Normans landing in Wexford, and then moving right across the country. And now it's part of our heritage. It's an unlooked-at time here, the Norman period. When it came to the Celtic Revival at the beginning of the twentieth century the cultural thinkers leapt over those times, in the search for their identity, going back to a more archaic Irishness in search of a 'purer' ancestor.

For them, that period was more readily identifiable with England because it could be seen as Anglo-Norman and thus something to be rejected – somewhat ironic when you consider that some of the main instigators of the Revival, such as W.B. Yeats or Lady Augusta Gregory, were themselves Anglo-Irish!

But my roots are right there in Norman Ireland, in the south-east, with the ruins of Norman castles and tombs. I became particularly interested in the effigies of Norman knights and ladies lying on their stone beds. Because theirs was at least at first a military occupation, they're always commemorated in those terms, in battledress. So, when I was in Poitiers and I saw the *gisants,* the stone effigies in the cathedrals both there and in the surrounding area, I felt a connection with what I knew from my own childhood, the sleeping dead. I was also fascinated by the rendering of chain mail in these carvings. Looking at how intricate it was, I tried to figure out how they made it, or remade it in stone.

But it also relates to the idea of 'continuous process', the laborious nature of making art, a term which you have used on occasions prior to this to describe your work. Often it's been an arduous, repetitive activity, such as the binding of long ropes of hair for your installation Keep *(plate 5.5), and it's one that you have associated with the invisible or hidden nature of women's work.*[4]

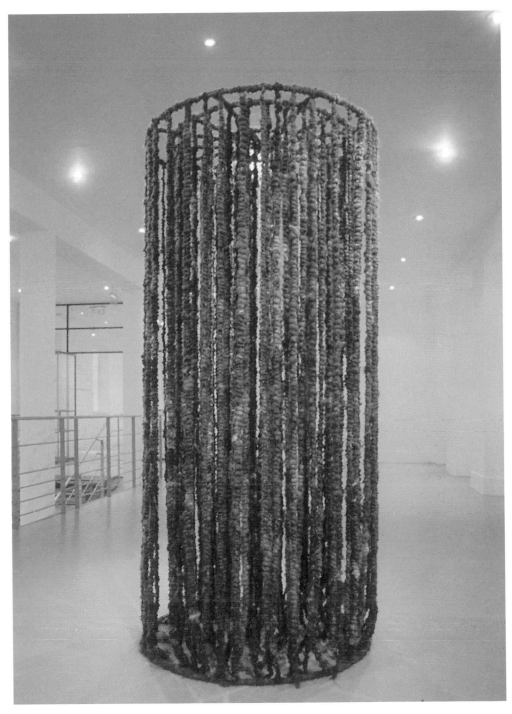

5.5 Alice Maher, *Keep*, 1992. Site-specific work, human hair and steel thread on metal frame, 274 × 122 cm. Old Museum Arts Centre, Belfast, Ireland. Photo reproduced courtesy of the artist.

Yes, I have made the evidence of labour an integral part of my work. Collecting berries, binding hair, painstakingly sticking thorns onto a surface, drawing a million strands of hair until they add up to a single image like *Ombre*: these all include time and action in the finished piece. And in drawing I try to follow the act of labour: in the chain mail drawings from 2001, for instance, I make a line like a knitter might knit a row, then the next one followed the first and so on until you came to the end, each line hanging on the one that went before it, faltering with your fatigue, tightening up with your attention. So that each one really is a record of its own making as well as a finished image. A knitted garment protects you from the cold but chain mail protects from aggression and death.

In looking at the Norman period it seems to me that what you are dealing with here is a further aspect of hybridity, as opposed to, say, any attempt to reclaim a sense of ethnic purity. This is something that has also informed your choice of materials; the objects constructed out of flax in familiar *utilized a material that has strong associations with Ireland because of its role in the production of linen, a commodity that has also tended to signify Irish ethnicity. But you had to get it from Belgium.*

Because it isn't grown in Ireland anymore! And the idea of 'pure Irish linen' is also like selling the purity of the west of Ireland. All the Free State imagery was of the west, the Connemara lakes or their little white cottages; the midlands or the south-east weren't considered good enough – their implications were too hybridized. But hybridity is always interesting because it's where two cultures meet, interwoven like chain mail. So I would definitely say that the midlands is a stimulating place to be as well, in that it's also culturally marginal.

Ambivalence, abjection and Irishness

FB: *Is there any degree to which you could see yourself as having an engagement with Celticness now? I'm thinking of* Gorget, *the necklace of heads that you made, where your source material came from a Celtic body ornament in the National Museum of Ireland.*[5]

AM: I've always used the image of a head as a being in itself, or at least metonymous. That notion of the head as a seat of power isn't just Celtic, by the way. However, what interested me about that necklace in the National Museum, which formed the basis for the dimensions of my piece, was that it's such a mysterious object. It was made of nine perforated golden balls, and it obviously had some kind of function, but what and for whom? Did the object have a memory? That's what interested me.

There is a significant precedent for the use of the head in Irish modernist painting, in Louis Le Brocquy's works from the 1960s, where his commemorations of Yeats or Joyce or Lorca frequently focused around one single male head.

Although, for him, this was bound up with an existentialist preoccupation with issues of human isolation, it was also identified with Celtic source material, whether from Ireland or France. Your engagement with the past, however, has involved a departure from Celticness and all its implications. But it seems to me that the way your work has evolved, you are now able to engage with that whole area on very selective terms, with less danger of being sucked into those very reductive associations. You can engage with an object like that necklace precisely because of its ambiguity, rather than as something that exemplifies Celtic identity.

And I'd be very wary of that. But I know that I walk a fine line with a lot of the subject matter I work with.

How do you negotiate that?

That is so difficult to answer. I don't know what the answer is – just make it and see. Sometimes I make objects that are very small, such as *The House of Thorns*.[6] There's a danger of them becoming sweet or cute, so you have to keep them on the tightrope. But I think the more threatening associations of my objects would help to keep them from being decorative – or being diminished by that term.

Something of that ambivalence, but more closely related to bodily processes, was present in the show you had in London, at Purdy Hicks Gallery in October 2001, which was called The History of Tears.

The title of that exhibition was taken from a work by Barbara Kruger: 'Who will write the history of tears?' I had been thinking about our cultural approach to tears and the continuous flow of weeping. I had also been making work over the years that involved the idea of continuous labour, starting with the hair. Then more recently I began to work with chain mail from the medieval armoury, which involves continuous lines that eventually add up to an integral image. The interest in weeping came after this. Writing the history of tears is such an impossible thing because it's so ongoing. Also, although tears are liquid coming from the body, similar to blood or sweat, there is no *physical* cause for them, like there is for lactation or bleeding, urinating or sweating. You're crying, leaking salt water, because something emotionally complex has happened. And it's the point at which this flow happens that I'm interested in.

The point of physically externalizing something that's an internal process.

And it's a liquid of course, which evaporates. In the series of drawings on black called *The History of Tears*, the figures are like fountains, or maybe they're somewhere between stone and smoke – they're so erased. I drew them first with white pencil then rubbed and rubbed them until they almost disappeared. So the liquid never stops coming out of their eyes, just flows. But as figures they're not

emotionally engaged with that – they are calm and immobile, like statues. The other big drawings on calico often use the shape of a tear, which is like a droplet, and multiply it by millions. Interlaced and interwoven, they suggest chain mail and the relationship of clothing and armour, protection and display, which has interested me for a long time, right back to the *Bee Dress*.[7] I also made a glass casket which was about the length of a child's coffin. Inside I placed blown-glass tears made by Jerpoint Glass in Kilkenny. I had found out about the Roman use of lachrymatories, glass bottles in which they collected the tears of mourners. These were stopped up and put in with the dead, so that your message of mourning was sent with them. That's how I got the title for the piece, *Lachrymatory*, after it was made – which is when all my pieces get titled!

But lachrymatories were so tiny, and your casket was huge by comparison. The shifting of scale has been very important in your work.

Yes, over the years. It usually swings from monumental to miniature without much in between. In those big chain mail drawings you could imagine that you were looking at something very small, but close up, so that it looks absolutely huge, like a fragment of cloth under a microscope. Or that you were absolutely tiny and looking at something gigantic, so there is a macro and micro point of view simultaneously, and always in flux.

What is that about for you?

I'm not too sure, really. I used to site it physically in relation to my own size and experience of the world. I suppose it's also spun off from fairy tales of people who grow too big or too small, so they don't fit into the world until something happens to redeem them back to the accepted. It's a bit like that with the hair imagery – it's excessive, with unacceptable amounts of hair. When it's cut and clipped correctly, it fits into the norms. But in such monumental quantities it's outside, wild, beyond the pale. In the margins, in the woods, outside, beyond our understanding, but for all that it grows right out of our own bodies.

This is verging on the territory of the abject, and that which is normally kept inside or attached to the body as being extruded in some way, producing a sense of horror or disgust.

Like all that hair. In *Keep* (plate 5.5), which was a tower of hair, many people didn't want to go inside – or they'd go in secretly. The only evidence of their passing would be a little dusting of hair on the floor each evening.

It was a strange experience being in the middle, surrounded by that amount of hair – both comforting and claustrophobic.

It was sensory in ways other than touch – you could smell it. And you were aware that the hair had come from all those different heads. There was a sense that you could be overcome with horror at any second, and I think it's the same

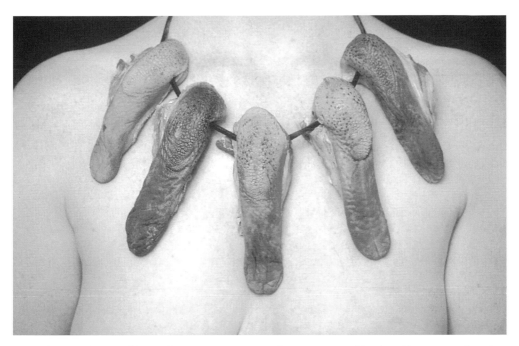

5.6 Alice Maher, *Necklace of Tongues*, 2001. Lambs' tongues and leather. Photo reproduced courtesy of the artist.

with those very big drawings, such as *Ombre* (plate 5.3). Sometimes people are overwhelmed by the size and the darkness of them – the notion that they could be an opening into another space rather than a two-dimensional surface.

Also the recent necklaces you have made with animal body parts, the tongues and the hearts of lambs are at the other extreme from any implication of sweetness.

The tongue is connected to my interest in language, which I addressed earlier in a piece called *Folt*; and I'm also interested in communication as a multiplicity rather than as a singular activity.[8] The idea came to me when I was passing through a market in Cork. On one stall was a mountain of lamb's tongues that actually looked very human – they're a similar size. So I brought them home, and it seemed that the most natural thing to do would be to string them together to make a necklace, given my interest in display and clothing. The photographs depict my body wearing the necklace (plate 5.6). There is a sense of horror evoked by the violence with which they were ripped from the heads of these animals. It's the same with the hearts, which are about the same size as human organs. I strung them around my neck and made a choker. Women wore chokers of velvet often displaying a love token, like a silver locket. But in actually wearing the meat hearts you are making visceral something that is usually only imagined or miniaturized, kept locked up. You are turning the body inside out, opening the forbidden chamber.

When it's contained in a locket it's made safe, but what you're doing is removing whatever has censored it into a sanitized form, restoring the original charge, as if restoring the ambivalence of desire through removing its repressions.

Even the word 'choker' is ambivalent, in the sense of being choked by love. A choker of real hearts exposes the material truth of the idea.

One potential difficulty with the use of animal parts, however, is in its connotations not only of the abject but of the 'primitive'. In this aspect of your work you are engaging with confrontational issues and materials which, in Western culture, have often been linked to both these categories.

There is also something quite empowering about identifying yourself as the 'Other', in speaking from a position of that which is repressed and denied and demeaned. Of course, Ireland was considered as primitive within British colonialism – and probably still is within some sites of power. But major changes have taken place in this area, with the shifts that have occurred in Ireland's economy and cultural identity since the beginning of the 1990s, bringing it well in from the periphery. So it is also with a sense of irony that I embrace a notional primitivism.

Yet in identifying yourself as an Irish woman and dealing with this imagery, there is still a potential danger of readings of Irishness – particularly female Irishness – as primitive. Despite the considerable shifts in Irish cultural identity in a post-colonial era, ethnocentric categorizations often take a lot longer to change. You have to confront meanings that existed long before you started working in this field, which again is part of the line that you walk. But it seems a constant feature of your practice has been a conscious avoidance of any kind of collapse into essentialist readings, even if you might flirt with them to some degree; it's more a case, I think, that this is a performance *of the primitive for you.*

Yes, I think that just about describes it. It's important to me to have some kind of distance, something that evolved also with my gradual move away from expressionism, because it opens up more questions about identity and issues of representation. Putting on the *Necklace of Tongues* was very much about *assuming* an identity; there's a sense, when one is wearing it, being given certain properties, like when I used to imagine wearing the *Bee Dress*.[9] So it *is* about taking on an identity as 'primitive' in some way, which was actually quite empowering – but this is not who I am, only something that I enact; in a sense I am performing the primitive here. It's also only one aspect of what I do among many, something incorporated in the hybridity that I constantly embrace in my work.

This is a difficult path to walk, but one that increasingly confronts aspects of the problematic nature of both Irish and female identity.

And I must say that in the last few years I've been more able to accept the varied associations of what I do, and to deal with that. At the end of the day it's as scary for me as for anyone else, but I embrace the contradictions of what my work implies.

Fionna Barber
Manchester Metropolitan University

Notes

With thanks to Alice Maher for the time and commitment that made this project possible.

1 This is an edited version of a conversation that took place in Dublin in March 2002.
2 *Celebration Robes*, joint exhibition with Joyce Wieland, Limerick: City Art Gallery, 1989; *The Thicket*, touring exhibition of recent work, Cork: Triskel Arts Centre, and other venues throughout Ireland, 1991–92.
3 *Ombre*, first exhibited as a wall drawing, Dublin: Green on Red Gallery, 1997.
4 *Keep*, Belfast: Old Museum Arts Centre, 1992.
5 *Gorget and Other Works*, New York: Nolan/ Eckman Gallery, 2000.
6 Included in the group exhibition *Art as the Object of Desire*, Belfast: Fenderesky Gallery at Queens, 1995.
7 The *Bee Dress* was included in Maher's exhibition *familiar* at the Douglas Hyde Gallery, Dublin, in 1994.
8 *Folt* (meaning abundance, tresses) was included in the group exhibition *Relocating History*, Belfast: Fendersky Gallery at Queens, 1993.
9 Alice Maher, *Necklace of Tongues*, Clonmel, 2001.

6.1 Kara Walker, *Beat*, 1998. Cut paper and adhesive on wall, 152.4 × 81.28 cm. Reproduced courtesy of the artist and the Brent Sikkema Gallery, New York City.

6

Reading Black Through White in the Work of Kara Walker

A discussion between Michael Corris *and* Robert Hobbs

Kara Walker, born in 1969 in Stockton, California, lives and works in Providence, Rhode Island. She studied art at the Atlanta College of Art, Atlanta, Georgia and the Rhode Island School of Design, Providence. She began exhibiting in the early-1990s and has shown extensively throughout the US and the UK. Walker's work has been exhibited at, among others, the Renaissance Society at the University of Chicago, the San Francisco Museum of Modern Art, the Hayward Gallery, the Barbican Art Gallery, London, the Armand Hammer Museum of Art, Los Angeles, and the Whitney Museum of American Art, New York. In 1997 Walker was the recipient of a John D. and Catherine T. MacArthur Foundation grant, the so-called 'genius' award. Most recently, Walker was the featured US artist at the 25th Bienal Internacional de São Paolo (23 March–2 June 2002).

As a complex and controversial artist who powerfully references the institution of slavery and the visual resources of racial stereotyping, Walker's work continues to raise issues germane to an understanding of the African-American diaspora. While clearly indexed to the debate on ethnically explicit visual art in the United States, Walker's concerns and the controversies they engender are not without resonance for contemporary British artists, critics and historians. Work of the past decade by British artists of Afro-Caribbean descent, such as Sonia Boyce, Isaac Julien and Keith Piper, serves to demonstrate the continuing vitality in visual art of the issue of race and the Black diaspora. It also shows how artists have managed to extend such analyses by inflecting them with gender and class. Not surprisingly, some of the most generative work in the field has been, and continues to be, produced by women artists.

MC: *When asked about her obsession with violence in American life, the artist Cady Noland indicated that it is the circumstances under which people treat other people like objects that she finds of interest. Noland became interested in social psychology and the analysis of psychopathic behaviour because of the social phenomenon of objectification. For the artist, such social mores define the outer limits of a tendency already inscribed within American history and culture.[1] Noland's powerful evocation of American violence is indexed to specific socio-cultural contexts or class strata. One of these has been aptly described by the historian Brandon Taylor as being 'redolent of the mid-West or*

6.2 Photograph of Cady Noland's installation at the Anthony Reynolds Gallery, London, 1989. Reproduced courtesy of the artist and the Anthony Reynolds Gallery, London.

Southern states'.[2] In her famously menacing installations of the early 1990s Noland always managed to treat violence as a differential category by sorting it out in terms of its relation to politics (for example, political assassination) and class (civil violence and police repression directed at a specific sector of the public), while making a more general point about its role in a society of conformity and harassed avenues of political dissent (plate 6.2). In Kara Walker's work, one also finds representations of violence framed by what strikes me as a similar kind of attitude. There is a menacing starkness, or cold-blooded feeling to Walker's panoramas. Representations of African-American slave bodies and white bodies are deployed as instruments to be used or vessels to be violated and discarded like trash. What is your impression of Walker's mixture of race and violence?

RH: Cady Noland's violence is directed outwards, while Kara Walker's is directed inwards, and its target is the effect of that highly ideological construct: race. Instead of achieving the critical distance permitted Noland by her study of psychopathic social behaviour, Walker looks at the racist stereotypes that affect her, and she employs abjection as a means for rethinking them.

6.3 (left) Cady Noland, *Your Fucking Face*, 1993–94. Aluminium over wood, stock: 152.4 × 142.2 × 20.3 cm, stool: 53.3 × 30.5 × 29.2 cm; and (right) *Gibbet*, 1993–94. Aluminium over wood draped with the American flag, stock: 152.4 × 142.2 × 20.3 cm, stool: 53.3 × 30.5 × 29.2 cm. Reproduced courtesy of the artist and Paula Cooper Inc., New York.

When you mention abjection, I cannot help but visualize Noland's self-portrait in a stockade (plate 6.3).

In Walker's art abjection is something distinctly different: a blurring of boundaries between self and shadow, black and white, publicly sanctioned acts and transgressive ones that are capable of destroying established and limited subjectivities (see plate 6.1). The body is opened to the social order, a more permeable world that experiences flows from the inside as well as from the outside. The ensuing destabilized abject realm becomes a virtual Garden of Delights on a par with Hieronymous Bosch's, in which couplings are less intended to constitute straightforward descriptions of orgiastic sex – although shock value does play an important role in characterizing the miasma of abjection – and more like symbolic references to the obfuscation resulting in an undermining of the established order of clearly defined stereotypes. The irony of Walker's work is found in her need to enter the stereotypical realm of the Antebellum in order to combat it. Conceptualized as the sense of emptiness that comes before the formation of a new ego – the void into which the present definition of the self is given up with no thought or hope of a new unifying ego – abjection represents the midnight of existence that Walker portrays as a insubstantial domain of vacancy lying beneath the surface of stereotypes.

Again, with reference to Noland's work, we understand the concept of abjection as it is coded through the use of the stockade, the allusion to the boxing ring, the restraining and offensive paraphernalia of police, and the way these elements are collaged or strung together. In principle, Noland's installations invite the physical participation of the viewer. Is there a similarly coherent, visceral iconography that is at work in Walker's panoramas?

The iconographic equivalent to the black hole and abjection in Walker's works are the piles of dung in *Slavery, Slavery!* which she at first excuses as a sign for 'letting it all hang out' (plate 6.4). Then she goes on to qualify faeces as a metaphor for 'finding one's voice in the wrong end; searching for one's voice and having it come out the wrong way'.[3] The difficulty facing those who have been deemed stereotypical and have internalized even a smidgen of its pernicious effects is that their voices have already been co-opted and lost. According to Julia Kristeva,

> excrement and its equivalents ... stand for the danger to identity that comes from without: the ego threatened by the non-ego, society threatened by its outside, life by death. ... Fecal matter signifies, as it were, what never ceases to separate from a body in a state of permanent loss in order to become *autonomous, distinct* from the mixtures, alterations, and decay that run through it.[4]

In *Slavery! Slavery!* Walker contrasts the heap of excrement (located at the extreme right-hand side of the composition) with an all-giving fountain (plate 6.5). Both are two-dimensional stereotypes in cut paper. While faeces reinforce the emptiness of a self that has already evacuated (abjected) itself, the fountain celebrates an ongoing permeable and continuously fecund mirror image that holds out the promise of a fuller self-image, even though it is, in essence, just another stereotype. We might say that the dung and fountain connote two different aspects of abjection: dung signifies the hollowness that attends rejection of one's current subjectivity, while the fountain portends a fuller, richer, and more complete self. Located to the side of the central moon in *Slavery! Slavery!* the two represent different cycles in the anxious night of destabilization that is the condition of abjection.

Walker asserts that there is no such thing as the African-American who is also not partially constituted by the racial stereotypes that were used to justify slavery, segregation, race murder, the KKK, etc. The critic bell hooks, on the other hand, interprets the stereotypes of Walker as a form of repression. They are seen by her to play into the hands of 'The White Man' who everywhere seeks to establish the conditions where actual and symbolic repression returns to thwart the aspirations of African-Americans. The stereotype, in effect, becomes a material fact in the ongoing repression of the African-American, a denial of her humanity. Walker is as personally aware as any African-American of the effect of racial stereotyping. Yet, she seems to be asking all Americans to take hold of this stereotype, to emblematize it, and to fantasize through it. Don't turn

6.4 Detail from Kara Walker, *Slavery! Slavery!*, 1997. Cut paper and adhesive on wall, 3.57 × 25.9 m overall. Collection of Peter Norton Family Foundation. Reproduced courtesy of the artist and the Brent Sikkema Gallery, New York City.

away from it; rather, recognize it as a profound part of your being and consciousness as an African-American (and, for another sector of the audience, as a White American). It's your 'Mom-and-apple-pie' moment, your share of the American Dream Death Trip. While no one is suggesting that Walker does not believe deeply that racial stereotyping is abhorrent and a key element of racist thought, it is interesting to me that the artist's use of such stereotypes has been most vehemently contested by an older generation of African-Americans. To my knowledge, no white commentators have taken issue with her use of stereotypical imagery. But before we get into the specifics of that controversy, I'd like to explore further here the nature and function of stereotyping. With regard to this, Manning Marable refers to the 'stumbling block of stereotypes' as 'the device at the heart of every form of racism today'.[5] For Marable, the degrading effect of the stereotype is not only the result of the objectification of human beings, but quite clearly a denial of a people's entire history and culture. Aside from Walker's fantastic portrayal of antebellum slavery, what role – if any – have other aspects of African-American diasporic history and culture played in the genesis and development of her work?

Although Walker's art has not been viewed in terms of the relatively recent post-Civil Rights fascination with black collectibles by upscale African-Americans, it is in part predicated on a re-evaluation of this material, which she collects on a modest scale. The first acknowledged gallery exhibition of black memorabilia was the 1982 show *Ethnic Notions* at the Berkeley Art Center, Berkeley, California, which featured the collection of Janette Faulkner, an African-American social worker who began acquiring so-called blackface objects in the early 1960s.[6] In her justification for building such a collection, Faulkner described her initial shock at finding in an antique shop a postcard picturing a stereotypical view of a man with missing teeth that bore the caption, 'dares mo laak dis back home'.[7] Faulkner explained that collecting and living with such objects – which presented her with an historical perspective – strengthened her ability over the years to cope with racial prejudice. Moreover, studying large quantities of this material enabled her to gain a needed aesthetic distance. Over time, she acquired the tempering lens of connoisseurship that enabled her to focus on issues of style, technique and quality, rather than dwelling exclusively on the subject matter of racial stereotyping.[8] But collecting Black memorabilia became much more than a rigorous act of valour enabling her to steel herself against racial prejudice, violence and adversity. Even though collectors of Black memorabilia have regularly taken refuge in the rationale that they are buying history, an appreciation for a past reality extending to its darkest aspects is, in retrospect, not the main reason for the pursuit of this material. In *Ethnic Notions*, Robbin Henderson, Director of the Berkeley Art Center, provides an answer by pointing out unequivocally that 'this is not a collection of artifacts about black history. Most of this material was created by white people. It is the consciousness of the dominant class which we see in this collection.'[9] The practice of collecting blackface memorabilia has thus become enormously empowering to blacks, as these artefacts are now being seen as an ongoing indictment of racist white attitudes that have materialized as racist Americana.

6.5 Detail from Kara Walker, *Slavery! Slavery!*, 1997, showing the fountain. Cut paper and adhesive on wall, 3.57 × 25.9 m overall. Collection of Peter Norton Family Foundation. Reproduced courtesy of the artist and the Brent Sikkema Gallery, New York City.

The suggestion that stereotypes depict the consciousness of the dominant class seems to me to be precisely at the heart of the criticism ranged against Walker and others who try make artistic use of such imagery. The charge against Walker is that stereotypical representations of African-Americans cannot be rehabilitated; they are absolutely inappropriate as resources of expression. During the late-1990s Walker – along with artists such as Glenn Ligon, Lorna Simpson, Michael Ray Charles, Ellen Gallagher, Fred Wilson and Robert Colescott – was among a coterie of African-American artists accused of racist complicity by Howardena Pindell.[10] Pindell contended that these artists had sold their souls to the white art mainstream precisely because they continued to provide degrading images of blacks for the amusement of primarily white art audiences. Walker's reply to her critics simply inflamed them. 'What is troubling and complicates the matter', writes Pindell, 'is that Walker's words in published interviews mock African-Americans and Africans ... She has said things such as, "All black people in America want to be slaves a little bit." ... Walker consciously or unconsciously seems to be catering to the bestial fantasies about blacks created by white supremacy and racism.' In a similar vein, the American artist Betye Saar[11] circulated a petition that urged the MacArthur Foundation to rescind its 'genius' award to Walker. How, in your estimation, does Walker's work – her use and staging of stereotypes – compare to that of other African-American artists of her generation? Do you believe that the anger and betrayal felt by some segments of the African-American community is justified?

The event that first alerted Walker to the ways that the enslavement of blacks can be both legitimized and romanticized was the 1977 television mini-series *Roots*, based on Alex Haley's 1976 book of the same title. This chronological tale, spanning the years 1750 to 1895, purportedly chronicles the diaspora of the author's own family from Africa to the New World and characterizes it as a journey from slavery to freedom. Although only eight years old when this mini-series made its initial appearance on television, Walker was puzzled by the fascination that both slavery and the antebellum period held for older African-Americans. 'I don't remember much of the story,' Walker recalled, 'but I know it was very important, we all watched it. Everyone came into school – it was fourth grade – and started making fun of it. So it became just another joke.'[12] Extraordinarily popular, the series attracted 130 million viewers: the largest television viewing audience in the United States up to that time. Walker was too young to realize that Haley's narrative of his family's battles against enormous odds enabled her elders at long last to talk about the execrable institution of slavery and their ancestors' participation in it. But she did discern how post-*Roots* African-Americans inadvertently began to idealize the legacy of resiliency and strength they believed themselves to have inherited from enslaved forebears. Instead of continuing to be ashamed of their distant connections with slavery, Haley's fans began acknowledging this heritage and searched for ways to research their own genealogical backgrounds – by first facing the void that slavery had become, and then moving, if possible, beyond the Middle Passage to Africa. Although this acceptance was a distinct gain, it had the unmistakable drawback of glorifying slavery as a sacred myth and essential rite of passage.

Years later, in response to this effect, Walker commented cryptically that 'black people's "tolerance" of racial horrors in the past makes them better masochists and more colorful rioters in the future.'[13]

The 1990s was a decade when a post-Civil Rights, African-American identity became a full-blown reality. There are many wonderful artists working with this identity, as you suggest. Questions most often asked about them are: do these artists really need to signal their ethnicity in their art? Are they being unnecessarily encumbered by their ethnic orientation? Perhaps the question that should be asked is: why, in the 1990s, did these artists feel the need to declare ethnicity a central aspect of their work? I think the answer lies in the double bind of being still encumbered by the idealism of the mid-century Civil Rights movement, while still having to suffer the injustices of discrimination. Each member of this generation has formulated his or her strategy for coping with this double bind. Lorna Simpson plays with the unattainable masks that haunted Pan-Africanists. Gary Simmons views African-Americans as the blackboard on which the smudged, chalk-written signs of white racism are still evident. Fred Wilson re-inscribes, in one of his most notable works, the material traces of slavery in an historic museum which tried over the years to efface them. Michael Ray Charles reasserts the iconic emblems of Jim Crow-era stereotypes, while Glenn Ligon's mantra-like repetitions reinforce yet again the damning epitaphs and proclamations of bigotry. Among this illustrious group, Walker distinguishes herself in terms of the dialectic between silhouettes as culture and shadows as nature that forces her cutouts to participate in the schizophrenic insanity of being stereotyped and then displaced. It is a moot point whether anger is the generative force for these works. I tend to think that all these artists are deconstructionists who are rigorously confronting the imprisoning effects of racism that have mediated their identity by plaguing it with inherent contradictions.

I would like to cite at length a postscript added by Pindell in 2002 to her paper delivered at the conference 'Trade Routes, History, Geography, Culture: Towards a Definition of Culture in the late 20th Century', organized as part of the Johannesburg Biennale, October 1997:

> *Rasheed Araeen in his article 'The Art of Benevolent Racism' in* Third Text *(summer 2000) examines what he calls the 'positive stereotype' which he feels is encouraged by 'benevolent racism.' The 'positive stereotype' is the expectation that artists of color will create work about their ethnicity, therefore locating themselves outside of the mainstream, separate and different. The mainstream feels that it is not racist in encouraging and embracing the work, but if the mainstream embraces the work, it will not tolerate or acknowledge work by non-whites that is not ethnically based in difference. White artists, on the other hand, can create work which is avant-garde and addresses a wide range of issues.[14]*

The current situation, argues Araeen, has increased in complexity because artists of colour are ranged against both the white establishment and the new

functionaries of colour appointed to protect neo-colonial power and beliefs. In other words, artists of colour are damned if they do, and damned if they don't. Araeen argues that 'the use of "negative stereotype" reproduces and perpetuates an "apartheid" imperialistic culture while the "positive stereotype" makes it look benign.'

Mainstream culture's familiarity with stereotypes does not equip it to understand the dynamics of how these hackneyed and usually pernicious labels can entrap their subjects, thus making the polarities of positive and negative stereotypes irrelevant distinctions. Because ideology's chameleon-like ability allows it to assume the look of reality, its capacity for subsuming stereotypes under the guise of 'the natural' has proven more insidious than one might expect. Firmly established in the annals of black cultural studies, the received wisdom regarding these images is derived in part from the prescient thought of the ex-patriate Martinican psychiatrist, theorist and revolutionary Frantz Fanon. In his widely read *Black Skin, White Masks*, Fanon employs Jacques Lacan's well-known 1938 recasting of Freud's theory of identity formation in terms of ongoing paranoia as a basis for his own discussion of the type of problems that can result from perpetuating racial stereotypes. Fanon substantially rethinks Lacan's Imaginary realm by bumping it up to a level that focuses on the way that entire social groups, consisting of individuals each undergoing a similar process, can be held hostage by an image. In the process Fanon apparently conflated aspects of Lacan's Symbolic order, designating the world into which one is born, with his Imaginary sphere, because the two realms are viewed dynamically as desired or (perhaps, more realistically) necessary images in the structuring of an ego consistent with the dominant social order. Known as the 'mirror stage', Lacan's theory focuses on the alienation of Self that comes from a child basing its identity on an external mirror image or another person. Even though the 'mirror stage' references the first occurrence of this process of ego formation through disjunction, this process can be reformulated in terms of an entire social group.

The result of this broad-based operation is an insidious falsifying ego that subjects and enslaves individuals both socially and culturally, forcing them to identify with the degraded state of being that they have internalized. Fanon dramatizes this situation in the following hypothetical, yet tragically real situation:

> As I begin to recognize that the Negro is the symbol of sin, I catch myself hating the Negro. But then I recognize that I am a Negro. There are two ways out of this conflict. Either I ask others to pay no attention to my skin; or else I want them to be aware of it. I try then to find value for what is bad – since I have unthinkingly conceded that the black man is the color of evil. In order to terminate this neurotic situation, in which I am compelled to choose an unhealthy, conflictual solution, fed on fantasies, hostile, inhuman in short, I have only one solution: to rise above this absurd drama that others have staged round me, to reject the two terms that are equally unacceptable, and, through one human being, to reach out for the universal.[15]

114

While Fanon's solution is assuredly modernist in terms of its quest for universals and essences, Walker's development is manifestly postmodernist as it views the world in terms of clichéd historical romances that reduce all humanity into stereotypes which, by their own definition, are locked into the rigidities of limited perspectives.

In a lecture given at the School of the Arts, Virginia Commonwealth University, on 24 October 2000, Walker alluded to the type of Lacanian reading of stereotypes that Fanon proposes. It's worth noting that her images have been so daunting that the Fanon connection has not been mentioned in the voluminous literature on her. 'When stereotypes attempt to take control of their own bodies,' Walker pointed out, referring to blacks at large, 'they can only do what they are made of, and they are made of the pathological attitudes of the Old South. Therefore, the racist stereotypes occurring in my art can only partake of psychotic activities.' Rather than subscribing to the previous generation's crusade to create a morally uplifting and regenerative art capable of revivifying stereotypes, Walker's statement suggests that well-intended efforts by artists such as Betye Saar are doomed to failure. This is because even the most seemingly benign stereotype by its very nature has created, in Walker's words, an 'unredeemable' form of alienation.[16] Regarding this entire generation's desire to gentrify stereotypical images of blacks, Walker succinctly commented, 'I saw a lot of works steeped in history and in the awareness of self and pride – and enormous intangibles, issues that often get didactic.'[17]

And the staging, or tropes employed by Walker (plate 6.6)?

The insanity that Walker pictures is not a direct transcription of the external world but is instead the ossified and dehumanizing world of the stereotypical, similar to the art of Warhol, which she has acknowledged admiring.[18] But Walker is more than a mere Warhol follower; she is, in fact, a fellow traveller because she has discovered her own terrain in the fictionalized histories constituting the contemporary genre of Harlequin Romances and their turn-of-the-twentieth-century antecedents. These cheap-pulp, fictionalized histories are the novelistic counterpart to the blackface contemptible collectibles that have unleashed the recent spate of ideological battles we have been discussing. As an African-American, Walker was familiar with the tremendous power of Harlequin Romances and their perpetuation of racist stereotypes, because she had been subjected to the analogous situation of becoming someone else's stereotype. This obviously painful experience resulted in a need to construct a pseudonymous identity for herself as a stereotype which was, in turn, capable of generating a new series of stereotypes. The situation is akin to having her shadow, her alias, give birth to a new order of being. Its distinct advantage is the distance that it creates between herself and her imagery, allowing her to heighten the stereotypical nature of her imagery so that its removal from the real world is one of its key features. Instead of using herself as a lens for viewing the past, she enlists the aid of an alias from another time as the perspective from which to assess the contemporary world, so that the present is viewed in terms of the past.

6.6 Detail from Kara Walker, *Camptown Ladies*, 1998. Cut paper and adhesive on wall, 2.74 × 20.42 m overall. Rubell Family Collection. Reproduced courtesy of the artist and the Brent Sikkema Gallery, New York City.

But this bygone era is an ideological past, not simply a distant historical period; in other words, it is the fictionalized version of the past that has developed according to the rigid genre rules of the Harlequin Romance.

Her pseudonym initially took on the wonderfully archaistic sobriquet 'Miss K. Walker, A Free Negress of Noteworthy Talent' and was first used in 1994 for *Gone*. The pseudonym was a hybrid predicated on the tensions that developed from her readings of such slave narratives as Harriet Jacobs's *Incidents in the Life of a Slave Girl* and such racist novels as Thomas Dixon, Jr's *The Clansman*.[19] This novel – which served as the basis of D.W. Griffith's film *Birth of a Nation* – spans the first years of Reconstruction from 1865 to 1870.[20] Walker then incarcerates both types of narration in the genre strictures of the Harlequin Romance, so that these earlier writings become the initial alembic that is then further distilled in terms of the distinct parameters used for contemporary pulp fiction. According to Dixon's story, Lydia Brown, the mulatto mistress of his protagonist Austin Stoneman, is portrayed as dragging her white lover into her 'black abyss of animalism'. Besides these sources, the persona of Miss K. Walker also draws on the artist's childhood fantasies about what life would have been like if she had been born a slave. These fantasies were undoubtedly catalysed by her experience of moving, when she was thirteen, from a liberal community in Stockton, California, to the reactionary town of Stone Mountain, Georgia,[21] where the Ku Klux Klan, which had been revived in the second decade of the twentieth century, held annual meetings.

I am struck by the sense of ambiguity that surrounds some of the action depicted in Walker's work. Do you agree with that assessment?

To return to Fanon, *Black Skin, White Masks* underscores the seductiveness of popular culture ideologies that are capable of alienating people from themselves:

> The Tarzan stories, the sagas of twelve-year-old explorers, the adventures of Mickey Mouse, and all those 'comic books' serve actually as a release for collective aggression. The magazines are put together by white men for little white men. This is the heart of the problem. In the Antilles … these same magazines are devoured by the local children. In the magazines, the Wolf, the Devil, the Evil Spirit, the Bad Man, the Savage are always symbolized by Negroes or Indians; since there is always identification with the victor, the little Negro, quite as easily as the little white boy, becomes an explorer, an adventurer, a missionary 'who faces the danger of being eaten by the wicked Negroes'.[22]

In the situation Fanon describes, ideology works through mass-media publications and encourages blacks to become blank screens for the projection of white racist stereotypes. Initially, they internalize white supremacist views by identifying with them; only later, and very rarely so, do they realize that their complicity results in estrangement from themselves. Their insight, however, cannot take the now comforting view of W.E.B. DuBois's 'double-conscious-ness', as described in *The Souls of Black Folk*. In it, DuBois posits the idea that

the black person can discern himself or herself being seen through the perspective of mainstream culture.[23] But the self is not the natural entity DuBois assumes it to be; rather, it is a cultural construct subject to the whims and wiles of the models it has internalized, resulting in a type of ongoing paranoia.

In addition to identifying with heroes, collusion with negative ideologies often occurs through humour, which cajoles people into laughing about situations that may undermine their own positions. Recognizing the danger of this form of entertainment, Walker has pointed out,

> I have a funny problem with humor, I guess, because I don't consider it fun. I remember cartoons on TV that were old, pre-Mickey Mouse cartoons. These mysterious black-faced mice. I saw new prints of old Bull Durham ads with these coon scenes, genre scenes, sitting on the porch with all the animals. ... Whatever else they might be, they were also intended to be hilariously funny. The black person was the butt of all kinds of jokes from Vaudeville to Hollywood on up. Where are we now? I think we've stopped being funny.[24]

Isaac Julien describes his own work as having been profoundly informed by a political diasporic consciousness and it remains occupied with contesting racist images and stereotyping. In this regard, Julien's 1996 film Frantz Fanon: Black Skin, White Mask *– co-written by Mark Nash – is absolutely central. Walker, on the other hand, is far more ambivalent about such representations. Henry Louis Gates, Jr, director of the W.E.B. DuBois Institute at Harvard University, defends Walker's work as an act of artistic exorcism. He has written that 'only the visually illiterate could mistake this post-modern critique as a realistic portrayal, and that is the difference between the racist original and the post-modern, anti-racist parody that characterizes this genre.' What, finally, is the African-American subject that Walker seeks to constitute?*

Kara Walker's works play off the seamy excesses of such books as Kyle Onstott's *Mandingo*, with which she is well acquainted.[25] The copy for the back cover of this 1950s bestseller, which was made into a motion picture, interpolates a readership wishing to view the world in stark contrasts and bold headlines:

> Expect the savage. The sensual. The shocking. The sad. The powerful. The shameful. Human Breeding Farm. Behind the hoop skirts and hospitality, the mint juleps and magnolia blossoms of the Old South was a world few people knew existed – a world of violence, cruelty, greed and lust. MANDINGO brings to vivid life the sounds, the smell, the terrible reality of the slave-breeding farms and plantations where men and women were mated and bred like cattle. You may rave about MANDINGO or you may hate it, but you won't be able to lay it down, because it is a terrible and wonderful novel! A novel no one dared to publish until now!

The present to which this hype refers is 1957, a memorable time as regards Civil Rights battles for African-Americans who had witnessed the successful

resolution of the Montgomery bus boycott the year before. *Mandingo*'s excesses may have appealed to racists, who felt angered by the passage of the Civil Rights Act. That piece of legislation provided the Federal government with the ability to enforce voting rights for all Americans; it also established a Federal Civil Rights Commission with the authority to investigate discriminatory conditions and recommend ways of correcting them. In addition, *Mandingo* furnishes other readers with a titillating and sadistic screen onto which their anxieties about the effects of integration could be projected, symbolically experienced, and discharged. Although Walker is unconcerned with *Mandingo*'s original readership, she allows its mixture of sex and violence in the antebellum South to suffuse her work with its moonlight-and-magnolia air, thereby providing it with an ideological platform for staging her orgiastic scenarios.

There is sufficient justification for terming Walker's use of the stereotypical subject matter of such semi-pornographic books as *Mandingo* as 'signifying' if one looks closely at the way African-American studies scholar Henry Louis Gates, Jr. qualifies the term. In his extract from *The Signifying Monkey*, entitled 'The Blackness of Blackness: A Critique of the Sign and the Signifying Monkey' (published the year before his more extensive work was released), Gates condenses his theories by defining signifying as an African-American 'trope for repetition and revision, indeed ... our trope for chiasmus itself, repeating and simultaneously reversing in one deft discursive act'.[26] Later in this essay, Gates abbreviates this definition even more, by equating signifying with 'parodying ... through repetition and difference'.[27] Gates's description of the figurative thrusts of the trickster figure – the signifying monkey – has been heralded as a major contribution to black literary theory. In retrospect, the incredible success of Gates's codification of this theory can be attributed to its ability to signify on both modernism and postmodernism, as it discerns the essence of postmodernism – an activity that is supposed to root out modernism's essences – to be consistent with African-American experience, which he reifies into a playful activity worthy of this infamous folk trickster. In the 'Blackness of Blackness' Gates undertakes the contradictory goals of explicating signifying's operations in terms of such classic rhetorical devices as chiasmus and metalepsis while preserving a distinct ethnic uniqueness for it. In doing so, he inadvertently sets up tensions between classical antecedents and African-American usage, so that signifying appears to be a distinct historical enactment of the mirror inversions of chiasmus. What makes signifying special is Gates's implication – supported by other prominent twentieth-century blacks from Zora Neale Hurston to Richard Pryor – that this process creates a space within the confines of mainstream culture for African-Americans to act. Of course, one can argue – as does theorist Homi Bhabha – that discernible differences occur whenever subjected groups mime their colonizers because their worldviews are so dissimilar.[28] Seen in this light, signifying is a special occasion of a much more thoroughgoing process occurring in colonial and postcolonial situations. In addition to its affinities with chiasmus, signifying cultivates tensions occurring in postmodern appropriation between established and new meanings that encourage readers to look for intertextual similarities and differences. And this Walker does when she hollows out spaces in *Gone With the Wind*, *Harlequin Romances*, history

119

painting and a number of other established sources in which to parade her cast of shadows. Her textual insurrection and redirection is chiasmic and appropriative; it is also a form of signifying because mainstream productions are being doubled in order to parody them and unfold a black perspective. This view characterizes society's ready acceptance of the clumsy machinations of entrenched ideology as incredulous and absurd shadow plays.

Would you comment on the kinds of bodies that Walker invents?

I do not think Kara invents bodies *as such*. Her figures are types, stereotypes actually, that have populated racist popular culture images for the past 150 years. In order to understand the semiotic of silhouettes as the essence of the bodies they represent – an idea that contributes to the irony of Walker's work – I would like to return to the origins of this nineteenth-century popular art form in the now-discredited science of physiognomy promoted by the minister Johann Caspar Lavater (1741–1801). In its overweening emphasis on the cranium and related cartilaginous areas, physiognomy differs from pathognomy, which purports to explicate the meaning of facial expressions created by coordinated movements of muscle and skin. In one interview, Walker indicated her knowledge of Lavater's physiognomy when she pointed to the nineteenth-century vogue for silhouettes and their connection with it:

> [The silhouette tradition] comes from a sort of polite middleclass society to some extent. It's not as haughty and aristocratic as a full-fledged oil painting portrait. Everyone could get one for a few pennies – and you had an image, you had connection with physiognomy.[29]

There is little doubt that the late eighteenth- and early nineteenth-century fashion for silhouettes developed from Lavater's tremendously popular demonstrations of physiognomy's merits, published in his *Physiognomische Fragmente zur Beförderung der Menschenkenntnis und Menschenliebe*, 4 vols (1775–8) and the English version, *Essays on Physiognomy* (1789–98). Six years later, a condensed version – *The Pocket Lavater* – was printed. No less significant a figure than Johann Wolfgang von Goethe (1749–1832) helped Lavater with his book. Their close friendship ended, however, when Goethe lost respect for Lavater's compulsion to convert people to his way of thinking, which the latter came to revere as if it were a new religion.

There is, admittedly, an intense spiritual subtext to Lavater's physiognomy because it developed out of the mystical thought of Emanuel Swedenborg (1688–1772). In particular, it relies on Swedenborg's idealist view of the world as a revelation of God's essential Being through His creations. Therefore, distinct correspondences between spiritual and earthly realms are evident, as well as those separating the interior realms and exterior visages of human beings. Taking up Swedenborg's theory, Lavater posited the concept of silhouettes as the primary diagnostic tool for physiognomic studies as he assumed that the divine spirit had a definite impact on human features. In Platonic terms, the profile was considered to be closer to the level of ultimate

Forms than the incidental accidents of symmetry or its lack because it was credited with reflecting formative psychic energies.[30] Although Lavater is guilty of subscribing to such clichés as aristocratic high foreheads, brutish thick lips and determined jaws, indicating his role as a synthesizer of popular attitudes rather than as a discoverer of a new interpretive tool, his *Essays on Physiognomy* – with its detailing sets of profiles and descriptions of how they reveal predominant individual features – influenced many painters. It also stimulated the widespread fashion for silhouettes and the popular belief in their ability to go beyond capturing a given sitter's physical likeness to convey a sense of his or her essential being.

What relation, then, does this popular form – the silhouette – have to Walker's imaginary scenarios?

Walker's two-dimensional silhouettes – which should be read as ciphers for two-dimensional characterizations – have as one of their sources the antebellum 'one-drop rule' that declared all mulattos to be legally categorized as negroes. This rule exacerbated rather than alleviated race relations because it ignored an intense and ambiguous middleground – mulatto slaves who were multiplying in the antebellum South as white masters coupled with their female property for sport and profit. In the 1850s this activity was efficiently organized and little discussed: female slaves were regularly impregnated, primarily in Virginia and the Carolinas, by both blacks and whites in order to meet the increasing demands for more negroes – to grow and pick cotton in the booming frontier slave states of Alabama, Mississippi and Louisiana. The number of mulatto slaves is estimated to have increased by 66.9 per cent in the decade before the Civil War.[31] As the astute chronicler Mary Boykin Chesnut of Charleston noted at the time,

> God forgive us, but ours is a monstrous system, a wrong and an iniquity. Like the patriarchs of old, our men live all in one house with their wives and their concubines; and the mulatto children one sees in every family partly resemble the white children. Any lady is ready to tell you who is the father of all the mulatto children in everybody's household but her own. Those, she seems to think, drop from the clouds.[32]

In consideration of this 'one-drop' ruling, it is important to note that Walker makes all the figures inhabiting her work, regardless of their ethnic affiliations, into black silhouettes. The implication is that the institution of slavery is itself a shadowy realm that joins together all those participating in it. Walker's work is far removed from the essentialist, modernist view of 1960s African-Americans, who proclaimed, 'Black is beautiful.' Her approach to blackness is closer to the parody of the 'blackness of blackness' prologue in Ralph Ellison's *Invisible Man*, summarized by Gates in the following manner:

> As Ellison's text states, 'black is' and 'black ain't.' 'It do, Lawd', 'an' it don't.' Ellison parodies here the notion of essence, of the supposedly natural relation between the symbol and the symbolized. The vast

and terrible Text of Blackness, we realize, has no essence; rather it is signified into being by a signifier.[33]

Similar to Ellison's parody, Walker's work presents black as a destabilized term, whose meaning ricochets back and forth among a number of variables. This assessment correlates with her conclusion that 'the silhouette speaks a kind of truth. It traces an exact profile, so in a way I'd like to set up a situation where the viewer calls up a stereotypic response to the work – that I, black artist/leader, will "tell it like it is". But the "like it is", the truth of the piece, is as clear as a Rorschach text.'[34]

In addition to playing with stereotypical figures arising from the antebellum South, Walker's art participates in a shadowy realm that deserves a far greater explication than it has thus far been given in writings about her work. Shadow functions as both index and icon, to use Charles S. Peirce's characterization of an index as a motivated and contingent sign and an icon as an illustrative one. They are both dependent on an external light source directed towards a given entity, and function as representations of that same entity. The status of shadows as ideological constructs bespeaks not a double death but instead a twofold removal from life, as the shades represented in Walker's work are unable to die because their only prior existence is a fictive one. Instead of denoting the essence of an individual soul, Walker's shadows are extrinsic forms detached from humanity, which they only distantly resemble. Moulds for replicating reality on a par with Warhol's standardized products, her stereotypical shadows are both absences and voids. 'It's a blank space', Walker said in reference to her silhouettes, 'but it's not at all a blank space, it's both there and not there.'[35] Her images are similar to the likenesses presented to the hypothetical prisoners in Plato's cave, whose only sense of reality are Forms' pale vestiges in the guise of shadows, which could be construed, as they are in Walker's art, as ideological constructs. Unlike the shadows described by psychologist C.G. Jung, that are purported to represent the essence of an individual's repressed self or a collective identity pleading for recognition, Walker's shades are far from repressed. Instead of begging for acknowledgement, they are blatantly disruptive in their attempts to supplant reality through shock.

Michael Corris
Kingston University

Robert Hobbs
Virginia Commonwealth University

Notes

1 See Cady Noland, 'Towards a Metalanguage of Evil', *Balcon Magazine*, 1989, re-edited 1992 and published as a pamphlet to accompany her project for Documenta IX, Kassel, Germany. That project – produced in association with the critic Robert Nickas – was described at the time by the artist as a three-dimensional realization of the essay.

2 Brandon Taylor, *The Art of Today*, London, 1995, p. 154. Noland – who now rarely exhibits publicly – is best known for works of exceptional visual and emotional impact whose elements are drawn from US history and contemporary American Society.

3 Jerry Saltz, 'Kara Walker: Ill-Will and Desire', in *Flash Art*, no. 191, November/December 1996, p. 84.

4 Julia Kristeva, *Powers of Horror: An Essay on Abjection*, trans. Leon S. Roudiez, New York, 1982, pp. 71 and 108.

5 Manning Marable, 'Black America: Multicultural Democracy in the Age of Clarence Thomas and David Duke', Westfield, NJ: Open Magazine Pamphlet Series, 1992, p. 3.

6 *Ethnic Notions: Black Images in the White Mind: An Exhibition of Afro-American Stereotype and Caricature from the Collection of Janette Faulkner*, exhib. cat., Berkeley: Berkeley Art Center, 12 September–4 November, 1982, p. 7.

7 *Ethnic Notions: Black Images in the White Mind*, exhib. cat., 1982, p. 7.

8 *Ethnic Notions: Black Images in the White Mind*, exhib. cat., 1982, p. 7.

9 *Ethnic Notions: Black Images in the White Mind*, exhib. cat., 1982, p. 12.

10 Howardena Pindell, 'Diaspora/Realities/strategies', a paper presented at 'Trade Routes, History, Geography, Culture: Towards a Definition of Culture in the late 20th Century', Johannesburg Biennale, October 1997, updated with a new postscript, January 2002, http://web.ukonline.co.uk/n.paradoxa/pindell.htm.

11 Pindell, 'Diaspora/Realities/strategies', 2002.

12 Saltz, 'Kara Walker', p. 84.

13 Anonymous, 'Extreme Times Call for Extreme Heroes', *International Review of African American Art*, vol. 14, no. 3, 1997, p. 8.

14 Pindell, 'Diaspora/Realities/strategies', 2002.

15 Franz Fanon, *Black Skin, White Masks*, trans. Charles Lam Markmann, New York, 1967, p. 197. Note that on p. 161, n. 16, Fanon describes Lacan's theory of the 'mirror stage', which he terms the 'mirror period'.

16 Cf. Betye Saar, 'Unfinished Business: The Return of Aunt Jemima', in *Betye Saar Workers-Warriors, The Return of Aunt Jemima*, New York: Michael Rosenfeld Gallery, 1998, p. 3. Regarding her own efforts to achieve the rehabilitation of a stereotype, Saar has stated, 'The "mammy" knew and stayed in her place. In 1972, I attempted to change that "place" by creating the series *The Liberation of Aunt Jemima*. My intent was to transform a negative demanding figure into a positive, empowered woman who stands confrontationally with one hand holding a broom and the other

armed with [sic.] battle. A warrior ready to combat servitude and racism.'

17 Saltz, 'Kara Walker', p. 82.

18 Dan Cameron, 'Kara Walker: Rubbing History the Wrong Way', *The Journal of Prints, Drawings, and Photography*, vol. 2, no. 1, September–October 1997, p. 11.

19 Harriet Jacobs, *Incidents in the Life of a Slave Girl*, The Schomburg Library of Nineteenth-Century Black Women Writers, New York and Oxford, 1988 and Thomas Dixon Jr, *The Clansman, An Historical Romance of the Ku Klux Klan*, New York, 1905.

20 Harriet Jacobs, *Incidents in the Life of a Slave Girl* and Thomas Dixon Jr, *The Clansman*, pp. 106 and 107.

21 Julia Szabo, 'Kara Walker', in *New York Times*, 23 March 1997, section 6, p. 49.

22 Fanon, *Black Skin, White Masks*, p. 145.

23 W.E.B. DuBois, *The Souls of Black Folk: Essays and Sketches* (1903), New York, 1961, pp. 16–17.

24 Saltz, 'Kara Walker', p. 84.

25 Alexi Worth, 'Black and White and Kara Walker', in *Art New England*, vol. 17, no. 1, December 1995–January 1996, p. 27.

26 Henry Louis Gates Jr, 'The Blackness of Blackness: A Critique of the Sign and the Signifying Monkey', in Henry Louis Gates Jr (ed.), *Black Literature and Literary Theory*, New York and London, 1984, rpt. 1990, pp. 285–321.

27 Gates, 'The Blackness of Blackness', p. 293.

28 Cf. Homi K. Bhabha, *The Location of Culture*, London and New York, 1994.

29 Saltz, 'Kara Walker', p. 82.

30 Victor I. Stoichita, 'Johan Caspar Lavater's Essay on Physiognomy and the Hermeneutcs of Shadow', trans. Anne-Marie Glasheen, *Res*, vol. 31, Spring 1997, p. 133.

31 Joel Williamson, *New People: Miscegenation and Mulattos in the United States*, New York, 1980, p. 63.

32 Catherine Clinton, *The Plantation Mistress: Woman's World in the Old South*, New York, 1982, p. 199.

33 Gates, 'The Blackness of Blackness', p. 315.

34 Armstrong, p. 106.

35 Saltz, 'Kara Walker' p. 82.

7

Corporeal Theory with/in Practice: Christine Borland's *Winter Garden*

Marsha Meskimmon

In-Between: bodies

I first saw Christine Borland's *Winter Garden* (2001, plate 7.1) in Sydney at the Art Gallery of New South Wales, where it was installed on a wide, white platform placed low to the ground.[1] Crouching slightly, the contents of the twelve hand-blown glass vessels came into view: in each floated a bleached sprig of Penny Royal preserved in an alcohol solution. Sometimes magnified, sometimes distorted by the variations in the glass, these exquisite white specimens, enveloped within softly slumped jars of fluid, invoked female corporeal presence without resort to any simplistic rendering of the body of woman. Indeed, I would argue that *Winter Garden* moves beyond the idea of the body as an object to interrogate sexual difference as a process which takes place at the interstices of diverse bodies – bodies of evidence, bodies of knowledge, the bodies of individuals and the composite body politic. Its strategies might well be understood as an aesthetics of the in-between, exploring embodiment as intercorporeality[2] and deploying connective, sensory knowledges to move across the material and discursive conventions by which woman has come to be defined.

Winter Garden demonstrates a critical awareness of contemporary feminist thinking around sexual difference, visuality, science, epistemology and power. However, its relationship to feminist theoretical work is not unidirectional or reductive; the installation does not simply illustrate a theoretical position or idea, nor does it await completion by the application of a theory from beyond. Rather, *Winter Garden* materializes concepts, makes ideas and multiplies variations of meaning as it enfolds 'theory' with/in 'practice' in a vital, corporeal exchange with bodies in the world. The viewer's body is implicated within the primary exchange as she/he bends to see the tiny leaves of Penny Royal and shifts positions and perspectives on the glass vessels to entertain their optical effects. But this physical encounter merely opens the piece to a host of other material exchanges with histories, myths, images, practices and politics. In an important sense, the work operates through a modulation between site and situation – it is the locus at which competing knowledge claims meet and an act of positional engagement between such claims. As a situating event, *Winter*

7.1 Christine Borland, *Ecbolic Garden, Winter*, as installed in the *Humid* exhibition, as part of the Melbourne Festival Visual Arts Program, Australian Centre for Contemporary Art, Melbourne, 2001. Installation approx. 100 × 150 cm, glass vessels each approx. 15 × 10 × 8 cm. Copyright © Christine Borland. Photo: John Brash

Garden not only queries what the viewer knows (of the bodies of women), but how s/he comes to know and to what end.

That contemporary women's art is capable of mobilizing the inventive nexus of the in-between so effectively invites feminist art critics and historians to move beyond the static dualism which pits theory against practice to begin to engage artwork otherwise. Such an engagement is both mobile and located; in configuring a resonant critical practice[3] and writing with art,[4] theory is not a pre-determined interpretive frame, but part of a mutual knowledge project, itself capable of creative change and development in its encounter with different images, objects and ideas. Thinking through some of the implications of corporeal theory is my focus here; turning back to Borland's multi-layered evocation of woman in *Winter Garden* permits me to take my first circuitous pass at the theme.

Siting a dozen glass-encased botanical specimens within the space of the gallery is an apt interrogation of our cultural investment in varied modes of display. The knowledge claims of the natural sciences, associated with strategic collection, distanced observation and objective deduction, are here connected, physically, with the pleasurable aesthetics of exhibition and the sceptical reinterpretation of scientific method by conceptual art.[5] But the display sets up further resonances between aesthetics and scientific method as it invokes the historical practices of collection in the early modern period, when the disciplinary boundaries between the arts and the sciences were not so sharply drawn. In the famous *Wunderkammer* of the seventeenth-century surgeon, anatomist and collector Frederick Ruysch, for example, embalmed foetuses could be found next to still-life *tableaux*, formed from the preserved capillary systems of humans and other animals.[6] Similarly, Gottfried Wilhelm Leibniz, a passionate advocate of the mode of display typified by the *Wunderkammer*, saw in these varied collections a mechanism by which to connect beauty with wonder and intellectual rigour – a manifestation of his concept of the *Ars Combinatoria*.[7]

Ruysch's work with the still-life *tableaux*, the embalmed and decorated foetal fragments he displayed and the illustration of botanical specimens throughout Amsterdam, was ably administered by his daughter Rachel, who became one of the most celebrated still-life painters of the eighteenth century.[8] While her prominence as an artist and her association with the most learned scientific societies in northern Europe may have been extraordinary, the important contribution of women artists to still-life painting in the period was underpinned by an extensive participation in the sciences, especially in collecting, analysing and recording the natural world. Indeed, the most famous entomologist of the later seventeenth century was the illustrator Maria Sybilla Merian, upon whose images and descriptions of species from the Dutch colonies in South America Carl von Linné (Linnaeus) depended for his own work.[9] The sprigs of Penny Royal in their glass vessels hearken to this history of information gathering, to a time when (European) knowledge of the world was entwined with the wonder and beauty of its exhibition. In the seventeenth and eighteenth centuries collecting, showing and imaging plants, animals and minerals was at once a scientific pursuit, an artistic endeavour and a colonial enterprise. The

power of the visual arts was incorporated into these practices with scores of artists producing detailed illustrations, pattern books of rare species and beautiful, informative paintings. It is neither coincidental that so many of these artists were women nor that their still-life painting gradually lost its association with the sciences as the disciplinary limits with which we are now familiar emerged.

Winter Garden enables us to imagine again the vital link between the gallery, the laboratory and the museum as mechanisms by which bodies of knowledge can be transformed into bodily pleasures and systems of control over 'other' bodies in the world. Much of Borland's work is characterized by just such a compelling connection between visual art and scientific experimentation, especially at the junction between bodies and the production of evidence – in archaeology, forensic science, medical education and, of course, museological demonstrations of eugenic theories of 'race'. For example, in *From Life* (1994), probably her most widely discussed installation, Borland acquired a skeleton from a medical supplier which was then refashioned through the forensic techniques of facial reconstruction, to provide evidence of an 'identity'. But the very locus of life, identity and knowledge was called into question by the work as the encounter with the boxed skeleton in the first installation room gave way to a final view of this body as a reconstructed sculptural bust, labelled simply 'Female, Asian, 5ft 2in tall, Age 25. At least one advanced pregnancy.' Thomas Lawson's response to the work was succinct: 'How, and by whom, is a life to be understood?'[10] In this work, we come to know far less about the woman whose bones we can buy, sell, reconstruct and analyse than we do about ourselves and the knowledges we systematically acquire as empowering commodities.

In *Winter Garden* we are not faced with the remains of a body nor, indeed, the likeness of any person, yet the questions of how, and by whom, life is to be understood are all the more pressing for this critical absence. In the space of the absent body is located a dynamic in-between; *Winter Garden* mobilizes diverse perspectives on 'life' and sexual difference without proposing a deterministic equation between the body and woman. Just as the skeletal remains reconfigured in *From Life* refused to reveal the truth of the female subject, *Winter Garden* confounds the assumption that the 'truth' of woman resides in her biology and focuses upon the most controversial elements of female corporeal experience in making this claim – natality, maternity and the control of fertility. Penny Royal, we are told in the notes to the work, is the Anglophone name of a local plant traditionally used by Aboriginal Australians as an abortifacient. In one sense then, the bleached branches floating in the softly curved vessels are like still-born foetuses within the womb, the harvest of a winter garden. On this reading, woman is the fertile earth awaiting fulfilment in maternity and any interference with this process equates the womb with barren ground; the matrix becomes the tomb. However, the complex material, textual and spatial play of *Winter Garden* cannot be reduced to just this singular reading, but instead opens the most entrenched naturalization of woman/maternity to the competing actions and claims of histories, knowledges and power.

The visceral effect of the hand-blown glass jars is a case in point. Their physical reference to the womb reminds us of the long legacy of intrusive forays into the interior spaces of the female body in Western medical image- and object-making, designed to 'see' and know the truth of human reproduction and, by extension, woman. The so-called 'waxen Venuses' of the Renaissance, offering their internal organs for inspection through layers of fenestrated flesh, are the precursors of our own medical mannequins and virtual viewing technologies (such as ultrasound), devices which enable us to see the processes otherwise hidden during pregnancy.[11] The problem of these hidden, interior female processes is the problem of the monstrous–feminine: the shape-shifting mysteries of maternity and the concomitant potential of women to issue forth monsters, births which do not conform to expectations and which are thus wondrous, awe-inspiring or grotesque.[12] It is not simply coincidental that the word 'monster' shares its root with 'demonstrate' (in *monstrer*), as showing, seeing and thus identifying others as irreducibly different is a key premise of monstering. In an important sense, the desire to look into the womb was intimately connected with the display, in transparent glass vessels, of still-born foetuses, 'monstrous' births and other wonders. So it is not surprising to learn that Frederick Ruysch was widely known in his day for his popular anatomical demonstrations and that his most significant medical work was undertaken in obstetrics. His stature, as a scientist and learned man, gave him access to the interior spaces of human bodies, and the most important access was to the matrixial space of human generation within the bodies of women.

In *Winter Garden*, the soft, matrixial forms of the vessels are belied by the brittle solidity of the glass which shapes them. This sensual double play invites us to connect the supple corporeality of the womb to the intrusive technologies through which we have ventured to view and display its contents. Glass, as the single most important component in Western optical technology of the modern period, played a fundamental role in the intellectual developments associated with the Enlightenment, not least the premise that clear and distinct vision could act as an aid in formulating objective, rational truth claims.[13] The transparency of glass, its strength and magnifying qualities, were drawn together in lens technologies which suggested that the whole of the natural world might be available for inspection, and thus, knowledge – from the smallest particle to the most distant star. Woman, as the object of visual scrutiny, was also placed under the glass, dissected, magnified, imaged and objectified as material to be known by an empowered viewer. But the soft-brittle lens-objects in *Winter Garden* do not simply reveal their contents, transparently, to a distanced, disembodied gaze (plate 7.2). Their modulation between optic and object, visual and tactile, sets up a complex, haptic, modulation of sensory experience for viewers, who become aware of their embodied vision as they move with the installation, catching faltering, yet compelling, glimpses of its fluidity within reflective and diffractive objects of display. *Winter Garden* does not just provide an artistic metaphor for the essential body of woman, but, rather, engenders an aesthetics that resonates at the in-between of corporeality, visuality and sexual difference.

7.2 Detail from Christine Borland, *Winter Garden*, 2001. Twelve hand-blown glass vessels containing bleached specimens of Penny Royal, preserved in alcohol solution, installation dimensions variable. Mervyn Horton Bequest Fund 2002, Art Gallery of New South Wales, Sydney, Australia. Copyright © 2002 Christine Borland. Photo: Jenni Carter for AGNSW.

At the heart of this work, and the questions it poses on the subject of women's bodies, is not so much maternity, but female natality and the control of fertility.[14] The fact that female bodies may bear children, not that they always can or will, makes female sexuality a primary object of cultural inquiry and restriction, and the control of women's fertility a central focus for political, religious, legal and medical debate. In highly complex and varied ways, the visual objectification of woman as the marker of sexual difference and the absolute manifestation of body and matter (opposed to masculine mind and form) participates in the cultural control of female sexuality by homogenizing differences between women. Within this binary logic, the point of natality assures female bodily essence; the proof that women's biology is their destiny resides in this indisputable truth and its sameness across nations, cultures and histories. But the stilled lives of *Winter Garden* suggest otherwise.

The sprigs of Penny Royal can be seen to pit two forms of knowledge against one another: the colonial acquisition and classification of botanical samples, often seen back in Europe in glasshouses, or 'winter gardens', and the native

knowledge of Aboriginal women, who understood the indigenous growth patterns and uses of local plants. The colloquial name 'Penny Royal' could hardly bear any more obvious a link to the British colonial domination of Australia and thus, Borland's deployment of this naming device against the information concerning the plant's indigenous use demonstrates a conflict between the instrumental knowledge of the imperial British scientific establishment and that of indigenous women.[15] Moreover, here the sprigs are rendered impotent, bleached, when they are disconnected from Aboriginal women's knowledge and made to be merely a display of colonial ownership. Significantly, a similar opposition between colonial and native knowledges also emerged three centuries earlier when Maria Sybilla Merian travelled to the Dutch colony of Surinam to collect species of insects and their plant hosts to illustrate for her great volume *Metamorphosis insectorum surinamensium*, published in 1705 in Amsterdam. Throughout this text, Merian relied upon the knowledge of indigenous people to explain the habitats, activities and uses of the plants and animals she imaged, a fact which made her work very different to that of many of the male European scientists who accompanied colonial expeditions in the period. The most striking example of Merian's reliance upon indigenous women's knowledge came in the illustration of the so-called *flos pavonis*, the plant used by both indigenous and enslaved African women in Surinam as an abortifacient.[16] The use of abortifacients by slaves in the West Indies was a fiercely debated political issue in the period, because it proved both that slaves had knowledges beyond those of their owners and that they were able and willing to make choices about the destinies of their offspring.[17] These facts fuelled Abolitionist arguments and made the obvious point that chattel slavery was an act of absolute inhumanity. In editions of Merian's volume published after her death (and in work which used her as a source), the abortifacient qualities of *flos pavonis* were excised.

While I am neither arguing that Merian was a proto-feminist in a modern sense,[18] nor that Borland was making any direct reference to Merian's work in *Winter Garden*, I would suggest that both these works problematize the natural association of woman with maternity/natality in extremely provocative ways. *Winter Garden* was not Borland's only work from this time to examine women's control of their own fertility in terms of histories marked by political and social inequities. *Winter Garden* was produced for the show *Humid* when it appeared at the Melbourne Festival in 2001; in the Bristol showing of *Humid* in the same year, Borland responded to the theme of female bodies with *Fallen Spirits*, in which bleached plane leaves, thought to have been used as a contraceptive by prostitutes in Victorian England, floated in a pool of alcohol spilt on the floor of the space.[19] Connecting the loaded euphemism 'fallen' with the banal reality of the poverty, danger and exploitation suffered by nineteenth-century sex workers in a port town, Borland located female sexuality firmly within the socio-economic frame of this particular historical moment. The two installations Borland produced for *Humid* shared a common thread in their determination to examine the control of women's bodies and fertility within periods riven by political conflict and socio-economic disparities of power, but their aesthetic strategies interrogated the significant differences between these histories and the

7.3 Christine Borland, *Winter Garden*, 2001. Twelve hand-blown glass vessels containing bleached specimens of Penny Royal, preserved in alcohol solution, installation dimensions variable. Mervyn Horton Bequest Fund 2002, Art Gallery of New South Wales, Sydney, Australia. Copyright © 2002 Christine Borland. Photo: Jenni Carter for AGNSW.

subjects who negotiated their roles within their parameters.[20] The double play with the matrixial glass vessels, the colloquial naming devices and the visual motifs linked to early European colonial expansion and the concomitant trade and display of specimens, makes *Winter Garden*'s intervention at the in-between of knowledges, bodies and power – very different to that of *Fallen Spirits*. The nineteenth-century pseudo-scientific theories which placed Aboriginal Australians at the very bottom of the hierarchies of 'race', united with the so-called 'whitification' policies which sanctioned rape and the forcible removal of indigenous children from their families, lends to the bleached branches of Penny Royal a very different, and particular, hue.

 Winter Garden makes a convincing case against a singular truth of female corporeality and any homogeneous representation of the body of woman. It does so by interrogating the most intimate and, ostensibly, natural locus of sexual difference through a strategic aesthetics of the in-between, drawing together diverse histories, discourses and material practices without reducing them to one. It engages productively with medicine and science, social and political histories, visual culture and philosophy, but, crucially, it intervenes as *art* – as a connective, affective mode of thought and meaning production which does much more than just 'represent' already present truths or 'translate' already known ideas into a visual or material form. On the question of female subjectivity, sexuality and bodies, art's significance is manifold; the histories of image- and object-making, of demonstration and monstering, and of the intertwined structural oppositions of matter/form, body/mind, woman/man, meet in art, while its ability to materialize ideas and create multi-sensory, embodied knowledges, argues for its potential to articulate difference differently. But what does it mean to say that *Winter Garden* does not 'represent' the body or corporeality and yet to suggest that female embodiment is critically articulated through the aesthetic strategies of the installation? Here we come full circle to the question of the in-between of theory and practice in contemporary women's art and the ramifications of this for feminist art critics and historians dedicated to the project of thinking female subjectivity and knowledge differently.

In-Between: feminist art/theory machines

Winter Garden, like much contemporary women's art, engenders new perspectives on the complex relationship between female embodiment and creative agency. While informed by feminist theoretical work, it is neither a mere illustration of theoretical concepts nor an object awaiting an interpretive act of theory to bring it to life. Rather, the sophisticated imbrication of theory and practice within works such as *Winter Garden* suggests new ways of understanding the theory/practice relation itself, neither opposing the terms in a binary hierarchy nor assimilating one to the other in a reductive homogeneity. Instead, we might posit feminist art theory and contemporary women's art as mutually transformative practices, engaging in exchanges between and across difference to the benefit of both. This is akin to the way Claire Colebrook

characterized the exchange between philosophy and cinema when she wrote, '[b]ut the two can transform each other. The creation of cinema challenged philosophers to rethink the relation between time and the image; but new concepts in philosophy can also provoke artists into recreating the boundaries of experience.'[21]

It is clear, however, that working in this way radically refashions the commonplace idea of 'theory' as an abstract system, capable of being applied to a variety of cases without being redrawn in the process. Understanding theory as itself part of a critical exchange, responsive to material and able to be revised, reformed and reconceived in diverse knowledge projects, stresses the contingency of 'theory' as a practice[22] and undoes its disembodied, transcendent status. In short, it corporealizes theory. The ramifications of corporeal thinking for both feminist epistemology and art theory are profound. A corporeal notion of theory acknowledges the significance of thinking-in-making and encourages the emergence of a dynamic, process-based criticism between texts and images – as well as between subjects and objects. It is precisely this dynamic mode of criticism, formed at the in-between of thinking and materiality, which has enabled female subjectivity and sexual difference to be reconceived against the grain of disabling normative conventions of woman as other.[23] Feminist art criticism and the contemporary practices of women artists have been crucial to the development of these ideas and they invite us to explore the significance of aesthetics and sensory knowledges in articulating embodiment through the in-between.

Discussing architecture and concepts of nature, Elizabeth Grosz further argued for the transformative power of the in-between:

> The space of the in-between is the locus for social, cultural and natural transformations: it is not simply a convenient space for movements and realignments but in fact is the only place – the place around identities, between identities – where becoming, openness to futurity, outstrips the conservational impetus to retain cohesion and unity.[24]

In her work on the in-between, Grosz made two other significant points: that the in-between is the privileged position from which to unravel dualism or an assimilative economy of the same, and that the in-between is not a physical location, a thing or an object, but a process.[25] Thinking back to the in-between of *Winter Garden* makes these two points clear.

Winter Garden did not represent the body or propose a singular, essential definition of woman by expressing the truth of human reproduction; its intervention was located at the interface of nature and culture, where dynamic exchanges between corporeality and differential socio-economic and political imperatives configured women and bodies as heterogeneous and diverse. The simplistic dualities which align woman with body, nature and immanence while subordinating these to man, mind, culture and transcendence are reworked in the transformative in-between of *Winter Garden*. Moreover, this in-between is a mobile process, bringing historically and materially distinct ideas into connection and demonstrating Stafford's claim that the pre-eminent activity of art resides in visual analogy: 'a metamorphic and metaphoric practice for

weaving discordant particulars into a partial concordance'.[26] I want to argue that exploring art in this way can transform critical practice as well, engendering a similar shift from object to process, asking not what a work of art *is*, but what it *does* – how art *works*.[27] Here, the full repercussions of a move to corporeal theory might begin to be felt as feminist art history and criticism become active, creative forces in the articulation of embodied subject positions in and through differential aesthetics.[28]

A corporeal practice of feminist art/theory is machinic – mobile, yet located, connective yet heterogeneous. It does not seek to label works of art or to identify 'positive' or 'negative' modes of representation, but to extend art's potential to make new configurations of knowledge. In this, it is what Rosi Braidotti would call a 'transdisciplinary' practice, a term she used to envisage feminist theoretical agency as nomadic and active, rather than static and reactive:

> I think that term 'transdisciplinary' is a rather adequate one in describing the new rhizomatic mode in feminism … The feminist theoretician today can only be 'in transit', moving on, passing through, creating connections where things were previously disconnected or seemed unrelated, where there seemed to be 'nothing to see'.[29]

The kind of feminist theorizing envisaged by Braidotti is not an abstract, Utopian ideal, but a concrete, political intervention into the making of knowledge, art and culture. While the feminist theoretician might be in transit, she moves within the frame of the knowledges she makes, and, if she creates connections which cross-disciplinary boundaries, they do not do so as universal, *a priori* laws. Transdisciplinary, corporeal theory is all the more rigorous because it cannot assume first principles, claim the position of absolute truth and replace the activities of thinking with commonplace opinions and presuppositions. As Colebrook put it: '[w]e destroy opinion and common sense by pulling our thinking apart… [looking] at how we compose our perceptions of the world, the force of those perceptions (affect) and how we create decisions, judgements and concepts.'[30] This is what the in-between of feminist art/theory addresses so well – how we compose perceptions and affects to create concepts in vital exchanges between images, materials, histories and ideas.

As a form of making at the in-between, feminist art/theory is accountable for the materials and valences it brings together and is responsible for creating compelling, sustainable connections where there seemed to be nothing to see, or worse, where there seemed already to be an obvious, 'natural' viewpoint. For example, my engagement with Borland's *Winter Garden* suggested connections between the work's aesthetic strategies, affective, material qualities and a diverse body of historical data, ranging from the development of the natural sciences and medicine, to the status of collecting in the early modern period, the role of women in still-life traditions, the colonial control of Aboriginal knowledge and fertility. This engagement is not transparent or neutral; I am creating a constellation of ideas, images and information to confront the limiting, masculine normative paradigms of the body and woman so to engender ways of thinking differently about female embodiment. Such a constellation conforms

134

broadly to what Braidotti called (after Donna Haraway) *feminist figurations*: 'Feminist figurations refer to the many, heterogeneous images feminists use to define the project of becoming-subject of women, a view of feminist subjectivity as multiplicity and process, as well as the kind of texts feminists produce.'[31] My engagement with *Winter Garden* invites readers to investigate its composition, the deployment of ideas therein and the extent to which these argue convincingly for this art's work in differently articulating female subjectivity, bodies and sexuality. Has the text, as a feminist figuration, set its terms to resonate at that transformative in-between?

This is a question which posits the work of feminist art/theory as invention rather than interpretation and suggests that art history and criticism are participants in knowledge projects, not transparent techniques by which underlying truths or meanings might be revealed. This difference is crucial. As Gilles Deleuze and Félix Guattari argued, '[c]oncepts are centres of vibrations, each in itself and every one in relation to all the others. This is why they all resonate rather than cohere or correspond with each other.'[32] Deleuze and Guattari were here envisaging 'thought as heterogenesis'[33] and not as iterative of a preformed real or a singular coherence. In art-historical terms, such thinking mediates against seeking an origin point for art's meaning, either in the intentions of the artist or in 'contexts' which precede and are reflected or represented in the work.[34] Here, the implications of the shift from object to process, from representation to articulation and from the logic of being to that of becoming, are at their most powerful. Feminist art/theory, conceived as corporeal, resonant thinking, is a mode of dialogic and engaged criticism which extends and amplifies the work of art through connections with other, diverse materials. It participates within an aesthetics of radical difference, formulating meanings as mutable figurations which are not tested by evaluating their ability to 'reflect' or 'represent' the already known, but by their potential to create and extend the parameters of our thinking and our knowledges.

It is not enough for feminist art history and criticism to appeal to a preformed 'theory' of 'the body' and apply this, for example, to *Winter Garden*. Nor is it sufficient to judge the installation as a reflection of the truth of the past or the commonplace opinions of the present. The mutually transformative power of art and theory at the in-between of female subjectivity, embodiment and aesthetics changes our address to the *work* of art and to the *work* of art history. As the future opens to new thinking, beyond the bounds of singular disciplinary stasis, what we knew of theory and practice will be challenged and changed. In articulating corporeality and embodiment as processes, contemporary women's art and feminist art theory are at the forefront of these changes precisely by residing at the in-between.

Marsha Meskimmon
Loughborough University

135

Notes

1 The work is now in the permanent collection of the Art Gallery of New South Wales, Sydney.

2 Gail Weiss posited this formulation in *Body Images: Embodiment as Intercorporeality*, London and NY, 1999. I have developed further this process-based, relational notion of intercorporeality in thinking differently about women's art practices in the fourth chapter of *Women Making Art: History, Subjectivity, Aesthetics*, London and NY, 2003.

3 I explored the notion of resonance in 'Jenny Holzer's *Lustmord* and Resonant Critical Praxis', *n.paradoxa*, vol. 6, *Desire and the Gaze*, June 2000, pp. 12–21 and, in lengthier form, in 'Practice as Thinking: Toward Feminist Aesthetics', in *Breaking the Disciplines: Reconceptions in Knowledge, Art and Culture*, co-edited with Martin Davies, forthcoming, Spring 2003.

4 Stephen O'Connell (now Zagala) used the phrase writing with art in 'Aesthetics: A Place I've Never Seen', in *Deleuze and Guattari: Critical Assessments of Leading Philosophers*, ed. Gary Genosko, London and NY, 2001, pp. 946–69; Trinh T Minh-ha coined the phrase 'speaking nearby' to denote a similar mode of address. See 'Speaking Nearby', interview with Nancy Chen (1994), reprinted in *Cinema/Interval*, London and NY, 1999, pp. 209–225.

5 For the pertinent connections between contemporary art in Scotland, the histories of conceptualism and scientific method, I am indebted to Melissa Feldman's excellent article 'Matters of Fact: New Conceptualism in Scotland', *Third Text*, no. 37, Winter 1996–7, pp. 75–84.

6 There are now many useful sources on the *Wunderkammer*: one of the best illustrated is still Rosamund Wolff Purcell and Stephen Jay Gould, *Finders, Keepers: Eight Collectors*, London, 1993.

7 For a wonderful account of Leibniz's concept of *Ars Combinatoria*, the *Wunderkammer* and the power of the visual in connective thinking, see Barbara Stafford, *Visual Analogy: Consciousness as the Art of Connecting*. Cambridge, Mass., 1999, esp. pp. 120–31.

8 Rachel Ruysch's links with her father's anatomical work and collection has tended to be overlooked in many sources, but was developed convincingly in Marianne Berardi's University of Pittsburgh PhD thesis, *Science into Art: Rachel Ruysch's Early Development as a Still-Life Painter*, 1998.

9 William T. Stearn documented the citations Linnaeus took from Merian in Maria Sybilla Merian, *The Wondrous Transformation of Caterpillars: Fifty Engravings Selected from Erucarum Ortus (1718)*, with an introduction by William T. Stearn, London, 1978, p. 18.

10 Thomas Lawson, 'Unrelenting Jet Lag and Iron-Hard Jets', in *The British Art Show 4*, exhib. cat., London: Hayward Gallery and National Touring Exhibitions, 1995, pp. 88–94, p. 89.

11 See, for some examples, the catalogue *Spectacular Bodies: The Art and Science of the Human Body from Leonardo to Now*, eds Martin Kemp and Marina Wallace, London, 2000, from the Hayward Gallery show of 2000.

12 While it would be beyond the scope of this brief essay to develop the intimate connections between maternity/woman and the question of the monstrous, this work has been pursued at some length in Nina Lykke and Rosi Braidotti (eds), *Between Monsters, Goddesses and Cyborgs: Feminist Confrontations with Science, Medicine and Cyberspace*, Zed Books, 1996. I considered the question of the monstrous in contemporary women's self-portraits in 'The Monstrous and the Grotesque: On the Politics of Excess in Women's Self Portraiture', in *Make: The Magazine of Women's Art*, October–November, 1996, pp.6–11, and have since learned much about the theme from the work of my PhD student: Rachel Gear.

13 See Alan MacFarlane and Gerry Martin, *The Glass Bathyscaphe: How Glass Changed the World*, London, 2002. Interestingly, in relation to the ideas here, the philosopher Benedict de Spinoza was a lens grinder.

14 Christine Battersby's book, *The Phenomenal Woman: Feminist Metaphysics and the Patterns of Identity*, Oxford, 1998, makes a convincing case that natality, not maternity, is the crucial element in thinking productively about corporeality and sexual difference.

15 There is no indigenous name given for the specimen, a fact which might reflect the almost complete loss with colonization in South Eastern Australia of the Eora language groups. For further information on the Eora languages, see Jakelin Troy, *The Sydney Language*, Canberra, 1993.

16 I am indebted to an essay on this topic by Londa Schiebinger: 'Lost Knowledge, Bodies of Ignorance, and the Poverty of Taxonomy as Illustrated by the Curious Fate of the *Flos Pavonis*, An Abortifacient', in *Picturing Science, Producing Art*, eds Caroline Jones and Peter Galison, London and NY, 1998, pp. 125–44.

17 For further discussion of these issues and the complex interaction between sexuality, sexual difference and slavery in the Americas, see Barbara Bush, *Slave Women in Caribbean Society 1650–1832*, London, 1990 and Geoff Quilley, Dian Kriz (eds), *Representations of Slavery*, Manchester, forthcoming, 2003.

18 Indeed, as I have argued elsewhere about Merian, such debates are anachronistic and rather unhelpful – she may have attended to indigenous women's descriptions of plants, but this did not stop her from having a slave. See chapter 6 of my *Women Making Art*, 2003.

19 For a review of *Humid* in Bristol, see Valerie Reardon, 'Humid', *Art Monthly*, no. 245, April 2001, pp. 36–8.

20 It is worth noting that Borland is not connected to the histories of these specific sites in any personal way and that her exploration of natality here is not driven by any sort of identity politics.

21 Claire Colebrook, *Gilles Deleuze*, London and New York, 2002, p. 7.

22 My formulation of 'theory as a practice' is indebted to Elizabeth Grosz's well-known argument that knowledge is a practice and not a contemplative reflection – see Grosz, *Space, Time and Perversion: Essays on the Politics of Bodies*, London, 1995, p. 37.

23 The shift from identity to difference has also been of critical import to post- and anti-colonial refigurations of 'race' – note, for example, the article by Gerardo Mosquera, 'Good-bye Identity, Welcome Difference: From Latin American Art to Art from Latin America', *Third Text*, no.55, Summer 2001, pp. 25–32.

24 Elizabeth Grosz, 'In-Between: The Natural in Architecture and Culture', in *Architecture from the Outside: Essays on Virtual and Real Space*, Cambridge, Mass., and London, 2001, pp. 91–105, 92.

25 On dualism, see Grosz, 'In-Between', pp. 93–4; as not a place, p. 91.

26 Stafford, *Visual Analogy*, p. 9.

27 The 'work' of art and the significance of the shift from object to process are discussed in detail in the introduction to my *Women Making Art*, 2003.

28 I am borrowing the term 'differential aesthetics' from the title of a thought-provoking volume edited by Penny Florence and Nicola Foster, *Differential Aesthetics: Art Practices, Philosophy and Feminist Understandings*, Aldershot, Hants, 2000.

29 Rosi Braidotti, 'Toward a New Nomadism: Feminist Deleuzian Tracks; or, Metaphysics and Metabolism', in C.V. Boundas and D. Olkowski (eds), *Gilles Deleuze and the Theater of Philosophy*, New York and London, 1994, pp.159–85, p. 177.

30 Colebrook, *Gilles Deleuze*, p. 27.

31 Braidotti, 'Toward a New Nomadism', p. 181.

32 Gilles Deleuze and Félix Guattari, *What Is Philosophy?*, trans. Graham Burchell and Hugh Tomlinson, London, 1994, p. 23.

33 Deleuze and Guattari, *What Is Philosophy?*, p. 199.

34 On the problem of such 'contexts' and the infinite regress to which this mode of interpretive justification can lead, see Mieke Bal, *Quoting Caravaggio: Contemporary Art, Preposterous History*, Chicago, 1999, pp. 175ff.

8

Cultural Crossings: Performing Race and Transgender in the Work of moti roti

Dorothy Rowe

> What performance where will invert the inner/outer distinction and compel a radical rethinking of the psychological presuppositions of gender identity and sexuality? What performance where will compel a reconsideration of the *place* and stability of the masculine and the feminine?
>
> Judith Butler, *Gender Trouble*[1]

moti roti was established by Keith Khan in 1991 as a diasporic London-based artist-led performance group straddling three cultures: Trinidad, Pakistan and India. Since 1990 it has produced a number of innovative and wide-ranging cultural critiques of identity construction in a popular, collaborative, accessible and interactive way. At the core of moti roti's artistic policy is the declared aim 'to make art projects that transform space, and the meaning of space' as well as 'to make art projects in the context of and with the intent of progressing current thinking about race, sexuality and gender'.[2] To this end, the company have produced a steady stream of high-profile multicultural and multimedia performance projects of which *Wigs of Wonderment*, of 1995 (plate 8.1), forms a part. Other projects have included *Before Columbus* (1992), a performance project for Notting Hill Carnival that explored the cultural wealth of six areas of the world before Christopher Columbus allegedly 'discovered' them; *Plain Magic* (1999–2001), an installation housed in specially commissioned marquees for touring to melas and festivals and performed by Sonia Boyce, Nina Edge, Keith Khan, D.J. Scanner and Ali Zaidi; and *Fresh Masaala* (1999), a multimedia installation exploring issues of British Asian identity. Performer/participants involved in moti roti are often also celebrated artists/ performers in their own right who temporarily come together under the curatorship of Keith Khan or Ali Zaidi for specific and unique installation/ performance projects.

Although many of the artists involved in the company at various stages are black or Asian women, their participation in the company is not circumscribed purely by their positions of 'difference'.[3] Those who have been involved with the company over the past decade include the actresses Shobna Gulati and Zita

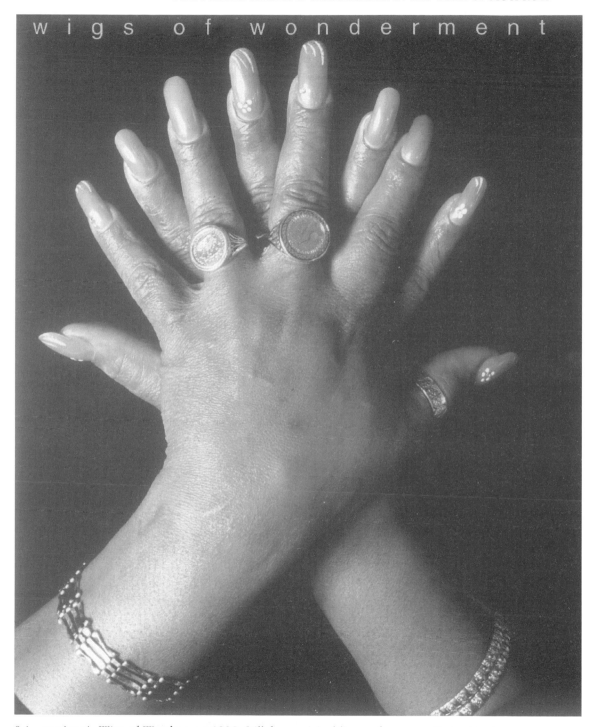

wigs of wonderment

8.1 moti roti, *Wigs of Wonderment* 1995. Still from original live performance. © moti roti.

Sattar and the artists Samena Rana, Veena Stephenson, Susan Lewis, Nina Edge and Sonia Boyce, amongst others, all of whom have appeared for temporary, sometimes site-specific and always collaborative, cultural projects, whilst simultaneously maintaining and developing their various separate artistic identities.[4] As race, sexuality and gender are the categories of identity formation that the company seeks to explore and transgress, the gender of the performer/participants is not pre-determined and the racial mix is always multicultural. Black, white or Asian, male, female, hetero, homo- or trans-, the issue of identity construction escapes the potentially ghettoizing categories of 'black art' or 'women's art' to confront instances of 'difference and excess' within the post-colonial, the hybrid and the diasporic spaces of cultural production within the global city.

Wigs of Wonderment was first performed by moti roti in 1995, having been commissioned as part of the ICA's *Mirage. Enigmas of Race, Difference and Desire* season, exploring and celebrating the critical writings of Frantz Fanon (1925–61). In the accompanying catalogue, commenting on the commissioned works for *Mirage* by artists including Boyce, Khan, Edge, Keith Piper, Isaac Julien, Renée Green and Steve McQueen, cultural critic Kobena Mercer observed:

> Each of these artists has contributed significantly to diaspora practices of cultural displacement in post-conceptual art, using a variety of materials and methodologies to examine and challenge the fears and fantasies that continue to enthral us to the extent that we are each obliged to be the bearer of an ego and its fictions of identity. If Fanon has found a new generation of readers in this context, then it is important to note how their mapping of 'Fanonian spaces' ... delivers the spectator into a place of radical uncertainty...[5]

It is within this 'Fanonian' context that *Wigs of Wonderment* offered its audiences a self-declared 'investigation of issues around race and gender, as manifest in hair and beauty', where the experience of beauty was performed as a 'sensory journey' for and by its participants. A common feature of moti roti projects is their adaptability for repetition in different spaces and *Wigs of Wonderment* is no exception, having been re-staged twice since the ICA event and adapted each time to its different venue and context. In 1996 it was recreated in Denmark as part of the fifteen-day *Copenhagen City of Cultures* festival (with four days of performances) and in 1998, with funds from the Black Theatre Co-operative, it was re-presented in Union Chapel, Islington for one day, as part of the *Windrush* celebrations during 'Black History month'.[6] More recently, it has been digitally adapted by the Live Art Development Agency in London as an interactive home performance accessed via CD-ROM. Although details of the project vary with each different performance, the general premise that there are several spaces or rooms animated through light, sound and smell, through which audience/participants are guided in order to experience different beauty treatments or performances on a one-to-one basis remains constant throughout (plate 8.2). As a live piece *Wigs* is performed either in one large

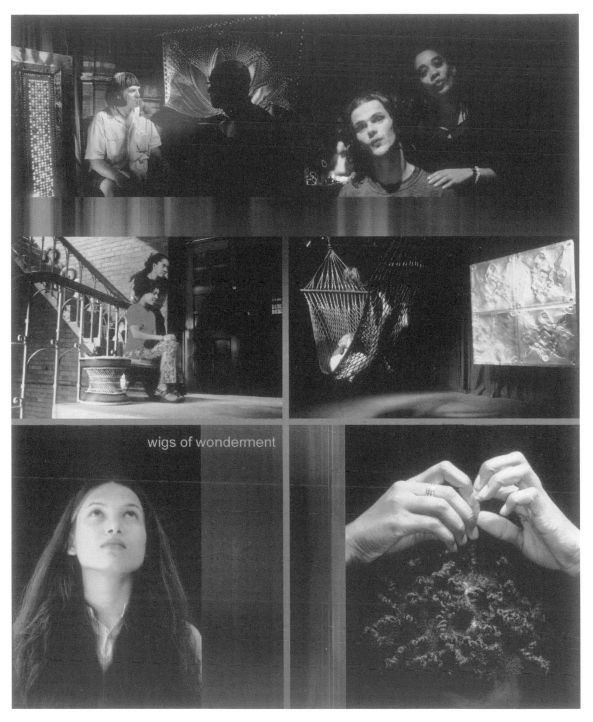

8.2 moti roti, *Wigs of Wonderment*, 1995. Stills from original live performance. © moti roti.

room with separate spaces created by lighting and hanging embroideries or else as a *physically* site-specific piece using a range of environments.[7] As Sonia Boyce and David A. Bailey have commented:

> As a one to one experience, a 'performer' offered each audience member a 'cultural makeover'. Each makeover responded to the individual's physicality and desires but also encouraged them to consider the broader issues of the appropriation of black popular culture in the West and the construction of identities...[8]

The re-working of *Wigs of Wonderment* in its most recent electronic format divides it into five different sections or 'rooms', gently echoing the five senses. The first room – 'Hair' – facilitated by Shobna Gulati and Georgina Evans, enables eight male and female participants of different ethnic origins to try on different wigs and discuss their reactions to their appearance in the wigs, the home-viewer having initially chosen whose performance they wish to listen to and watch by clicking on a wig and dropping it onto a participant's head. In the second room – 'Make-up' – participants (male or female) are given a makeover by BBC make-up artist Tammy Harewood, who talks with them about make-up, its uses and its contexts in racial and gendered terms. Again, the home-viewer uses the mouse to click on different visual frames and listen to different narratives. 'Dressing-up' with wigs and make-up in the first two 'rooms' of the electronic project enables participants temporarily to adopt gendered and racial identities that might be the antithesis of who they ordinarily think they are. 'Stance' is the title for the third sequence in which Anand Kumar, an Indian male-to-female cross-dresser in a sari performs popular Indian dance movements to music on a main public shopping street in East London. The viewer witnesses a film of the performance alongside reaction shots of people in the street watching the dance. The audience become witnesses both to the dance and to the viewers' reactions, and the performance provokes a variety of intriguing speculations on the performative nature of cultural identity and racial stereotyping in the post-colonial era.

All these acts of performance aim to disrupt preconceptions of stable racial, sexual and gendered identities. They are supplemented by the narrative elements of the 'Perfume' and 'Garden' rooms (sequences four and five) which explore constructions of 'the exotic' both through the sense of smell and via oral traditions of fable, myth and storytelling. Room four, the 'Perfume' room, consists of an animation of a series of perfume bottles, each containing the essence of a perfume, the origin of which is explained by Ali Zaidi. Each bottle may be picked up (by clicking on it and dropping it into a delicate silver cauldron) and the mixture produced by the combination of two different perfume essences is then explained in terms of the sensuous effects it will have upon those who smell it. The 'Garden' room (sequence five) consists of a series of stories, myths and fables about flowers and herbs, narrated by the ceramic artist Nina Edge.

During the live versions of *Wigs*, the participants, guided from room to room by 'flow coordinators', activate the performance by their presence in a particular space, a technique that has been translated into virtual terms by using a mouse rather than the 'flow coordinators' (plate 8.3). Through an emphasis on the

8.3 moti roti, *Wigs of Wonderment*, 1995. 'Flow co-ordinators'. Photographed at an original live performance. Photograph © Julia Cody.

sensuousness of visual, auditory and olfactory experiences, set off against the disrupted identities generated by the artifice of the masquerade, the piece offers opportunities for a creative exploration of identity formation as a performative act. The use of performance as the medium with which to enact this particular set of issues is peculiarly appropriate to the ideas that the company wish to explore. Performance work facilitates dialogue and opens up the possibilities for interrogating the participants' cultural assumptions in a non-threatening (because knowingly artificial and theatrical) environment. In her ground-breaking proposition for a destabilization of hegemonic ideas concerning fixed gendered identities and sexual identifications, *Gender Trouble,* first published in 1990, the same year in which moti roti was founded, Judith Butler introduced a radical new agenda for interpretive change within the sphere of (white heterosexual) identity politics which, although only focused on gender opened up ways of rethinking 'the experience of subjectivity and identity in the postmodern world' through notions of performance.[9]

Colliding with Butler's incisive questions concerning gendered identities and embodied subjectivities, post-colonial criticism and theory has also provided a cohesive set of analytical tools for interrogating Western hegemonic structures of race, class and gender, prompted by Homi Bhabha's earlier observations that 'an important feature of colonial discourse is its dependence on the concept of fixity in the ideological construction of otherness.'[10] Dislodging fixed epistemological frameworks of subjectivity and identity formation has been a key activity for feminist and post-colonial theorists alike. Recent theorists of performativity have clearly laid to rest the notion of the existence of stable signifying practices of meaning generation in which notions of 'truth' might be said to reside in objects that simply await 'correct' interpretation. 'Fixity' has given way to fluidity, intersubjectivity and open-endedness, in which both artist and interpreter 'are caught up within the complex and fraught operations of representation – entangled in intersubjective spaces of desire, projection, and identification.'[11]

One of the pivotal ways in which meanings are generated by *Wigs of Wonderment* in its various live manifestations (as well as through the filmed sequences of the electronic version) is via an initial emphasis on a one-to-one dialogue between the individual performer and participant in front of a mirror, with no other audience present. The presence of the mirror as crucial to the effects of the performance offers a cogent reminder of Lacan's account of subjectivity, in which the founding moment of recognition of the self via the mirror is a *mis*-recognition that belies the fragmentary nature of the subject whose identity it is being used to secure (for Lacan this uninterrupted dualism, either between self and mirror or self and mother, is the Imaginary). The subject's entry into the Symbolic upon the acquisition of language is a traumatic moment that is founded upon a primary loss of connection to the maternal body and the concomitant repression of the desire for reunification as a result of the subject's acceptance of the law of the father, or the phallus.[12] The phallus as both sign and signifier of order and language is, according to Lacan, predicated upon its visibility, its presence, which, as he recognizes, makes it both fragile and arbitrary and in constant need of

reiteration in order securely to produce its effects.[13] The entry into the Symbolic and the acquisition of language then, is the point at which gendered sexual identity is constructed via the figuration of the visible presence of anatomical difference (those in possession of the phallus and those without). However, as Jacqueline Rose observes, 'the phallus needs to be placed on the axis of desire before it can be understood, and questioned, as the differential mark of sexual identification.'[14] Once understood in these terms, the visual field of Symbolic signification is shown to be one that is fraught with repressed desires, signified through the structuring presence of the phallus, in which feminine sexuality can only be formulated as an imitative masquerade in reference to the phallic sign.

The mirror offers its viewers a fantasy of wholeness in which signs of identity can be as easily constructed as they can be dismantled and re-created. The effects of the *Wigs* performances, as I outline below, demonstrate that whilst identity can be temporarily secured through visible external manifestation and appearance, subjectivity remains elusive, fragmentary, ephemeral and contingent. It is this dialectic between visible identity constructions and embodied subjectivities that forms the pivotal point of exploration for performers and participants of *Wigs of Wonderment*. It is the field of vision as the site of the objectifying 'phallocular' gaze that has been most open to contestation, resistance, reclamation and critique in feminist and post-colonial theory over the past few decades.[15] Judith Butler, in particular, has done much to highlight the problems inherent in Lacan's psychoanalytic economy in which the formation of 'the feminine' is predicated as one of masquerade structured through loss, desire, absence and lack of signification. It is Butler's critique, amongst others, that has opened up new spaces for flexible explorations of gendered, racial and sexual identities such as the ones that are intelligently and knowingly staged in the creative formation of *Wigs of Wonderment*. Both Butler and Marjorie Garber have problematized Lacan's structural framework of binary identity formation through the introduction of what Garber describes as the 'category crisis' evoked by a disruptive 'third term' embodied in the figure of the androgyne, the transvestite, the transsexual and the cross-dresser.[16] As Butler notes, 'the notion of an original or primary gender identity is often parodied within the cultural practices of drag, cross-dressing and the sexual stylization of butch/femme identities.'[17] Such parodic imitation, although often confused as a misogynistic device designed to threaten the supposed existence of an 'essential' or originary feminine identity, actually exposes the very idea of the existence of an originary feminine identity. As Butler explains:

> The performance of drag plays upon the distinction between the anatomy of the performer and the gender that is being performed. But we are actually in the presence of three contingent dimensions of significant corporeality: anatomical sex, gender identity, and gender performance. If the anatomy of the performer is already distinct from the gender of the performer, and both of those are distinct from the gender of the performance, then the performance suggests a dissonance not only between sex and performance, but sex and gender, and gender and performance. As

much as drag creates a unified picture of woman (what its critics often oppose), it reveals the distinctness of those aspects of gendered experience which are falsely naturalized in a unity through the regulatory fiction of heterosexual coherence. *In imitating gender, drag implicitly reveals the imitative structure of gender itself – as well as its contingency ...*[18]

Although this extended passage implies a singular focus on male-to-female cross-dressing, and indeed, within *Wigs of Wonderment*, it is male-to-female transgender that receives specific attention through the 'Stance' sequence, it would be a mistake to assume that transgender is only a male prerogative within the context of gender identity exploration as performed through *Wigs*. Although perhaps not explicit in the way that 'Stance' is, certainly in the 'Hair' sequence possibilities for transgendered identity are explored by both male and female participants to varying degrees. In both the original performance and in the electronic staging the provision of the five different 'rooms' individually and collectively offer sites of exploration of the implications of Butler's radical reassessment of the performativity of identity, in racial as well as gendered terms (plate 8.4). Viewers are constructed both actively and passively, depending on which part of the performance space they choose to enter. As onlookers, the audience are invited to make choices – do they want to witness the visual and speech effects of an Afro wig on a white European female, a long, blonde wig on a black British male or a ginger crop on an Asian girl, for example? Or what heady mix of exotic perfume or dazzling make-up would they like to consume – as well as be consumed by? Within certain structural parameters, the choice becomes theirs and the project absorbs its audience through a seductive dynamic of identification, desire, disrupted expectations and frequent laughter. The power of play and of identity formation rests partially with the audience and partially with the reactions that their matching of wigs and make-overs with participant–performers generate.

Within the electronic version of the performance, a full range of ethnic and gendered participants are present to enable the audience to make their choices and have fun with the results. Frequent laughter, shock and discomfort are just some of the emotions that are generated by this gentle probing of identity construction which cuts beyond categories of ethnicity and colour and exposes the cultural assumptions that accrue to such basic 'facts' as hair and skin. Interestingly, it is the long, blonde wig and the Afro wig that cause some of the most forceful responses, because both are so heavily caught up in Western constructions of race and beauty. As metonymic signifiers for the dialectical tension between the West and its 'Others', these markers of gendered, racial and sexual identity have a long tradition within Western traditions of representation and still exert powerful effects within mythical narrative constructions of beauty and power. Whilst the Afro wig is symbolic for some of the participants of the Black Power movements of the 1960s and 1970s, particularly for the younger black generation for whom the memory is a significant reminder of respect for the struggles of their parents' and grandparents' generation, it is also caught up within a white Western myth of 'primitivism'. For one white participant it is the

8.4 moti roti, *Wigs of Wonderment*, 1995. 'Wigs'. Photographed at an original live performance. Photograph © Julia Cody.

perfect vehicle for 'dressing up' for a fancy dress party; it is a wig that she would wear with a wooden animal necklace to construct an outfit so that she can pretend to belong 'to an African tribe'. For the same participant, the short ginger crop has powerful associations with childhood memories, as well as reminding her of a gay male friend. Such diverse reactions expose interesting issues of internal stereotyping and cultural assumptions. However, because of the way in which the performance is orchestrated, no sooner has one set of assumptions been aired than a totally opposing one is also available, thus exposing the instability of racial and cultural stereotypes and emphasizing instead issues of diversity, hybridity and the fragility of individual identifications. The long, blonde wig also produces interesting cultural effects. For some it is reminiscent of the Hollywood starlet, whilst it reminds others of black session singers of the 1970s; for virtually all the participants it is the most potent sign of artifice and masquerade. It signifies Western constructions of glamorous femininity at its most extreme, artificial and performative and it becomes a potent marker of identity that can be put on or taken off at will.[19]

The hegemonic signifying circuit of stereotypical behaviour patterns and identity formations is interrupted as performers encourage their participants to explore, affirm, confront or deny the fragility of their own gendered, racial and sexualized assumptions. The emphasis on the visual effects that are engendered by the performative practices played out across multiple registers of 'spectatorial identifications' are supplemented through recourse to a range of other sensory experiences, lest the audience become too enmeshed in the scopic dangers of the phallocular visual field.[20]

A crucial issue at stake in this reading of the supplementarity to the visual that is provided by the sensual, is one that Peggy Phelan identifies as the 'contradiction between "identity politics" with its accent on visibility, and the psychoanalytic/deconstructionist mistrust of visibility'.[21] As she deftly goes on to explore, the investment in the visible as a sign of the real, a sign of presence, that has underpinned the philosophy of much of the identity politics practised by sexual and racial minorities over the past few decades, is tactically problematic because it relies for its effects on the very system of representation that it seeks to undermine. As Phelan indicates, such tactics assume that 'what one sees is who one is' but as both psychoanalysis and performance theory have demonstrated, what one sees is an unreliable mis-recognition structured through the phallocentrism of the Symbolic. Thus, if the visible is unreliable, recourse to the other senses becomes a further mode of de-articulating stable visual signifying practices. In the 'Perfume' room and the 'Garden' room, although in the electronic re-staging the audience cannot actually experience the scents that are concocted, or the tastes and smells that they are told about, their auditory evocation through vocal presence is powerful enough to titillate the olfactory senses with the desire for experience of them. Furthermore, this recourse to an extended sensual field as a means of disrupting the dominance of the visual within Western metaphysics as a recent strategy of much aesthetic and cultural discourse, is prompted by the desire to dislodge what Martin Jay has described as 'the scopic régimes of modernity'.[22] French feminist philosopher Luce Irigaray has also been particularly instrumental in opening up discourses around

the senses by pointing out that 'investment in the look is not as privileged in women as in men':

> More than any other sense, the eye objectifies and it masters. It sets at a distance, and maintains a distance. In our culture the predominance of the look over smell, taste, touch and hearing has brought about an impoverishment of bodily relations ...[23]

Irigaray's philosophical project seeks to formulate a role for the subjective feminine within radically different structures of European thought to those dominated by the transcendental universalism of Western metaphysics and Cartesian dualism. Her writing does not seek to oppose existing epistemologies so much as to dismantle them in order completely to rebuild them, offering new structures for the envisioning of embodied subjectivities in which feminine subjectivity can be presenced. For Irigaray, it is touch that is brought into play with vision and conceived in terms of vision – the two become entwined within the textures of light that give them coherence.[24] The physicality and concomitant eroticism of massage played a key role in the sensual experience engendered in the live performances of *Wigs*, where touch, smell and voice were combined to evoke a sense of the 'exotic Other', a site of relaxation, pleasure and desire. Significantly, however, for Jacques Derrida and Jonathan Rée, it is hearing and the power of the voice as much as touch that provides a compelling mode for resisting the trap of ocularcentrism, and it is the capacity of the audience and interpreters for hearing voices and music that also plays a crucial role in the effects produced through the language and sounds of *Wigs of Wonderment* in both its live and its electronic forms.[25]

Sound, vision, performance and mimicry all combine in Anand's spectacular 'Stance' in which the concept of a 'cultural make-over' explored in the first two spaces ('Hair' and 'Make-up') is enacted in a third space via a short film of an Indian male cross-dresser, Anand Kumar, adorned in a red sari and performing Bollywood-style Indian dance movements to music on a main public shopping street in East London to the delight, bemusement and embarrassment of on-lookers and passers-by. In the privileged space of voyeuristic removal, the home-viewer can choose to watch the movements and listen to the music whilst simultaneously observing isolated close-up camera shots of the reactions of the filmed audience of shoppers, market traders and locals. The spaces of identification for both the home-audience and the on-site observers remains deliberately ambivalent and open ended, playing upon the ambiguities of this politically charged urban area.

This intervention by Anand into the public space of Green Street, Upton Park in East London, provokes a variety of intriguing speculations on the performative nature of cultural identity and racial stereotyping in the post-colonial era. As a physical location, Green Street is one of those many urban spaces in Britain that offers a nexus of contradictions, marked and re-marked by the conflicting histories that animate the area. Whilst West Ham football stadium is located near to one end of the street, along the rest of the street is an eclectic mixture of shops, many of which are run by and cater specifically to the

Asian communities of the area. In the past this area, like many other multi-cultural neighbourhoods in East London, has been a target for racially motivated attacks: the football terraces at West Ham are notorious seedbeds of recruitment for the British National Party. The area is a lively blend of multicultural urbanism, typical of many metropolitan spaces within contemporary post-colonial Britain. Art projects performed or enacted in public spaces often have an interesting way of teasing out such tensions, giving them a focus and contextualizing them within larger political terrains. Rachel Whiteread's 1993 controversial concrete casting of the interior of 193 Grove Road in Bow, *House* (plates 1.1 and 1.2, pages 318 and 320) is a cogent reminder of how art works in public spaces can animate and give focus to a host of subliminal politicized and historically deeply rooted tensions, eliciting graffiti, demonstrations and a media furore concerning property rights, ownership and concepts of 'home', homelessness and community issues. As Doreen Massey has observed:

> The East End is an area which oozes meaning as a place, both locally and in the national psyche. The meanings are, however, varied and much contested. This is the home both of Alf Garnett and of a constantly-added-to ethnic mix; of the battle of Cable Street, Brick Lane and dockers marching against immigration. It is a locality in which notions of community … are at the very heart of politics and of daily life. A reference to 'tradition' in the East End can bring to mind radicalism and ethnic diversity or racism and community closure …[26]

By choosing Green Street as the location for this particular performance, moti roti have identified and acted upon an interesting set of cultural and racial tensions and have animated them in a humorous and appealing way. By using humour and parody to draw attention to ugly issues of racism and homophobia, heavy-handed moral judgements are avoided, yet the point is made effectively and does not impair the aesthetic enjoyment of the sequence.

The choice of an Indian male-to-female cross-dresser for this particular aspect of the project continues the theme of destabilization of the norms of cultural expectation that runs right through *Wigs of Wonderment*. In his fascinating study of Indian masculinity under Empire, *Effeminacy: The Economy of Colonial Desire*, Revathi Krishnaswamy traces the history of a concept of 'effeminism' in colonial India in which masculine colonial subjects were dominated through the British colonizers' insistence on their innate effeminacy.[27] Yet, as he argues, the category of effeminacy was also a performative strategy that was recuperated by the educated Hindu elite in the eventual subversion of colonial authority through Gandhian nationalism:

> Effeminacy was simultaneously a mimicry of subversion that successfully disrupted colonial authority in certain contexts as well as a mimicry of subjugation that kept lower castes, religious minorities and women under elite male control …[28]

Krishnaswamy demonstrates that Indian male androgyny, as constructed through and by Empire, operated on multiple political registers of colonial politics and desire, as both mimetic and contingent. Such mimicry, resonant of both Butler's and Garber's analyses of drag as a potentially subversive strategy that can operate to destabilize fixed gender categories, also elicits an interesting commentary from Homi Bhabha, that contextualizes Butler's analysis of parodic repetition within the paradigms of post-colonial critique. Bhabha observes that 'colonial presence is always ambivalent, split between its appearance as original and authoritative and its articulation as repetition and difference.'[29] The structures of colonial identity are deconstructed by Bhabha along the same axes as those of gendered identity by Butler and it is the introduction of the 'hybrid' (Bhabha) or the 'third term' (Garber) that enables the parodic repetition performed by the androgynous Anand to effect its subversion of the hegemonic stereotypes of popular Indian culture and ethnic gendered identity. As a performance, *Wigs of Wonderment* exposes the lack of a stable field of representation for materializing Asian sexual identities. As B.J. Wray has astutely observed, 'clearly resignifications of lack can only occur within the paradoxical situation of inhabiting a construction in order to critique it' but Wray also argues that there are 'multivalent ways in which parodic provocation unsettles viewers'.[30] This is clearly evidenced not just by Anand's performance, but also across the entire conception of the *Wigs of Wonderment* project where viewers' assumptions about racial, sexual and gendered identities become the point not so much of unsettlement as of frequently humorous and always empathetic inquiry.

An overriding impression that the viewer/participant is left with after viewing/participating in *Wigs of Wonderment* is the sensuousness of the piece in all its aspects. It is a visual and auditory feast and whilst olfactory and haptic sensations of taste, smell and touch cannot be recreated through the electronic version, touch and smell at least are an integral part of the live performances and the second-hand experience of their effects is cleverly restaged electronically in sequences four and five, the 'Perfume' and the 'Garden' rooms. In its site-specific performances, different artists played different roles within the staging of the piece. Whilst the first artist discusses plants and their perfumes with initial entrants to the piece, the fifth artist is engaged in the task of discussing and choosing 'ittar' (perfumes) with the participant (after they have tried out their wig and had their make-over). The final artist, number six, is then engaged in giving the participant a head massage, using both hair oils and the ittar that the person has brought in with them from the previous stage of the performance (plate 8.5). In the CD-ROM, this aspect of the performance is given its own sequence and it occurs after Anand's dance. It is perhaps the most direct interaction that the viewer has with the piece in terms of being implicated in the choices of scent that s/he makes. Visually this sequence is stunning: a deep velvety black background provides the setting for a jewel-like array of ittar or perfume vials that are suspended in mid-air above a small, delicate silver cauldron. Each vial contains a dazzling coloured 'liquid' that is the scent. With one click of the mouse, the viewer chooses their scent and triggers an erotic commentary narrated by Ali Zaidi's deep and languid voice. Zaidi gently, sensuously and seductively explains what the scent is, what its origins are and

8.5 moti roti, *Wigs of Wonderment*, 1995. Head Massage with hair oils and perfume (ittar). Photographed at an original live performance. Photograph © Julia Cody.

what its sensual properties are believed to be, before the delicate vial plunges into the silver cauldron and the viewer is enticed to choose again. Each vial is combined with another, mixed in the cauldron and produces a 'scent' which Zaidi explains. The visual and sensory effects of this sequence are breathtaking and the interaction is intimate and compelling. Again, the emphasis on the realm of the senses could be read as part of moti roti's more general attempts to explore different strategies of identity subversion.

The narrative tone of Ali Zaidi's voice in the 'Perfume' room constructs an exotic and erotic mood, whilst the engaging monologue performed by Nina Edge in the 'Garden' room mixes the informative with personal and anecdotal cultural references that weave a set of stories about the healing and/or magical properties of particular flowers, herbs and spices. Stories, fables, myths and anecdotes ranging from the sublime to the ridiculous are proffered for our entertainment, education and amusement in the final sequence of the performance. The power of these stories often rests in their long history of oral tradition in which healing properties of plants or their powers of emotional effect are aspects of discourse that can neither be proved nor refuted, thus taking a place within our cultural heritage and subtly enriching it. Quite often, such stories disclose their foundational moments in 'Other' spaces – both historical and geographic; such locations are conjured as distant and 'exotic', providing them with the power and authority of 'difference' whilst at the same time introducing an element of scepticism and doubt in the 'excess' of their construction and invention. The history of storytelling and the oral tradition in both Eastern and Western cultures is a powerful one that betrays double-edged characteristics. Whilst myth-making and storytelling are a fundamental part of the processes of social, cultural and individual identity formation, they are also nebulous activitites that can perpetuate misunderstanding, stereotyping and superstition. Within the context of the performance as a whole, I would suggest that whilst sequence five invites its audience to learn and enjoy the fables that have accrued to the plants, spices and flowers that they pick, it may also suggest that they should be cautious about their identifications with – and beliefs in – all the stories that they are told.

Dorothy Rowe
Roehampton, University of Surrey

Notes

The author gratefully acknowledges the generous assistance provided by moti roti, AAVAA and The Live Art Development Agency; in particular she would like to thank Sonia Boyce, David A. Bailey, Lois Keidan, Keith Khan, Karla Barnacle-Best, Gillian Elinor and Alison Bean.

1 Judith Butler, *Gender Trouble: Feminism and the Subversion of Identity*, London and New York, 1990, p. 139.

2 moti roti, 'Mission Statement', 'Artistic Policy: Aims and Objectives', 'Aesthetic Ethos' and 'Wigs of Wonderment', London, September 2002.

3 For more discussion on issues of 'difference' in relation to black and Asian women artists, see Dorothy Rowe, 'Differencing the City: urban identities and the spatial imagination', in Malcolm Miles and Tim Hall (eds), *Urban Futures: critical commentaries on shaping the city*, London and New York, 2003, pp. 27–43.

4 Samena Rama took part in moti roti's *Colours of Asia* mixed media exhibition curated by Ali Zaidi in 1992 and subsequently died tragically in the same year. For further information about this artist, see Samena Rana, 'The Flow of Water' in Sunil Gupta (ed.), *Disrupted Borders: an intervention in definitions of boundaries*, London, 1993, pp. 166–73.

5 Kobena Mercer, 'Busy in the Ruins of Wretched Fantasia', in *Mirage Enigmas of Race, Difference and Desire*, an ICA/inIVA season, London, 1995, pp. 18–19. The Institute of International Visual Arts (inIVA) is based in London and directed by Gilane Tawadros. As an organization it 'creates exhibitions, publications, multimedia, education and research projects designed to bring the work of artists from culturally-diverse backgrounds to the attentions of the widest possible public.' For further details, see the website at www.iniva.org

6 moti roti, 'Mission Statement', 'Artistic Policy: Aims and Objectives', 'Aesthetic Ethos' and 'Wigs of Wonderment', London, September 2002.

7 I use the distinction of 'physical site-specificity' in the sense put forward by Miwon Kwon in her recent attempts to recuperate the political aspects of the term from its otherwise overdetermined use as a general label for all non-studio art practice. Kwon's distinction between physical, phenomenological and discursive types of site-specificity helps to reinvigorate the critical language and conceptual understanding of the genre: Miwon Kwon, *One Place after Another. Site-specific art and locational identity*, Massachusetts, 2002, pp. 1–32.

8 Correspondence between the author, Sonia Boyce and David A. Bailey, July 2002.

9 Amelia Jones and Andrew Stephenson (eds), *Performing the Body: Performing the Text*, London and New York, 1999, p. 2.

10 Homi K. Bhabha, 'The Other Question – The Stereotype and Colonial Discourse', *Screen*, vol. 24, no. 4, November 1983, p. 18.

11 Jones and Stephenson (eds), *Performing the Body*, p. 1.

12 The moment of the subject's entry into the Symbolic is also a point of rupture and as Jacqueline Rose, amongst others, observes, 'in Lacan's account, the phallus stands for that moment of rupture.' Jacqueline Rose, *Sexuality in the Field of Vision*, London and New York, 1986, pp. 61–2.

13 For further details, see Jacques Lacan, *Écrits: A Selection*, New York, 1977, pp. 285–7.

14 Jacqueline Rose, *Sexuality in the Field of Vision*, p. 63.

15 I adapt the term 'phallocular' from Martin Jay's discussion of 'Phallogocularcentrism: Derrida and Irigaray', in Martin Jay, *Downcast Eyes: The Denigration of Vision in Twentieth Century French Thought*, Berkeley, California, 1993, pp. 493–542.

16 Marjorie Garber, *Vested Interests: Cross Dressing and Cultural Anxiety*, London and New York, 1992, pp. 11–13

17 Butler, *Gender Trouble*, p. 137.

18 Butler, *Gender Trouble*, p. 137.

19 As is by now well rehearsed within the history of psychoanalysis, Joan Rivière, in her groundbreaking essay 'Womanliness as Masquerade', published in 1929, argues that feminine subjective identity is necessarily constructed as artificial since there is no place open to the position of the 'feminine' within existing models of psychoanalysis that formulate identity difference as being structured through the visible presence of the male phallus and its concomitant lack or absence in the female; see Rivière in Victor Burgin *et al.* (eds), *Formations of Fantasy*, London and New York, 1986, pp. 35–44. Psychoanalytic theory is useful in this context because its main concern is the analysis of subjective identity formation, precisely the topic that moti roti seeks to explore in *Wigs of Wonderment*. As already indicated, psychoanalytic theory derived from Lacan offers an explanation of the founding moment of the recognition of the self via the mirror as a *mis*-recognition that belies the fragmentary nature of the subject whose identity it is being used to secure. As individuals, our identities and our sense of ourselves and who we are are shaky constructions cobbled together out of a host of life experiences and circumstances of birth. It is this contingency that *Wigs of Wonderment* exquisitely, elegantly and humorously foregrounds.

20 Jones and Stephenson (eds), *Performing the Body*, p. 7.

21 Peggy Phelan, *Unmarked: The Politics of Performance*, London and New York, 1993, p. 6.

22 Martin Jay, 'Scopic Régimes of Modernity', in Hal Foster (ed.), *Postmodern Culture*, Seattle, 1988, pp. 3–7.

23 Luce Irigaray interviewed in Marie-Françoise Hans and Gilles Lapouge (eds), *Les femmes, la pornographie et l'eroticisme*, Paris, 1978, cited in Jay, *Downcast Eyes*, p. 493.

24 As Cathryn Vasselau comments in her reading of Irigaray's thought, 'an elaboration of light in terms of texture stands as a challenge to the representation of sight as a sense which guarantees the subject of vision an independence, or, in which the seer is distanced from an object': Vasselau, *Textures of Light: Vision and Touch in Irigaray, Levinas and Merlau-Ponty*, London and New York, 1998, pp. 12–13.

25 For further details on Derrida's position in relation to both ocularcentrism and hearing, see Jay, *Downcast Eyes*, 1993, in particular pp. 511–16. See also Jonathan Rée, *I See a Voice: A Philosophical History of Language, Deafness and the Senses*, London, 1999.

26 Doreen Massey, 'Space-time and the Politics of Location', in James Lingwood (ed.), *Rachel Whiteread: House*, London and Oxford, 1995, p. 46.

27 Revathi Krishnaswamy, *Effeminism: The Economy of Colonial Desire*, Michigan, 1998, reprinted in

Rachel Adams and David Savran (eds), *The Masculinity Studies Reader*, Oxford and Mass., 2002, pp. 292–317.

28 Krishnaswamy, *Effeminism: The Economy of Colonial Desire*, p. 304.

29 Homi K. Bhabha, *The Location of Culture*, London and New York, 1994, p. 107.

30 B.J. Wray 'Performing Clits and Other Lesbian Tricks', in Jones and Stephenson (eds), *Performing the Body*, pp. 189 and 192.

Lubaina Himid's *Plan B*: Close-up Magic and Tricky Allusions

Jane Beckett

In a symposium held at the beginning of the 1990s to discuss the debates surrounding multiculturalism, identity politics, their philosophical and political implications, Cornel West raised questions on the nature of the construction of identity:

> For me identity is fundamentally about desire and death. How you construct your identity is predicated on how you construct desire and how you conceive of death: desire for recognition; quest for visibility (Baldwin – no name in the street; nobody knows my name); the sense of being acknowledged; a deep desire for association – what Edward Said would call affiliation. …And then there is a profound desire for protection, for security, for safety, for surety. And so in talking about identity we have to begin to look at the various ways in which human beings have constructed their desire for recognition, association, and protection over time and in space and always under circumstances not of their own choosing.[1]

The provocative probing at the visual representation of multiculturalism and identity politics have been a crucial part of British art politics since the 1980s, in which issues of recognition and inclusion, history, institutional practices and policies, and the making of images have been central. Lubaina Himid's 1999/ 2000 Tate St Ives installation *Plan B* inhabits many of the themes mapped out in Cornel West's presentation – history, identity, danger, recognition. Her working practice has been a continuous exploration of some of these issues, from the direct engagement with the representation of Black people in Britain, the making of the history of image-making and the borrowings of modernist painters from African art in her installations *A Fashionable Marriage* (1986), *The Ballad of The Wing* (1987),[2] *Vernet's Studio* (1994)[3] and *Naming the Money* (2004).[4] Her installations, like those of many contemporary British artists, have a staged theatricality, but she is actually a painter who closely engages with painting. This can be through close observation of modernist techniques and subject matter, as in her multilayered canvas *Freedom and Change* (1984),[5] which quotes Picasso's 1920s beach paintings and his set and costume designs for the Diaghilev ballet of the same date, but turns the reference in the images of running Black women and the accompanying cut-out white critics buried up to

their necks. Her *Revenge: A Masque in Five Tableaux* (1992) draws on seventeenth-century masque design and political theatricality, but looks closely at nineteenth-century French painting and British abstract art, while, as Griselda Pollock noted, 'actively citing and referencing artistic codes associated with historical moments within modernity that are stamped by the colonial rape of Africa'.[6] In recent works, Himid has temporarily abandoned the portrayal of Black women (seen in plate 1.6), moving instead to images of the beach, beach houses and the sea. The ten large canvases of *Plan B* were generated from a body of liquitex acrylic and charcoal paper works and a series of small notebooks containing writing, drawing, collage and photographs, relating to the period that Lubaina Himid spent as artist-in-residence at Tate St Ives during 1998 and 1999.[7]

Plan B is the title of the installation, and one of its principal paintings (plate 9.1). In colloquial exchange 'Plan B' denotes a fall-back position or schema, an uneasy space never supposed to come about, premised as it is on a previous (or parallel) Plan A. It implies the bringing forward of possibilities and proposals shadowing a first plan. The term refers simultaneously to a past and to a possible future in which closure is effected on a Plan A and it is necessary to plug the gap left or remedy elements of the initial idea. It also suggests the re-ordering of a schema turned topsy-turvy, forming a blueprint for a space that has been re-routed or displaced whether through failure, violence or changed conditions. Plan B signifies a strategic plan that may or may never take place, contrarily both a rethink for now and the future and a card held up one's sleeve just in case.[8] In this sense it involves artifice, the shading of one representation by another. The sheer speculativeness of the concept makes an uneasy, porous space with ill-defined and leaky edges, which also paradoxically has the verve and energy of renewal, the making of a new map. Plan B is a hidden scheme, secondary but not necessarily inferior, enabling events to take place not as originally plotted or planned, but nevertheless successfully bringing a scheme to fulfilment. Plan B is quintessentially a reconfiguration, rapid yet planned.

Some of the elements embraced by the concept of a Plan B – parallel/double narratives, dislocation and notions of violent intervention – are some of the themes of Lubaina Himid's *Plan B*, which also pursues issues from her earlier work in the interrogation of history and the contrivance of new narratives. The *Plan B* canvases, like those of her earlier works draw on deeply personal experiences; in this case they are crammed with references bearing testimony to her experiences of the Cornish coast and weather and perceptive and witty allusions to the significant works of English modernism and contemporary art displayed in the Tate or held in its collections. The ten paintings that make up the *Plan B* installation vary in size and format and are presented in three distinct movements with variations, refrains and repetitions. There are three upright, four text/image and three horizontal canvases. The final (upright) triptych – the pool series – are explicitly titled *Red, Blue* and *Yellow* while in the second (horizontal) triptych the titling is more ambiguous: *Everybody Is, Partition* and the central panel *Plan B*, which names the installation. The images are principally full-frontal, but the spatial play within them, and the scale changes

of the depicted objects unravel the frontality. This and the grid-like compositions of the three pool paintings play with a decorative aesthetic but this too is undermined in the bold use of colour and through the eruption in some passages in each canvas of what Himid has termed 'a sense of the gloriousness of possibility and the deliciousness of paint'.[9] The pool canvases carry narratives of colour, the substance of paint, while the textual border of *Everybody Is* and the titles of the three horizontal canvases, like headline banners, offer stories to unfold within them. These two groups contrast with a group of four paintings in which antiphonal narratives, scripted on the canvas, are opposed to, and apparently disavowed by, their visual counterparts. As Lubaina Himid has said, 'woven into the dialogue there should be an inkling of danger, a call for change, a sense of the gloriousness of possibility.'[10] *Plan B* becomes a complex multitextuality of resonant voices, telling different, sometimes conflicting, sometimes simultaneously the same, stories.

The exhibition takes up the term 'plan' to offer a complex itinerary of representations, tales of mystery and illusion and, as in all good mystery stories, the unfolding of unexpected events. A 'plan' can be a map of a place or site, and the series may offer a cartography of Cornwall. A plan may also be a spatial projection on a two-dimensional surface which, it could be argued, is, in its conjuring up of familiar, hidden, unknown or future spaces, a form of illusion, a major theme of the work. But the word also connotes planning, or projection, contriving something to be done, a strategy for action, a blueprint of desire. *Five* (1992, Leeds City Art Gallery), a painting from *Revenge*, powerfully invokes such plotting in its representation of two women seated at a circular table, emblematic of a global map.[11] Africa and America are marked on its surface and at its centre stands a sugar bowl, its single serpentine line of white dots traced on blue suggesting diasporic links and the intermeshing of trade in slaves and sugar. The connections between colonialism and death are underscored by the invocation in the title of the painting of a line from Shakespeare's *The Tempest*, 'Full fathom five thy father lies...', in which Ariel tells of a death by drowning. In *Revenge*, to mourn is to plot retribution. If the positioning of the two figures reprises Man Ray's photograph taken in 1922 of Alice B. Toklas and Gertrude Stein in their Parisian apartment, the painting dislodges and reconfigures received conceptions of modernism, sexuality and history.

During the residency in St Ives, *Plan B* formed in dialogue with many different traditions and personal experiences, including that of living in a town saturated in the traditions of English modernism, quintessentially visible on the walls of Tate St Ives, and where the histories of the artists and writers of St Ives past and present are so tangible in the streets, galleries and shops. Echoing through *Plan B* is the presence of women writers, painters and sculptors in St Ives: the young Vanessa Bell on holiday, Frances Hodgkins, who stayed during the 1914–18 war, Barbara Hepworth, with her studio and sculpture in the town (her studio is now a key site in the making of English modernism), the writer Virginia Woolf.[12] These are not accidental references but an active citing and sourcing of artistic codes of modernist aesthetics and the presence of women in the modernist canon. Of *Revenge* Himid has said:

9.1 Lubaina Himid, *Plan B*, 1999. Acrylic on canvas, 122 × 305 cm. Artist's collection.

These paintings are as much about the stuff in which they are painted as they are about the events which they remember and evoke. I have taken when and what and where it seemed appropriate, from whom I wished to borrow and reinterpret. There are references to Turner and Tissot ... Riley and Bell... .[13]

There are similar multiple evocations in *Plan B*, notably Vanessa Bell. Writing of Bell's *Studland Beach* (*c*.1912, Tate, London), Maud Sulter suggested that the painting 'resonates the words "if only" over and over again.'[14] Lisa Tickner has drawn attention to the painting's relationship to Virginia Woolf's *To the Lighthouse* in its return to the memories of childhood, and the death of Virginia and Vanessa's parents. Tickner shows how, for Vanessa Bell, *To the Lighthouse* of 1927 was 'a portrait of mother, which is more like her to me than anything I could ever have conceived possible. It is almost painful to have her so raised from the dead.'[15] And she further draws a connection in Woolf's novel between the act of painting, the dipping into blue paint by Lily Briscoe and dipping into the past, not 'the arbitrary resolution of perception into a patch of pigment, but an objective correlative for Mrs Ramsay's sense of self'.[16] The beach thus becomes a complex site of creative work, memory, desire and death.

Studland Beach is related to a small body of paintings and photographs made on different trips to Studland in Dorset between 1909 and 1912, and, as Lisa Tickner has suggested, is marked off from the images made *in situ*:

The sensations of place and moment, of a particular set of emotions, are recollected in the tranquillity of the studio. But something happened in the process of adjustment and simplification which is of more than formal interest.[17]

Formally, the 'process of adjustment' entailed a tightening of forms and an organization of colour for the overall structure and design, but this re-ordering, as Tickner argues, has a bearing on the shaping of meaning. So, too, for Himid. The liquitex acrylic and charcoal paper works made *in situ* in St Ives were all 'useful somehow for the next stage'. The time and necessary space for this reforming, this re-consideration have been invoked by bell hooks:

I think often and deeply about women and work, about what it means to have the luxury of time – time spent collecting one's thoughts, time to work undisturbed. This time is space for contemplation and reverie. It enhances our capacity to create. Work for women artists is never just the moment when we write, or do other art, like painting, photography, paste up, or mixed media. In the fullest sense, it is also the time spent in contemplation and preparation. The solitary space is sometimes a place where dreams and visions enter and sometimes a place where nothing happens. Yet it is as necessary to active work as water is to growing things.[18]

Lubaina Himid worked in the lifeguards' hut on Porthmeor beach, directly in front of Tate St Ives.[19] (plate 9.2) This became 'the solitary space for

9.2 Photograph of Lubaina Himid in lifeguards' hut, Porthmeor Beach, St Ives.

contemplation and reverie', where 'dreams and visions' entered. In two critical periods in the hut she transformed the long, thin space used by lifeguards during the summer and in which their wet suits were still stored. She stapled paper to the walls and worked on four different walls, one of which could only take long, thin strips of paper or canvas. During two bitterly cold winter months (November 1998 and March 1999) when it was, she recollected, 'very very cold' (echoing Frances Hodgkins's letters home), she wore double layers of clothing, walking boots and a hat.[20] She amassed drawings, watercolours and gouaches and several canvases. The available wall spaces determined the configuration of sketches and influenced the format of the final canvases. The re-working of the sketches, their forms and colours, across the final ten canvases back in her studio in Preston necessarily reshaped their meanings, and prompted a rethinking of directions. As Himid noted, 'If it wasn't so frightening it would be exciting to see how the image and text work from '97 around interior domestic spaces and their double persona as war zone and havens of peace have transformed over the last year and a bit.'[21] In these transformations colour, form and overall structure of completed works changed, as the resonances of Maud Sulter's 'if only' readings of Bell's *Studland Bay* also transformed the titling of *Plan B*. Not the 'over and over again' of 'if only', but the traumatic and transformative emergence of a 'Plan B'.

Between the brief visits Himid made to St Ives in 1997 (November) and 1998 (February) focus on the work intensified 'and the walls (opened up) to reveal the sea.'[22] The sea, the beach and its structures and forms have been critical in Himid's painting. 'The beach', Maud Sulter wrote, 'is a site of cultural struggle',[23] the site, she argues, of colonial violence and neo-colonial fantasies.

9.3 Lubaina Himid, *Metal/Paper*, 1995. Acrylic on canvas, 153 × 213 cm.
Exhibited *Beach House*, Wrexham Library Arts Centre, 1995.
Artist's collection.

In her extended revisions of the narratives of history which have excluded and
misrepresented the histories of black peoples, from the mid-1990s Lubaina
Himid turned her attention from 'the problems of loss, mourning, absence',[24] to
the intersection of presences and absences, in a series of paintings of beach
houses, sea and beaches from sites that map an English childhood playing on
beaches from Lytham St Annes in Lancashire to Shanklin on the Isle of Wight
into an adult mapped world which embraces Beit el Ras, Havana, Santa Monica
and Malibu. Her exhibition *Beach House* (see plate 9.3) took the image of that
widely diverse seaside building, the beach house, to explore issues of identity

and history, while drawing on memories and experiences of beach houses and sea edges worldwide.[25] Like modernist women painters such as Bell and Winifred Nicholson, Himid uses metaphor, 'to see an everyday object like a beach hut *both* in its true grandeur and oddity *and* as a form that can condense into itself other associations'.[26]

In her statement in the catalogue for *Beach House*, Himid refers to paintings in the collection of Kettle's Yard Cambridge,[27] the letters of Frances Hodgkins and to the painters of St Ives. And she foregrounds themes developed in the first stages of *Plan B*: distant war, house/hut, St Ives, memory and the sea:

> During World War One, the painters of St Ives could not paint the sea or coast line. Torture to have to turn their easels inward, their backs to the world, the roar of the waves and the wind. The threat of war something to be glanced at furtively over one shoulder until the planes came. ... I long to sit and stare out from a stone house high above the waves and marvel at the light the warmth and the great distance from London. Quaint nostalgic small neat pretty and rather simpering St Ives until a storm rises and dashes hope and treasure onto the rocks.[28]

Working in the lifeguards' hut, and the intense cold, shifted the view of the sea from the beach and the external structures of beach huts to looking from the inside out. The lifeguards' hut contained long strip windows giving the artist, like the lifeguards, uninterrupted views onto the sand, the sea and the sky. Windows appear throughout the canvases of *Plan B*, opening up, closing and bordering the spaces. They may allude to a repertoire of window images from early modernist Parisian windowscapes, to Winifred Nicholson's windows onto the Cumbrian and Cornish landscapes or even those images which daily accompany television weather forecasts. In Winifred Nicholson's paintings sills, edges and panes frame and close off access to an outside world, made the more tangible from being seen from the interior world. Whereas in Himid's *Our Entire Food Supply* (see plate 9.8) and in *Plan B* windows offer glimpses of sea and sky, in *Havana Nightschool* (see plate 9.10) the openings in the walls refuse views beyond. A window which is merely a small aperture in *The Glare of the Sun* comprises a whole wall in *Everybody Is:* here outside and inside oscillate, both one yet neither (see plates 9.7 and 9.5–9.6). In the painting *Plan B* (plate 9.1) the ten window openings each contain a small seascape with differing cloud and sea colours and formations. But the insistent horizon line inscribes flatness, denied in the left-hand angled window opening but reiterated in the overall range of blacks which dominate the canvas and in the tessellated black, white and grey strip that runs from top to bottom of the canvas on the right-hand side.

It was, Lubaina Himid recalled, 'quiet inside' the lifeguards' hut: '[I] could hardly hear the sea.'[29] But the sea, lapping at the walls, is everywhere in *Plan B*: seen through glass walls and apertures or filling the frame, at times delicate, an enticing watery blue, at times stormy and threatening to engulf or drown the fragile barriers which hold it back. The paintings all contain images of the sea, developing the seascapes from *Beach House*, but omitting the beach huts, although these, too, are present in their absence as Himid worked inside the

lifeguards' hut. The paintings of *Plan B* belong to a cultural and autobiographical history of the beach. There are cross-references to places visited and painted earlier,[30] and to the sea as an imaginative resource. So tangible a presence in *To the Lighthouse,* the sea evokes mourning and loss in *Plan B*, as in the novel: 'through the open window the voice of the beauty of the world came murmuring, too softly to hear exactly what it said – ... – entreating the sleepers ... if they would not actually come down to the beach itself at least lift the blind and look out.'[31] These themes of mourning, loss, memory, interval and time reverberate through *Plan B*. There are echoes, too, of Iris Murdoch's *The Sea, The Sea* (1978), in which she writes of the instability of the water's surface, its transluscent and opaque colours, the effects of light. For Murdoch too, it is the framing of the image of the sea that links the ocean to memory, to interval and to time:

> The sea which lies before me as I write glows rather than sparkles in the bland May sunshine. With the tide turning, it leans quietly against the land, almost unflecked by ripples or foam. Near to the horizon it is a luxurious purple, spotted with regular lines of emerald green. At the horizon it is indigo. Near to the shore, where my view is framed by the rising heaps of humpy yellow rock, there is a band of lighter green, icy and pure, less radiant, opaque however, not transparent. We are in the north and the bright sunshine cannot penetrate the sea.[32]

Glimpsed through, framed by, the window openings in the painting *Plan B* is a tempestuous sky and rolling waves, their colour heightened against the deep black walls and the black, white and grey tessellated panel. A dark, troubled sea has flooded the interior, its white flecks suggesting glints of light, spume, or drowning bodies: the safety of the interior breached, the room may have become a watery tomb. In *Partition* (plate 9.4) the sea runs in a different perspectival space to the granite pebbles over which it washes and which it has thrown up. In Plan A, of course, these pebbles are swept away, and only sheets of clear sand punctuated by small strips of grey granite shards remain: the desired holiday beach for sunbathing or surfing. But we are on the dangerous and haunted territory of Plan B and no where is this more evident than in the text/image paintings.

More often than not space in these paintings is puzzling. Multiple perspectives trick the eye. Visual questions are posed but not answered. Sketches and descriptions of conjuring tricks and magic turns, drawn from popular books collected by Himid, offer teasing and humorous clues.[33] Just what is that folded paper inside the cup in *Partition*? Taken from a diagram for a conjuring trick in which water miraculously turns into confetti, a metal cup used for the trick is depicted divided by a partition, for water on one side and confetti on the other. The water drains from the cup into the base of the saucer leaving only confetti to be thrown at the audience. The partition dividing the cup gives the name to the painting and carries multiple connotations of personal and political separations. The act of conjuring and performing tricks involves forms of deception, making people and things appear other than they are, but also

9.4 Lubaina Himid, *Partition*, 1999. Acrylic on canvas, 122 × 305 cm. Artist's collection.

involves great skill in the sleight of hand and play with visual and psychological expectation. In the performance of tricks the task is to focus the viewer's attention on one or more objects, so that the exchange process is masked. *Plan B* is about the trickiness and obliqueness of meaning. Throughout *Plan B* Himid plays with visual expectation, with the presence and absence of objects and people as well as with dramatic changes of scale and form. She deploys the art of illusion in conjuring and magic tricks. The diagrammatic form of the ribbon from the card trick 'Cleopatra's needle', in which a pack of cards is apparently threaded on a ribbon with a darning needle, is woven like a national emblem across an early paper work and the final canvas, *Everybody Is* (plates 9.5 and 9.6). Clock faces from puzzle book images and from tide tables are propped up in *Our Entire Food Supply* (see plate 9.8). As in the conjuror's use of mirrors and magic boxes, a chair in *Partition* is partially hidden or reflected. A broad band in strong pink divides the work and the tessellated panel in two. Together they sever a large cup with a dotted edge from a cylindrical room, whose space is further fractured by a screen or mirror in or through which the chair is glimpsed. The circular space on the right evokes the Rotunda entrance of Tate St Ives, itself an echo of classical amphitheatres and temples (plate 9.11), where the visitor may await the opening of a play or anticipate the beginning of the event which might be *Plan B*. The circular room is punctured by three windows offering further spaces, which all seem divergent as none is on the same axis and yet which are conjoined: paradoxically, the horizon line remains constant. If this spatial play and evocation of the sea offers recollections of Alfred Wallis, there are also here, as through the series, other echoes of the structures of English modernity of the 1930s: swimming pools, garden screens and interior designs. Moreover, the juxtaposition of inexplicable objects on divergent scales and the spatial illogicality recalls Paul Nash's painting after 1918, in which he suggested that there was a 'magical presence ... which conjured up fantastic images of the mind. You might say it was haunted.'[34] Nash's conjunction of interior and

165

9.5 Lubaina Himid, paper work for *Everybody Is*, 1998. Acrylic on canvas, approx. 60 × 100 cm. Artist's collection.

exterior, in paintings such as *Harbour and Room* (1932–36, Tate London), disturbed spatial perspective his and conjunction of incongruent objects are alluded to throughout *Plan B*. Lubaina Himid's canvas builds from Nash's work to play with presence and absence, so that, particularly in the four text/image paintings, what is seen in the visual field is undermined by the written text panels, causing uneasiness for the viewer.

A 'plan' also suggests the route of a journey, a scheme for a voyage. This is a major theme in *Revenge*, as in *Between the Two My Heart is Balanced* (plate 1.6), which portrays two women in a boat shredding maps, and *Memorial to Zong* (artist's collection), which takes up a central theme in the artist's work of the power of water over life and death. *Plan B*, imprinted with the artist's travels, is about difficult and dangerous journeys. Travelling across Britain from north to south offered the artist a space in which not only to read, think and plan, but also to reconsider the journeys drafted in a series of small notebooks in which *Plan B* was first mapped out in the winter of 1997.

In four canvases hung together at Tate St Ives – *The Glare of the Sun*, *Our Entire Food Supply*, *The Sharp Undergrowth* and *Havana Nightschool* (plates 9.7–9.10) – the left-hand text panels offer first-person narratives in a tone of recollection, the lines written out by hand. As in an antiphon, there are repetitions and responses of different voices, graphically marked in different colours, and as the plain song of the antiphon preceded the psalm, the meaning of which it illustrated and reinforced, so the words introduce and respond to the visual field. But there is no apparent coincidence between text and image. The stories seem to be a part, a fragment, of a larger narrative outside the frame. They tell tales of harrowing journeys through 'sharp undergrowth' which

9.6 Lubaina Himid, *Everybody Is*, 1999. Acrylic on canvas, 122 × 305 cm. Artist's collection.

'scratched and tore at our limbs' made in 'freezing nights' and in 'the glare of the sun'. They tell of exhaustion, despair and fear of starvation after 'Our entire food supply was devoured early on by a pack of stray animals.' Their narrators' fear of discovery and death brings to mind the narratives of Black peoples in America, passages in Toni Morrison's *Beloved*, Michelle Cliff's *Free Enterprise*,[35] or Chester Himes's Harlem cycle (1958–68).[36] Terror and desolation are, however, displaced by sensory recollection, safety and freedom. When the food supply is lost, 'we tried to remember which mushroom berries and bugs our grandmothers had once taught us were collected by their mothers years before' with the result that 'the forest fed us well.' The recollection in *Havana Nightschool* (plate 9.10) of 'the glorious words of our old songs' promises a survival 'long enough to enjoy our freedom'. After 'the glare of the sun' comes help, comfort and friendship; after 'desperate fear' the possibility of 'a new life'.

Chester Himes used the thriller genre to explore issues of Black experience in the United States. His crime novels set in Harlem have elaborate and dramatic plots with strong characters, humour and biting social comment. *Plan B*, his final, uncompleted novel, develops cataclysmic and terrifying visions of the potential consequences of racism. Not only the pace of the narrative in Himes's detective series, particularly *Plan B*, reverberates in Lubaina Himid's painted texts but also the irony, jokes and, above all, the visual play with objects and space. In Himid's paintings the handwritten texts are accompanied by images of interiors containing tables, chairs, clocks, jugs and/or bowls, except in *The Sharp Undergrowth*: here an empty room, its clean symmetry reminiscent of heroic modern architecture or great ocean liners, seems perilously balanced between sea, land and sky. Glazed or open at the sides, it offers views of the sea and sky: a ladder hangs on the far wall. The eerie emptiness seems to threaten, yet the sheer brooding presence of the sea haunts the space. In *The Glare of the Sun* the tabletop floats like a miasmic illusion of the sea, a deep blue band

167

9.7 Lubaina Himid, *The Glare of the Sun,* 1999. Acrylic on canvas, 122 × 244 cm. Artist's collection.

9.8 Lubaina Himid, *Our Entire Food Supply,* 1999. Acrylic on canvas, 122 × 244 cm. Artist's collection.

168

The sharp undergrowth scratched and tore at our limbs as we trekked mile after mile knowing all the time our route was in danger of being discovered. We only stopped at all when we were utterly unable to continue and then it was only for short amounts of time usually in the dead of night. After many weeks of living in desperate fear the begining of a new life seemed possible as we reached the mountains.

9.9 Lubaina Himid, *The Sharp Undergrowth*, 1999. Acrylic on canvas, 122 × 244 cm. Artist's collection.

we grew rapidly more exhausted as the endless days of running and hiding continued. Some of us became dangerously disheartened and began to hear strange terrifying noises all around wailing screaming moaning. Far away yet near at hand. We wasted precious time standing still trying to fathom their origins. Our fear was unbearable. After many terrible nights of this we slowly began to remember the glorious words of our old songs. This united us and we had the strength to see that we could indeed survive long enough to enjoy our freedom.

9.10 Lubaina Himid, *Havana Nightschool*, 1999. Acrylic on canvas, 122 × 244 cm. Artist's collection.

169

9.11 Lifeguards' Hut and Tate St Ives, Porthmeor Beach, St Ives. Photo: Jane Beckett, 1999.

outside. The evening light of winter floods onto the sea blue walls of *Our Entire Food Supply*. *Havana Nightschool* is the only title to specify location, and to suggest a setting in the capital of Cuba where centuries of Caribbean history jostle: from piratical marauding, conquistador gold trading, colonialism, the development of sugar plantations and slavery, to the struggles for independence, the revolution of 1959, the socialist transformation and the current economic crises. But the canvas also carries personal memories of a visit to Cuba in 1994, of the wild colours of the sea and sky and of the peeling buildings in Havana. These vibrant colours recur in *Plan B* (plate 9.1). If, in *Havana Nightschool*, the yellow, pink and deep purple colours may evoke the city, the stark empty space, unfilled chairs and darkened windows (it is night) suggest an event completed or perhaps still to be enacted. The implied presence here is tangible in its total absence.

There is an interesting shift of mood between the sketches in the small notebooks and the final canvases. In the earlier studies oval tables and ladder-backed chairs, elaborate wallpapers and decorative carpets recall 1950s designs by Lucienne Day.[37] In the notebooks a double-page spread pairs an image with a very brief text which speaks more of survival than of fear – 'The terrain was rough but our training helped us gain the upper ground', 'At the second attempt we managed to reach the other side.' 'We crossed the river at night it was deep and cold but by morning we were safe' is accompanied by a study of a bed covered in west African fabric, with a row of cushions, placed before a cross-hatched wall on a checkerboard floor. The whole is comprised of vibrant patches of blue, yellow and black: is this the space of safety reached by the 'we' of the narrative? But while patterned surfaces play a significant part in the drawings, they have been excluded from the image/text paintings. The brilliance,

translucence and clarity of watercolour has been set aside for the rich opacity and strong colour of paint.

In two of the three pool canvases *Red* and *Blue* (plates 9.12 and 9.13) African kente cloth enhances the spatial ambivalence. Cloth plays a significant part in conjuring tricks. Handkerchiefs, scarves or napkins are used as the shielding device in a trick, the material that transforms one object into another. Kente cloth also played an important part in the paintings of *Revenge*, where 'the patterns on the cloth hold the clues to events.'[38] A similar interlaced pattern appears in both, interrupted or pierced by or perhaps screening or framing, at the top, a long window through which the sea and sky are glimpsed. In *Yellow* (plate 9.14) the smooth surface is perforated by a sharply angled window, similar to that in *The Glare of the Sun*. Whereas in *Blue* the sea is icy green, in *Red* it is a strong ultramarine. The play with illusionary space is very marked in these paintings and references the tricks and illusions of conjurors, in which the depicted space is not what it seems. Comparison with some of the preliminary studies for the pool paintings reveals rooms transformed into swimming pools, white with blue-black/indigo surround in *Blue*, blue water with yellow surround in *Red*. Even the pools disturb. *Yellow* and *Blue* have no water, while *Red* appears to be filled with liquid but it may merely have blue sides.

Himid's delight in 'the deliciousness of paint' colour is critical to visual strategies. Of the loaded palette of colour in *Revenge* Jill Morgan remarked:

> Juxtapositions, chosen of earthy colours, ermine blacks, reds, turquoise blues, oranges, a reclaiming of the colour palette of Africa and a dipping of the brush into the history of Western art. Lubaina has understood the importance of colour in the control of meaning. Within modernism colour has been used to represent, to own, entire civilisations, or to take colours sacred to a way of seeing and use them as a mirror, or a cipher for 'new' ways to see.[39]

Colour is similarly a key thematic of *Plan B*. Within the series are multiple references to a modernist play with colour, the red, yellow and blue of the pool paintings possibly echoing Barnet Newman's *Who's Afraid of Red, Yellow and Blue* (Stedelijk Museum, Amsterdam), which itself cites Mondrian's classic abstract canvases of the interwar years. Colour complimentaries of red and green, and tonally close, nearly discordant colours, such as mauve/yellow, or pink/orange, dominate the four text/image paintings. In her increasing assurance in the use of colour, apparent in *Plan B* in the play with colour tonalities and discords, Himid elaborates on subtle perceptions of colour and colour movement, and also on its symbolic force, equally essaying an exploration of the self as a painter.

Plan B was made over a period of two very poignant years in global and local history, which encompassed the report on the Stephen Lawrence Inquiry in Britain, conflict in Iran, and the re-eruption of violence through ethnic cleansing in the Balkans. The reporting of these events has carried narratives of nation, violence, danger, death, dislocation and relocation, stories of people hiding in woods, escaping to and through the mountains. While these, too, are among the narratives to which *Plan B* alludes, there are imprinted in these canvases the

9.12 Lubaina Himid, *Red*, 1999. Acrylic on canvas, 275 × 122 cm. Artist's collection.

marks of the painter Frances Hodgkins's disturbance by war. There are also resonances of the gendered territory of twentieth-century war as viewed by the female subject, notably in the writings of Martha Gelhorn[40] and Gertrude Stein, which develop the notion of the impossibility of 'directly' seeing the war.

In 1915 Frances Hodgkins, then settled in St Ives/Cornwall, wrote to her mother, not only about her painting, her studio and her new lodgings ('much nicer rooms and hideous furniture') but the recent news which stupefied her:

> It is impossible to escape depression ... I have sent you papers with glowing accounts of [New Zealanders'] doughty deeds. The losses are appalling. The Times today gives the list of officers' causalities ... as 1,400 odd! *in ten days* on all the Fronts. These are days of pure killing. We will never be able to forget it. The material desolation or the awful personal loss.[41]

Within these events Hodgkins also wrote of the intense cold and the weather – 'a violent storm and terrific sea running'.[42] She also wrote of her studio, which 'gave onto a yellow sandy beach & at high tide the waves beat against the walls and sometimes the window'[43] and the beach outside the studio windows:

> A few hardy souls are still dipping in the foam, in spite of wind & rain. As I write

there are two girls in front of my window (of 7 Porthmeor Studios) bobbing about like corks in the surf, peacock waves breaking over them and rain coming down. ... The Zepp[elin] raids over London were real & earnest. [44]

Plan B bears witness to Himid's concern with myth, with history and contemporary politics. The early 1990s preoccupation with the formation of a common European identity, which stressed commonalities of culture and the policing and maintenance of European boundaries began to be re-articulated towards the end of the decade. In the strategy that defined a 'Fortress Europe', as outlined by Phil Marfleet, Islam became the new enemy within and without, posing not simply difference but disruption and danger to European culture and civilization.[45] Increased security anxieties and fears of insurgency, within this new mapping reconfigured Europe's key boundaries from the Mediterranean from the straits of Gibraltar to those of the Bosporus.[46] While Himid was in residence in St Ives making the paper works, listening, as she notes, to the radio as she worked in the lifeguards' hut, not only were Europe's edges crumbling in Kosovo, Albania, Croatia and Serbia Montenegro and in Chechnya but there was also bombing in Iraq. As she commented:

Since returning from St Ives the blurring of the edges of the warzones has become extreme. ... How is it possible that when I was in St Ives in

9.13 Lubaina Himid, *Blue*, 1999. Acrylic on canvas, 275 × 122 cm. Artist's collection.

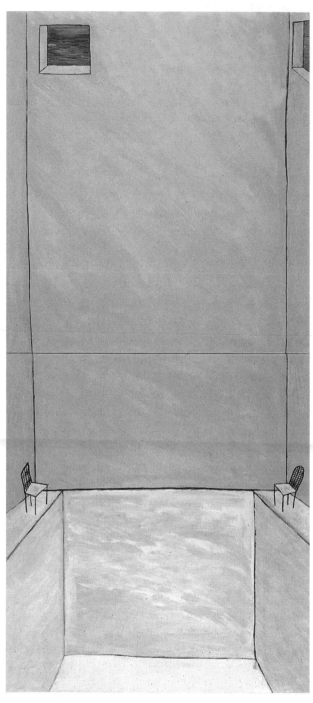

9.14 Lubaina Himid, *Yellow*, 1999. Acrylic on canvas, 275 × 122 cm. Artist's collection.

November Britain bombed Baghdad, when I was in St Ives in March Britain prepared to bomb Belgrade ….[47]

It is the edges of war as reported in the media which framed the production of her paintings. Just prior to the residence in Cornwall discussion in the press, on television and radio reported on the war in the Balkans, with journalists sending seemingly unmediated dispatches from the borders of Kosovo, not from inside except on rare occasions, and interviewed by other journalists constructing judgements about what was going on in the region. Stories of displacement and disappearance run through *Plan B*, resonating with comment on the rebuilding of Sarajevo, concerns about ethnic cleansing or cluster bombs, and the images of fleeing peoples, damaged villages, towns and countryside devastated by war and empty of inhabitants.[48]

But it was not only war outside national boundaries that concerned Himid at this time. She also observed that 'while shopping for fabric in Brixton or Brick Lane we ran the risk of injury and trauma, or while sipping a drink in Soho, we ran the risk of dismemberment or death.'[49] The diverse discourses of violence, the many voices, written, visual and heard, and stories, repeatedly addressed the unravelling boundaries, edges and internal fabric of millenial Europe. Partly these, partly reading Gertrude Stein's *Wars I Have Seen* and the letters of Frances Hodgkins,[50] wove into

174

the dialogue of *Plan B* that 'inkling of danger, [a] call for change'.

In *Wars I Have Seen* Gertrude Stein constructed the female subject as an observer of wars. The prose moves between observer and observed, humorously and sharply elaborating in modernist form on European wars, including two in the Balkans, the Spanish Civil War and two world wars, specifically as a Jewish woman living through German occupation.

> Just at present we are all quiet in very wintry weather here toward
> the end of February, and if or where or when or if the Americans will be
> coming soon, well will they.
>
> Of course these days when there is no way of getting new books I have
> to read the old ones and fortunately I have great quantities of detective
> stories and adventure stories and each one of them now has a different
> meaning, it is one of the real most important things about war, the making
> geography come alive ...[51]

The text panels of *Plan B* conjure echoes of Stein's *Wars I Have Seen* in the prescient sense of danger and tangible fear, and the intervening humour.[52] Of August 1943, Stein writes:

> Here we can see every night when the moon is bright, and even when it is
> not, we cannot see them but we hear them, they hum and then from time to
> time they drop a light and they give us all a very great deal of delight...[53]

And of men returning to France from prison in Italy during 1944:

> Then they got on the way but they found out it would be a very long way
> so some of them and among them two of them went another way. They got
> into the mountains and everybody they met was carrying large bundles,
> they were bundles of shoes and clothing, and so they went in the same
> direction ...[54]

The impelling force of fear and the intangibility of knowledge is refrained in *Plan B*'s text panels: in *The Sharp Undergrowth*, 'After many weeks living in desperate fear the beginning of a new life seemed possible as we reached the mountains' or, in *Our Entire Food Supply*, 'We were cautious and very afraid but the forest fed us well.'

Narrative has been much scrutinized in recent literature as a textual and figurative strategy of recounting. In a stimulating account of the metaphors which arise 'whenever we talk about the relation of narrative to its objects', Susan Stewart foregrounds 'history and stasis, inside and outside', the gigantic and the miniature.[55] Her reflections on place, time and scale, on longing and belonging offer a framework for consideration of the issues presented in *Plan B*.

Like Hodgkins's paintings, Stein's writing and Gelhorn's dispatches, Lubaina Himid's *Plan B* was produced in a moment of intense military activity in Europe and beyond, conjoined with internal civil scrutiny. In its confrontation of empty rooms and the sea, *Plan B* painfully explores the physical sense of being inside a

Index